GALE

CATALOGUE

CATALOGUE OF THE
JAPANESE PAINTINGS
AND PRINTS
IN THE COLLECTION OF
MR & MRS
RICHARD P. GALE

Vol. 2

by

J. HILLIER

with an introduction by

RICHARD P. GALE

1970

PUBLISHED BY ROUTLEDGE & KEGAN PAUL LTD.

for

THE MINNEAPOLIS INSTITUTE OF ARTS

Printed in The Netherlands by Joh. Enschedé en Zonen, Haarlem,
on Mellotex Smooth High White paper,
the colour illustrations in four colours offset,
the black and white illustrations in sheet-fed gravure,
the text in letterpress in Monotype Bembo.
Photographs by Carroll T. Hartwell, Curator of Photography
at The Minneapolis Institute of Arts.
Designed by B. de Does.

© 1970 by J. Hillier
First published 1970 by Routledge & Kegan Paul Ltd.
Broadway House, 68–74 Carter Lane, London E.C.4.
No part of this book may be reproduced in any form
without permission from the publisher, except for
the quotation of brief passages in criticism
ISBN 07100 69138

PART 2

KITAGAWA UTAMARO

(1754–1806)

Earlier appraisals of the Ukiyo-e artists were inclined to make Kiyonaga the culminating figure, and the artists that followed after him the representatives of a decadence, but to-day Utamaro's unsurpassed ability as a designer, coupled with his innate expression of the *fin de siècle* in his prints and albums have given him the place of Ukiyo-e artist *par excellence*.

Although he is so celebrated, nothing is certain regarding his parentage or birth-place, but he is known to have studied under Toriyama Sekien, a Kanō-trained artist with an individual style. Utamaro's early work, under the name of Toyoaki (also read Hōshō), consists mainly of actor-prints in Katsukawa style, but about 1782 he took the name Utamaro and for some time was much influenced by Kitao Masanobu and Kiyo-naga. But his development was towards a broadening of his scope as well as an enrichment of his artistry, and in 1788 he designed two outstanding works of quite opposite char-acter, the 'Insect Book' (*Mushi Erabi*) and the 'Poem of the Pillow' (*Uta Makura*), one of the finest of all erotic albums.

From that time on his genius found full expression in the designing of colour-prints, albums and *ehon*, his association with Tsutajū, the most resourceful and visionary of the Edo publishers, leading to sets of prints, such as the three-quarter-length pictures of beau-ties on mica ground and the 'Large Heads' (*ō-kubi-e*), that established him as the leading Ukiyo-e artist of the day, and that continue to excite the admiration of art-lovers, East and West.

As a painter, Utamaro never succeeded to the extent he did as a designer of prints. The medium was perhaps uncongenial, or his main preoccupation in designing for the broadsheet, and the need to think always in the terms of the colour-print, possibly mili-tating against the sort of freedom and mastery one might have expected of him.

In the latter part of his career, overworked by the exacting publishers, perhaps debilitated by excess (though this frequently-made charge is rebutted by some modern biographers, notably Mr. Shibui), and living in a world of falling standards in manners and morals as well as art, his own gifts failed to some extent, though to the end he was occasionally capable of great things, and his *Annals of the Green Houses* of 1804, in which several of his pupils collaborated with him, is one of his most notable *ehon*.

His death in 1806 seemed to coincide with the end of an era in Ukiyo-e. Technically, the colour-print medium had been brought to perfection, but the taste of the public no longer demanded the type of print, especially in the realm of the Pictures of Beauties and the Kabuki 'Actor-print', which had led to the artistic masterpieces of the 1790s of

Utamaro, Eishi, Sharaku, Chōki, Shunei and the early Toyokuni. Other great prints, especially in the field of landscape, lay ahead, but the period immediately following the death of Utamaro was one in which the Ukiyo-e school was at its lowest ebb since the time of Moronobu.

143 THE FICKLE TYPE

Ōban colour-print; $14\frac{1}{4} \times 10$ in.; *c.* 1792

Half-length portrait of a young woman in a blue robe falling off her shoulder and wearing a yellow *obi* patterned with black feather design. She seems to be returning from a bath, has her hair coiled on her head, and holds one end of a towel trailing over her shoulder in her hands. The background is white mica.

One of the series entitled 'Ten Facial Types of Women', *Fujin Sōgaku Juttai*.

SIGNED: Sōmi Utamaro ga (drawn by Utamaro the Phrenologist). CENSOR'S SEAL: *Kiwame*.
PUBLISHER: Tsuta-ya.
PRINT PUBLISHED: Sale catalogue of M.C. (Chavarse), Paris, 15 February 1922; Ledoux, 1948, no. 48.
FORMER COLLECTIONS: Chavarse; Ledoux.
ACC. 140.

This series has a three-panelled cartouche, the title of the set in the right panel, the artist's signature in the left, and the centre is either left blank in some issues or in others bears the 'type' or, literally, 'expression' the artist is portraying. This specimen lacks an inscription in the centre cartouche, but others have the words *Uwaki no sō*, 'The Fickle Expression'. This subject, one of the most monumental of all Utamaro's designs, is illustrated widely: suffice to mention, for reference purposes, V. & I., Paris, 1912, no. 41, pl. XVI; *Ukiyo-ye no Kenkyū*, August 1926 (which has an article by Inoue dealing with the central cartouche of the series), figs. 4 and 5; Narazaki/Mitchell, *The Japanese Print*, pl. 60 (the Tokyo National Museum impression); Yoshida, *Utamaro Zenshū*, no. 112–3; Shibui, *Zuten*, p. 49.

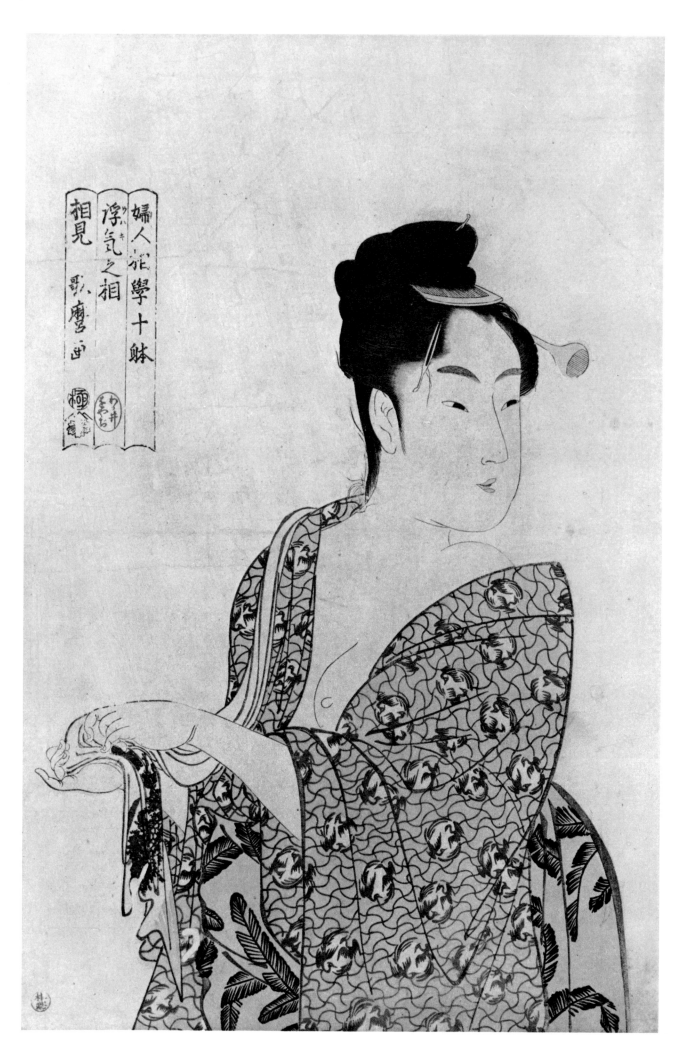

CAT. NO. 143

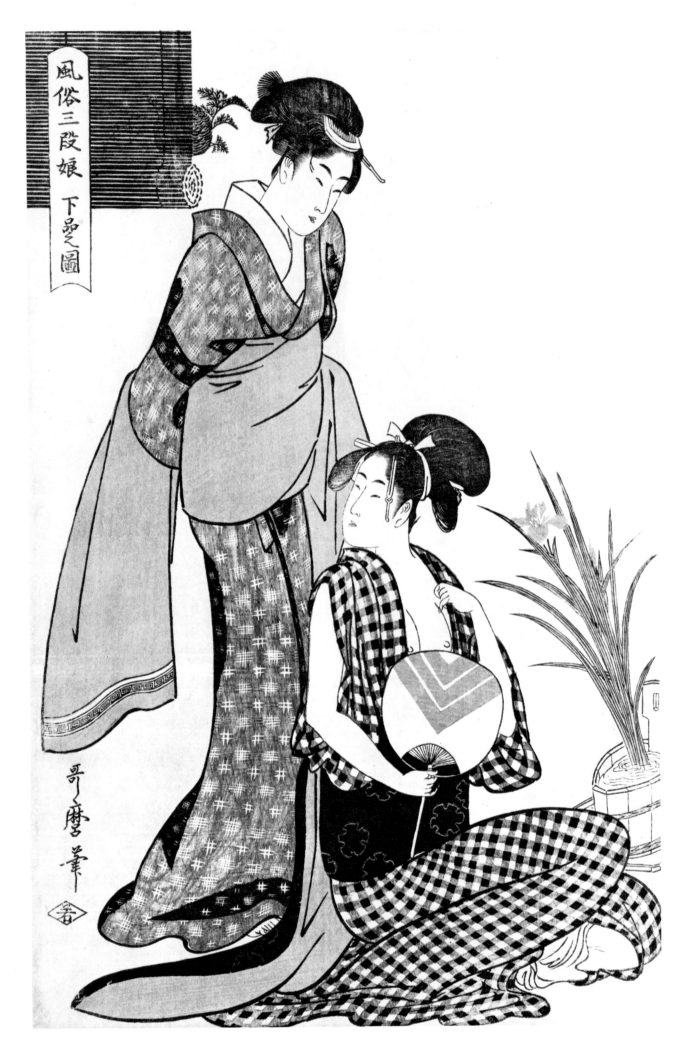

CAT. NO. 144

144 GIRLS OF THE LOWER CLASS

Ōban colour-print; 15×9⅞ in.; *c.*1793

A girl wearing a loose black-and-white-checked bath-robe, open at the front and tied with a green-lined black *obi* kneeling by a tub of irises and holding a fan with purple chevron pattern, her companion, in a thin grey *kimono* patterned with hachures in white and yellow, standing behind, tying her pink *obi*. Yellow ground. The title of the set is *Fūzoku Sandan Musume* ('Customs of the Three Classes of Young Women'), and the two girls of this print represent the lowest class, the sub-title being *Gehin no zu* ('Picture of the Lowest Class').

SIGNED: Utamaro *hitsu*.
PUBLISHED: Wakasaya.
PRINT PUBLISHED: Rouart Sale Catalogue, New York, 1922, no. 831; Ledoux 1948, no. 29.
EXHIBITED: M.I.A., 1961, no. 99.
FORMER COLLECTIONS: Rouart; Ledoux.
SUBJECT ILLUSTRATED: The impressions illustrated in V. & I., Paris 1912, no. 166, *U.T.*, vol. VII, no. 127, Yoshida, 322, and Shibui, *Zuten*, p. 146 differ from the one here catalogued in that the robe of the seated figure is printed with a different pattern. Ledoux thought that the other version was later, but there seems no evidence to support that suggestion.
ACC. 188.

This set is one of the earliest with a yellow background, an innovation followed by a number of contemporary artists, Eishi in particular.

145 A BEAUTY OF THE SOUTH

Ōban colour-print; 14¾×9¾ in.; *c.*1793

Bust portrait of a courtesan, wearing a transparent black-and-white *uchikake* and a purple *kimono* with white calligraphic decoration partly seen through the *uchikake*, holding up a round fan which bears a picture of Shinagawa Bay and a verse signed Magao, a well-known *kyōka* writer of the time, translated by Ledoux:

> 'Even as guests do,
> So do the summer breezes,
> Ever returning,
> Come to Sode-ga-ura
> Place of heavenly coolness.'

The print has a mica ground. The title cartouche reads *Nankoku Bijin Awase* ('Beauties of the South').

SIGNED: Utamaro *hitsu*.
PUBLISHER: Tsuta-ya.
PRINT PUBLISHED: Ledoux, 1948, no. 43; Gentles, *Masters of the Japanese Print*, no. 93.
EXHIBITED: M.I.A., 1961, no. 97; Asia House Gallery, 1964, no. 93.
FORMER COLLECTION: Ledoux.
SUBJECT ILLUSTRATED: *U.T.*, vol. VII, no. 166; Sotheby Sale Catalogue, 9 July 1925, no 43, pl. IV; Kondō, *Utamaro*, no. 30; Yoshida, no. 332; Shibui, *Zuten*, p. 185.
ACC. 194.

Sode-ga-ura is the same as Takanawa, Shinagawa, the bay to the south of Edo, and the *Nankoku* of the title is thus explained. No other print of this series has been recorded. Shibui, in *Ukiyo-e Zuten*, suggests that from the context of the poem possibly we are meant to deduce that the name of the girl is Konosumi.

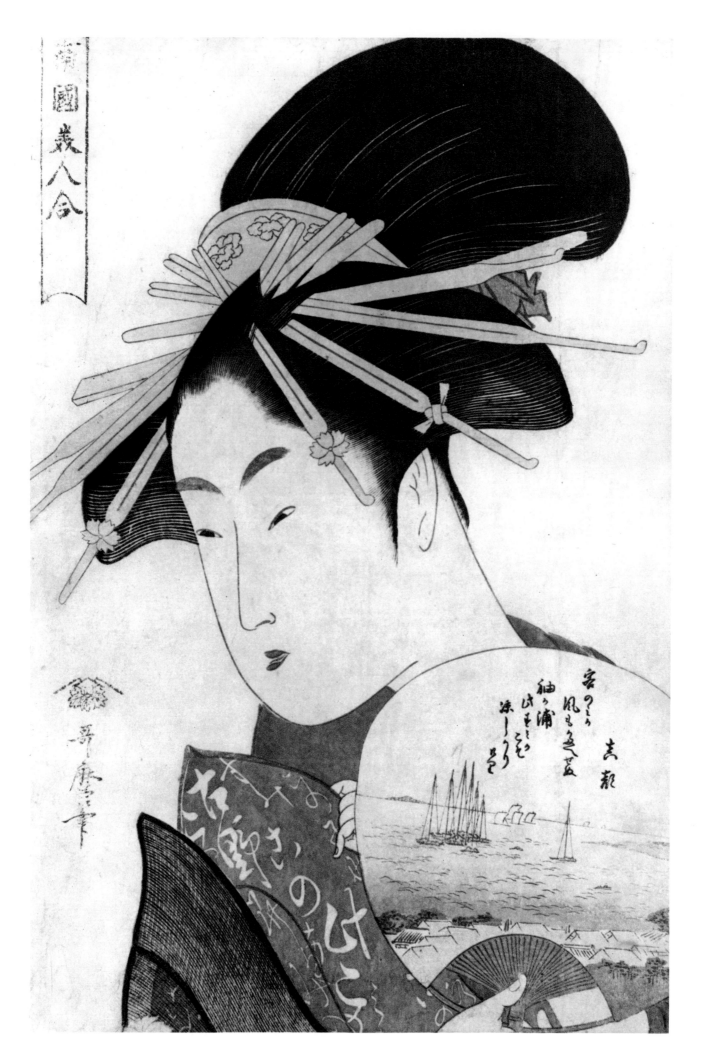

CAT. NO. 145

146 THE WAITRESS OKITA

Ōban colour-print; 14¾×9¾ in.; *c.* 1793

Half-length portrait of Okita, a waitress at the Naniwa tea-house, carrying a green tea-bowl on a black-lacquer tray. Her main dress is blue with a design of *kiri* in white, and her *obi* is black with a scroll pattern in light reserve. Below that is a narrow red sash over a fawn-gold skirt. Mica ground.

The cartouche top left has an inscription signed Katsura no Mayuzumi, to the effect that it was written whilst he was resting at the Naniwa tea-house, the poem that follows conveying the idea, with the play on words greatly loved by the light versifiers, that Okita and the Naniwa-ya were a great draw to travellers.

SIGNED: Utamaro hitsu. CENSOR'S SEAL: *Kiwame.*
PUBLISHER: Tsuta-ya.
PRINT PUBLISHED: Sale Catalogue, Hôtel Drouot, Paris, 6 April, 1922 (Mutiaux), no. 250; Ledoux, 1948, no. 44; Gentles, *Masters of the Japanese Print*, 1964, no. 95.
EXHIBITED: Paris, Musée des Arts Décoratifs, 1912, no. 68; M.I.A., 1961, no. 101; Asia House Gallery, 1964, no. 95.
FORMER COLLECTIONS: Mutiaux; Ledoux.
SUBJECT ILLUSTRATED: In many publications, e.g. *U.T.*, vol. VII, no. 139; Ficke; *Chats on Japanese Prints*, pl. 38; Shibui, *Zuten*, p. 46. A variant, lacking the cartouche, is illustrated in Yoshida, no. 314, and Shibui, *Zuten* p. 46.
ACC. 154.

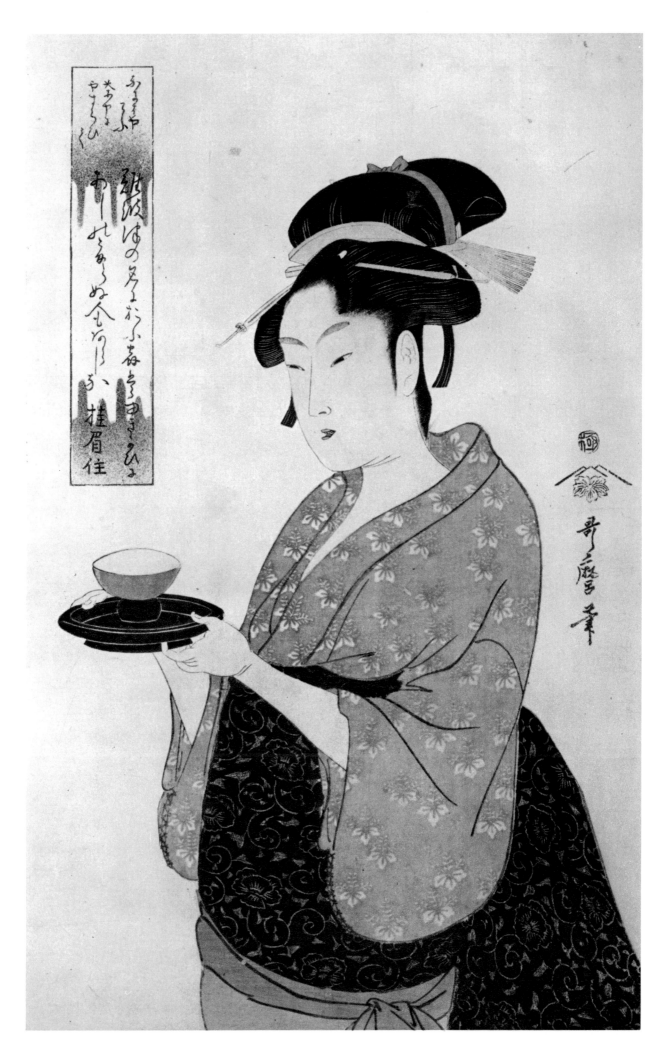

CAT. NO. 146

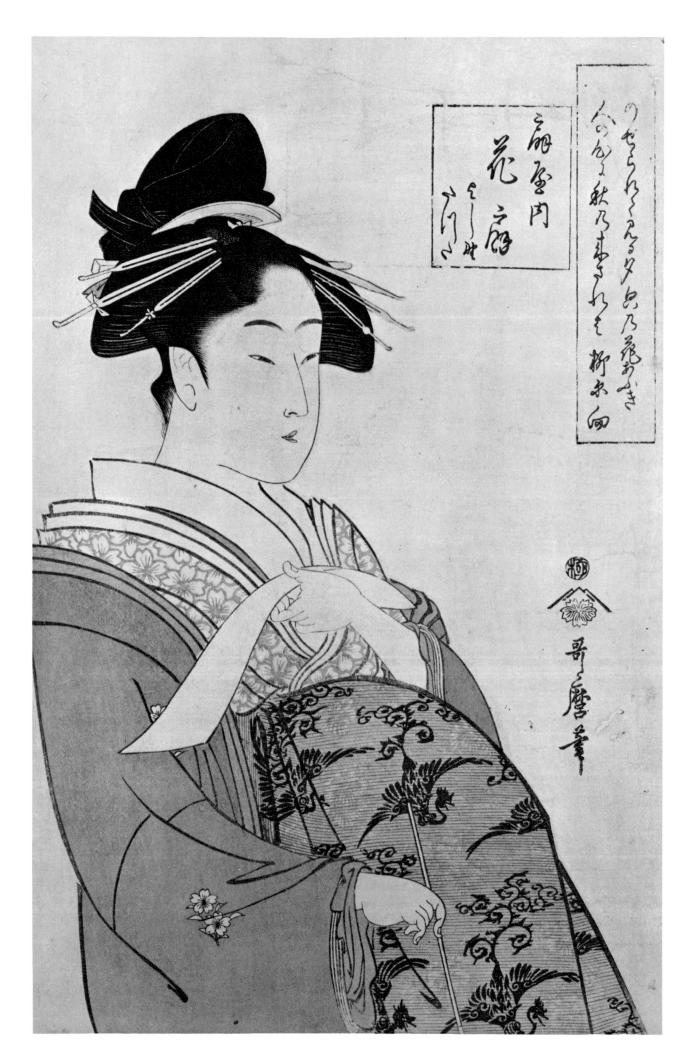

CAT. NO. 147

147 HANA-ŌGI HOLDING A POEM-PAPER

Ōban colour-print; 14½×9¼ in.; *c.* 1794

Half-length portrait of the courtesan Hana-Ōgi of Ōgi-ya holding a blank poem-strip (*tanzaku*) and a brush. Her outer garment is purple, and beneath are a succession of *kimono*, pink, white with pink floral decoration, white, pink, white; her *obi* is brocaded, with a pattern of stylized birds in dark brown on tea-brown. Mica ground.

The square cartouche has the names of Hana-Ōgi and her two *shinzō*, Yoshino and Tatsuta, whilst the oblong cartouche is inscribed with a poem signed with a name meaning 'From the other side of the Yanagiwara' (a suburb of Edo). The poem admits of several translations, one being:

> 'When autumn entered my heart
> Then I wandered into obscure paths;
> And look! as the night engulfed me
> Hana-Ōgi came into flower!'

SIGNED: Utamaro hitsu. CENSOR'S SEAL: *Kiwame.*

PUBLISHER: Tsuta-ya.

PRINT PUBLISHED: Ledoux, 1948, no. 40.

EXHIBITED: M.I.A., 1961, no. 102.

FORMER COLLECTION: Ledoux.

SUBJECT ILLUSTRATED: In many places, e.g. V. & I., Paris 1912, no. 62; Sotheby Catalogue, 2 June 1913, no. 92; U.T., vol VII, no. 55; Yoshida, no. 172; Shibui, *Zuten*, no. 3, p. 50.

ACC. 189.

Hana-Ōgi was one of the favourite courtesans of the Yoshiwara over a surprisingly long term of years, and Ledoux gives an interesting account of her career, listing over a dozen portraits of her by Utamaro and other artists.

This print is one of three with similar oblong and square cartouches, the other two prints portraying Miyabito of Ōgi-ya and Wakaume of Tama-ya. All three are illustrated in Shibui, *Zuten*, p. 50.

148 THE 'SNOW HERON' DANCER

Ōban colour-print; 14¾×9⅜ in.; *c.*1794

Head and shoulders of a Dancer wearing the flower-starred hat, *hanagasa*, and carrying two other similar hats, *sodegasa* 'sleeve-hats', her costume patterned with a meandering stream and blossom motive. Mica ground. One of a set *Tōsei Odoriko Soroi* ('Selection of Modern Dancers'), with sub-title *Sagi-musume* ('The Heron Maiden').

SIGNED: Utamaro hitsu.
PUBLISHER: Tsuta-ya.
FORMER COLLECTIONS: Stonborough; Bess.
SUBJECT PRODUCED: V. & I., Paris, 1912, no. 101, pl. XLVI; Matsukata Catalogue, no. 55 (in colour); *Ukiyo-e Zenshū*, vol. 3, pl. 19; Catalogue of Asahi Shimbun Utamaro Exhibition, 1965, no. 13.
ACC. 370.

In his note in *Ukiyo-e Zenshū*, vol. 3, on the Tokyo National Museum impression of this print, Mr. Takahashi Seiichirō refers to the *naga-uta* ('long poem') *Sagi-musume*, which gave the title to this print, and to Utamaro's rather indirect illustration of it. *Sagi-musume* ('The Heron Maiden') is the story of a white heron transformed into a girl who aspires to live the life of an Edo beauty, but who ends dismally by being condemned to torment in Hell. The play was performed first in 1762 and became a firm favourite in the repertoire of the Kabuki stage. Artists such as Bunchō, Harunobu, Shunshō and Koryūsai invariably chose to depict *Sagi-musume* in the appealing guise of a forlorn maiden in the snow. Utamaro, clearly not referring to any specific performance, has depicted the dancer who presumably mimed certain episodes of the story. Seiichirō relates the print to a passage which he quotes from the *naga-uta* with the sense, 'The love in my heart is transient as a snow-storm of blossom: it is a pity even to brush it off with the *sodegasa*' (the 'sleeve-hat,' one of which the dancer carried in each of her hands and waved with fan-like motions).

An account of various performances of *Sagi-musume* and a translation of part of the *naga-uta* are given by Waterhouse in his *Harunobu and his age*.

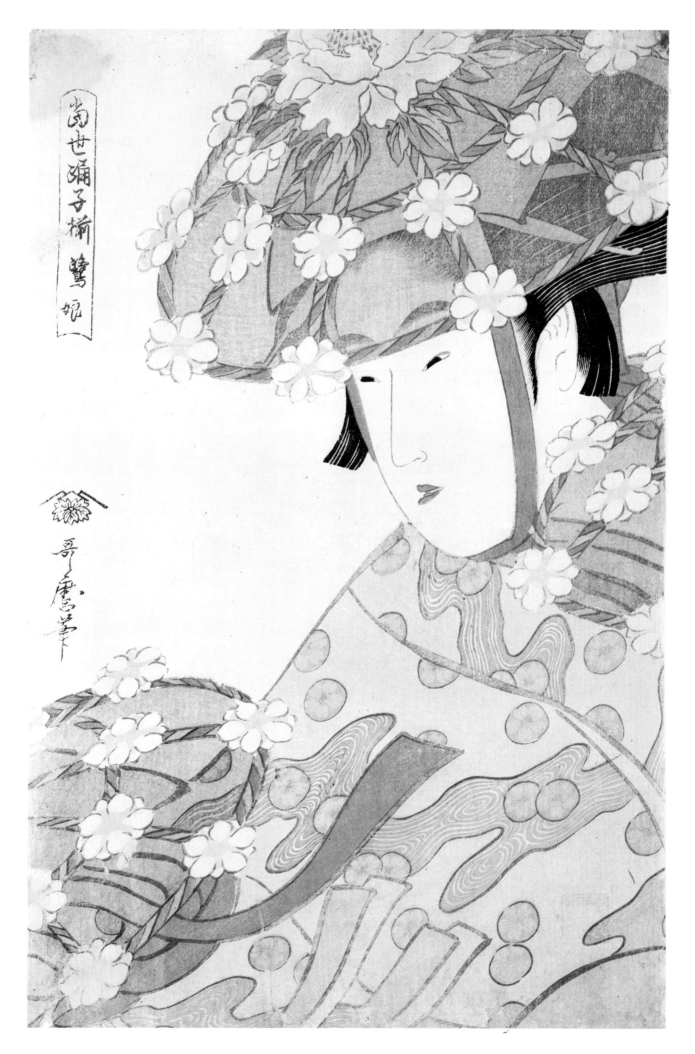

CAT. NO. 148

149 THE SINGER TOYOHINA TOMINOTO

Ōban colour-print; 15¼×10¼ in.; *c.*1794

Head and bust of the celebrated singer Toyohina Tominoto in black gauze *uchikake*, pink *kimono* showing at the neck, a fan in one hand, the other pulling up the collar of her white under-*kimono*, traces of mica on the 'horn-hiding' hair-covering, an inset cartouche giving the name of the series, *Kōmei Bijin Rok'kasen* 'The Most Famous Beauties as the Six Immortal Poets' and also various objects forming a rebus on the girl's name, viz. *Tomi* (lottery), *mo* (duckweed), *to* (hone) and *To* (door), *yo* (night) and *hina* (doll). Grey ground.

SIGNED: Utamaro *hitsu.*
PUBLISHER: Ōmi-ya.
EXHIBITED: M.I.A., 1961, no.98.
SUBJECT ILLUSTRATED: Ficke Second Sale Catalogue, 1925, no.173; Sotheby Sale Catalogue, 5 October 1964, no.92; Yoshida, no.297; Shibui, *Zuten,* p.56.
ACC.209.

The 'Six Immortal Poets' formed another classical concept that was often illustrated in more or less 'straight' style by Ukiyo-e artists, with the six poets (accounted as the greatest since the tenth-century anthology, *Kokinshū*) in period costume or else in *mitate* form, as in this instance, where beauties of the day are made to represent the Immortal Six. Although the girls names are easily solved from the somewhat childish rebus in the cartouche of each print, there does not seem any way in which the poets can be identified. The Six Poets were: Ariwara no Narihira, Ono no Komachi, Sōjō Henjō, Bunya no Yasuhide, Kisen Hōshi and Ōtomo no Kuronushi.

A second version of at least two of the six in the set was published, with a portrait of one of the poets in the cartouche instead of the rebus, but Toyohina does not appear to have been re-issued in this form.

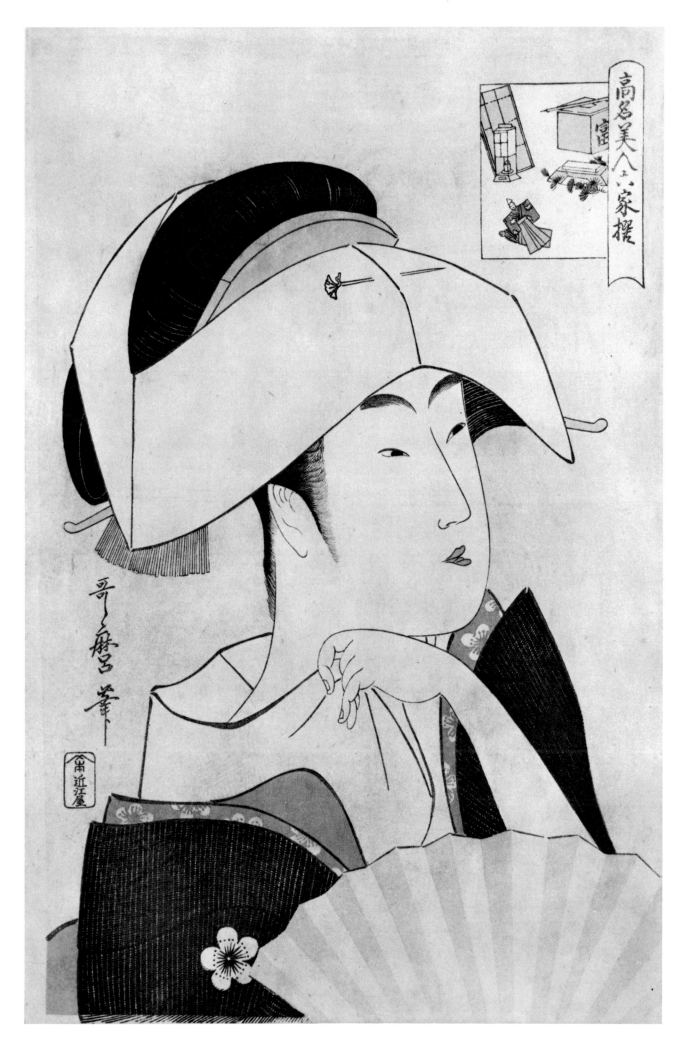

CAT. NO. 149

150 THE KITCHEN

Ōban diptych colour-print; each sheet 14¼×9¾ in.; *c.*1795

Women are gathered around a stove preparing a meal in a kitchen, one, in faded purple, using a bambo opipe to blow into the charcoal fire, another, behind her, in purple-striped *kimono*, about to ladle something into a bowl, but withdrawing with closed eyes from the steam suddenly emitted, a third in a blue-and-white-squared garment squatting and peeling an aubergine, and a young mother in blue, harassed by a child clinging to her back, trying to wipe a bowl of red-and-black lacquer. The green (perhaps once gold?) oven has been lacquer-printed; in this, as in other known impressions, the lacquer surface shows signs of cracking. Yellow ground.

SIGNED: Utamaro hitsu.
PUBLISHER: Uemura-ya.
PRINT PUBLISHED: M.I.A., 1961, no.105, fig.14.
EXHIBITED: M.I.A., 1961, no.105.
FORMER COLLECTION: Schraubstadter.
SUBJECT REPRODUCED: Hayashi Catalogue, 1902, no.797, p.188; V. & I., Paris, 1912, no.90, pl.XLI; Yoshida, no.232; Shibui, *Zuten*, p.111.
ACC.196.

Another picture of an oven similar to the one in this picture and with an old crone blowing up the fire with a bamboo pipe, appears in a small book by Utamaro, 'Edo Sparrows' (*Edo Suzume*), 1786, reproduced in Hillier, *Utamaro*, p.22.

The technical device of overprinting certain details with lacquer noted in this print is observable in a number of other prints of this period, another example being the 'Mother and Child' print, no.151 in this collection.

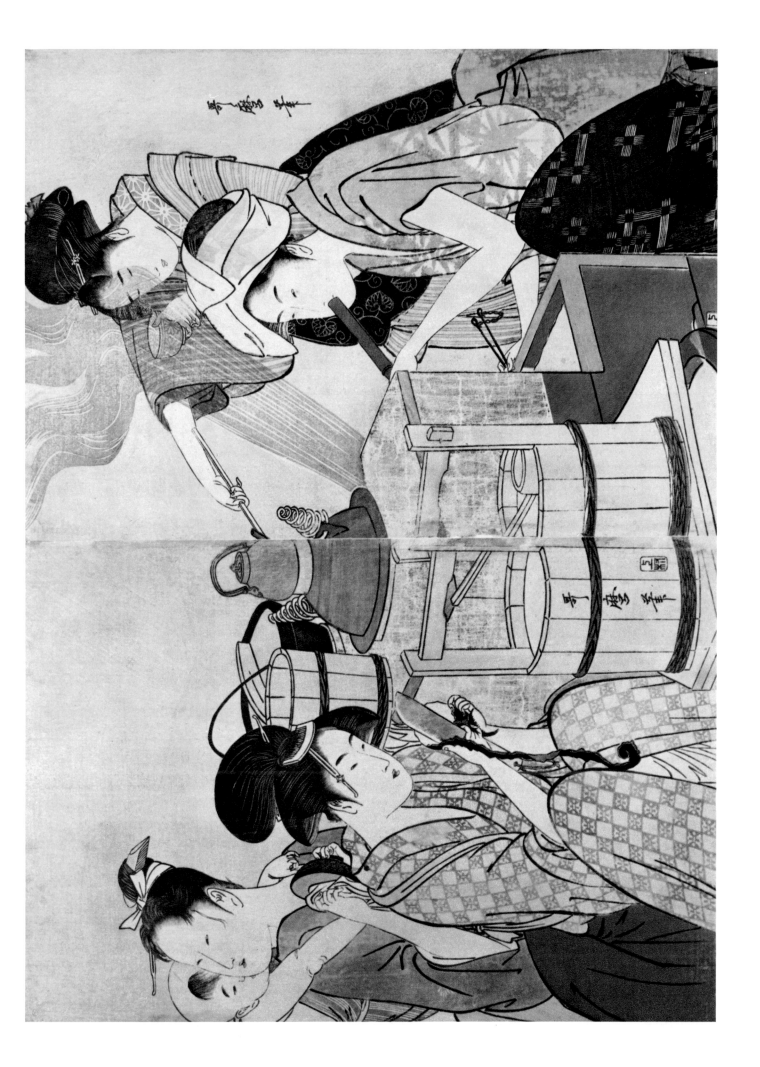

CAT. NO. 150

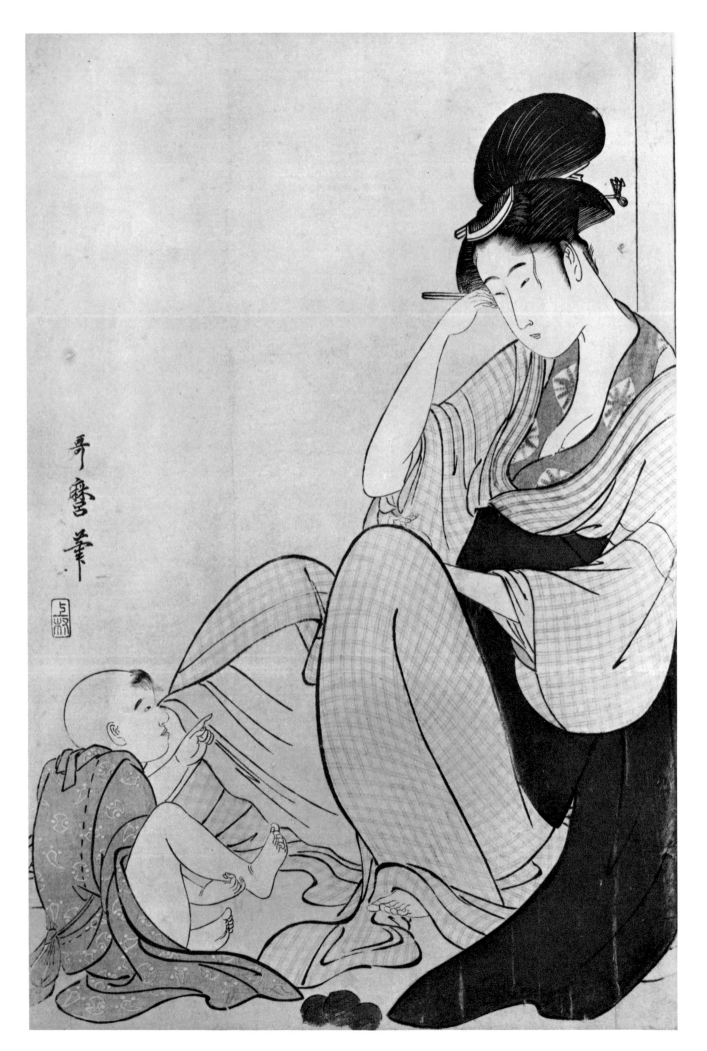

CAT. NO. 151

151 MOTHER AND CHILD

Ōban colour-print; 14⅞×10 in.; *c.*1795

A young mother in a pink *kimono* and violet under-garment, seated with her back to a wall, indolently scratches her ear with a hair-pin, making a *moue* as she does so, a baby in pink seated at her feet pointing up at her. Yellow ground, the green of the *obi* lacquered.

SIGNED: Utamaro hitsu.

PUBLISHER: Uemura-ya.

PRINT PUBLISHED: Sotheby Sale Catalogue, Madame Michele Stoclet, June 1966, no. 130.

FORMER COLLECTION: Stoclet.

SUBJECT ILLUSTRATED: V. & I., Paris, 1912, no. 91, pl. XL (the Koechlin print, in which the *obi* is similarly lacquered); Priest, *Japanese Prints from the Henry L. Phillips Collection*, Metropolitan Museum of Art, 1947 no. XXI; Shibui, *Zuten*, p. 193; Yoshida, no. 81.

ACC. 361.

CAT. NO. 152

152 THE FARMER'S WIFE

Ōban colour-print; 14¼×9¾ in.; *c*.1795

Head and shoulders of a smiling woman, her hair in disarray and her *kimono* falling from her shoulder and revealing her bosom, a towel carelessly draped over one shoulder. In the fan cartouche resting on a skep of straw above, she is identified as the 'Farmer's Wife', and a short poem refers in an apt, rustic simile to the watering of the seeds of love in the rice-plant nursery. Grey ground.

SIGNED: Shōmei Utamaro hitsu. SEAL: Honke.
PUBLISHER: Matsumura.
PRINT PUBLISHED: Stonborough Sale Catalogue, Paris, 1938, no.440.
FORMER COLLECTIONS: Stonborough; Bess.
SUBJECT ILLUSTRATED: V. & I., Paris, 1912, no.149, pl.LXV; Yoshida, no.226; Shibui, *Zuten*, p.63.
ACC.369.

The prefix *Shōmei* (the 'real', or 'genuine') to his name and the seal Honke ('Original House'), introduced for certain prints about this time, has been taken to indicate that Utamaro's popularity was leading to imitations and copies even in his own day, but either of these additions could equally well have been copied by determined pirates, and it is just as likely that they are further evidence of the artist's pride and a confidence in his leading position in Ukiyo-e in the prime of his life.

153 SHAVING A BOY'S HEAD

Ōban colour-print; 15⅛×10¼ in.; *c.* 1797

A father, in a grey, white and blue check, gingerly shaving the top of a baby boy's head whilst the child, in white-diamonded pink garment, is held tightly by the kneeling mother between her right thigh and her bared breast; she is in yellow with a purple *obi*. The store-chest left is lacquered, and the flat water-bowl is printed in gold (changed now to green). Grey background.

SIGNED: Utamaro hitsu.
PUBLISHER: Ōmi-ya.
PRINT PUBLISHED: M.I.A., 1961, no. 103, fig. 13.
SUBJECT REPRODUCED: Yoshida, no. 681; Shibui, *Zuten*, p. 196.
ACC. 274.

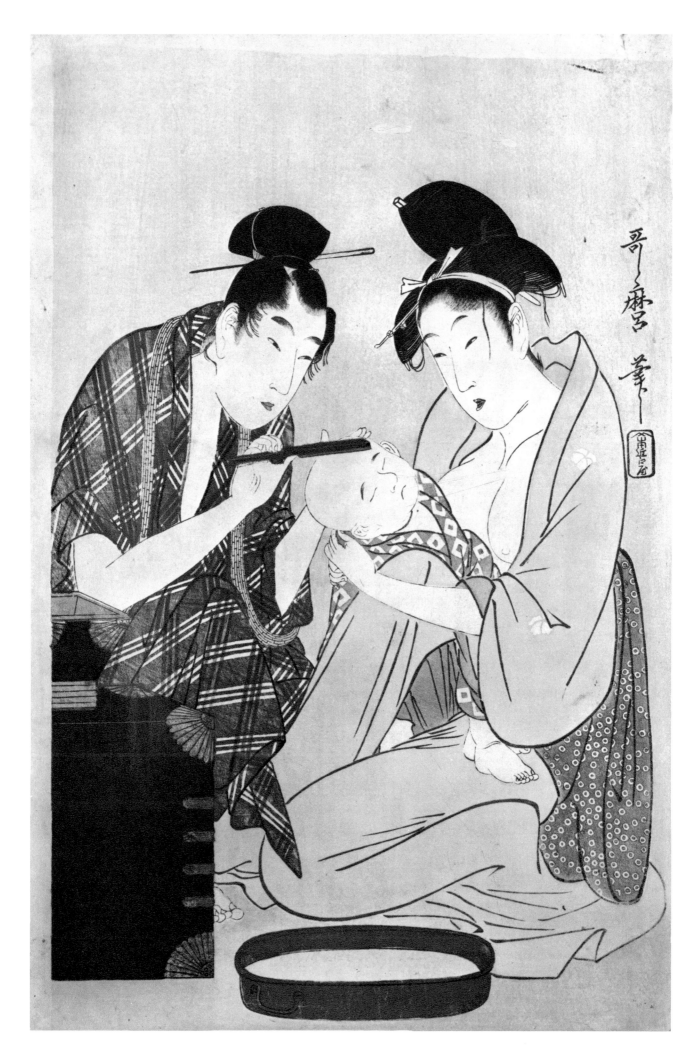

CAT. NO. 153

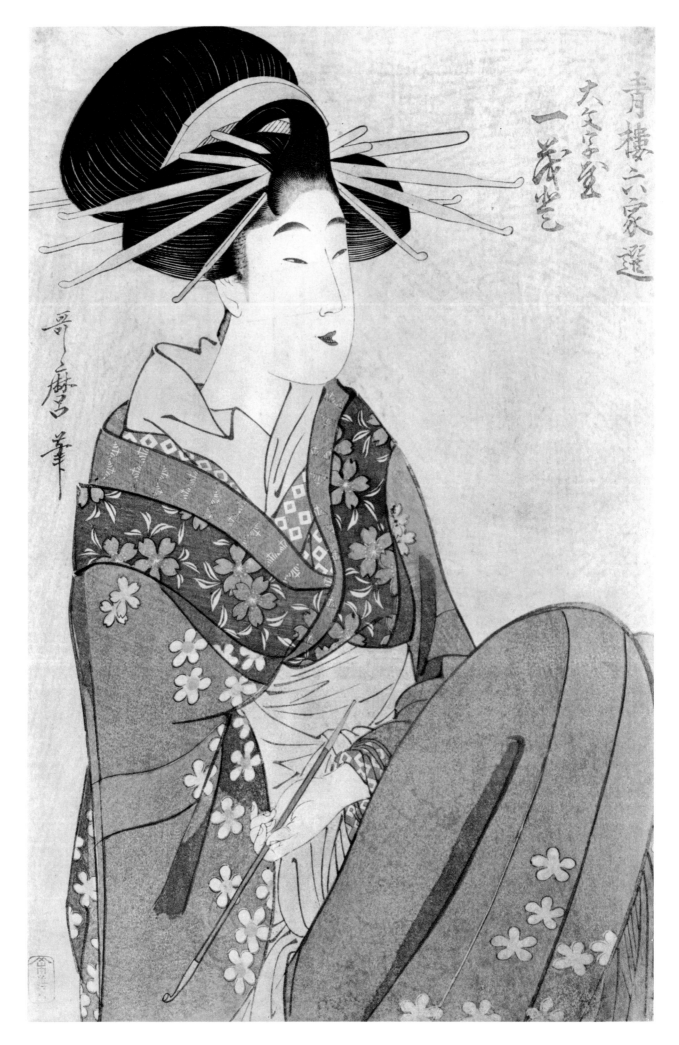

CAT. NO. 154

154 HITOMOTO OF DAIMONJI-YA

Ōban colour-print; 14⅞×9⅞ in.; *c*.1797

Half-length figure of the courtesan Hitomoto of Daimonji-ya seated on the floor with her right knee raised and with a long tobacco-pipe in her hand. The colour is complex, and one of the interesting technical features is the denoting of folds (at the thigh, for instance) in the *uchikake*, which is purple with blue bands, by a deeper purple; other *kimono* are green, red and pink, with varied decoration, and the *obi* is white. The title of the series is *Seirō Rokkasen* ('The Six Immortal Poets of the Green Houses').

SIGNED: Utamaro hitsu.
PUBLISHER: Ōmi-ya.
PRINT PUBLISHED: Ledoux, 1948, no.36.
FORMER COLLECTION: Ledoux.
SUBJECT REPRODUCED: Yoshida, no.690; Shibui, *Zuten*, p.58.
ACC.195.

Ledoux pointed out that the red at the extreme right-hand corner has been touched up with a brush. His remarks in relation to this print on the difficulty of detailing the colours of Japanese prints, 'because of the complexity and sophistication of the design and printing', agree with the view expressed in the Cataloguer's 'Note', p.xvi.

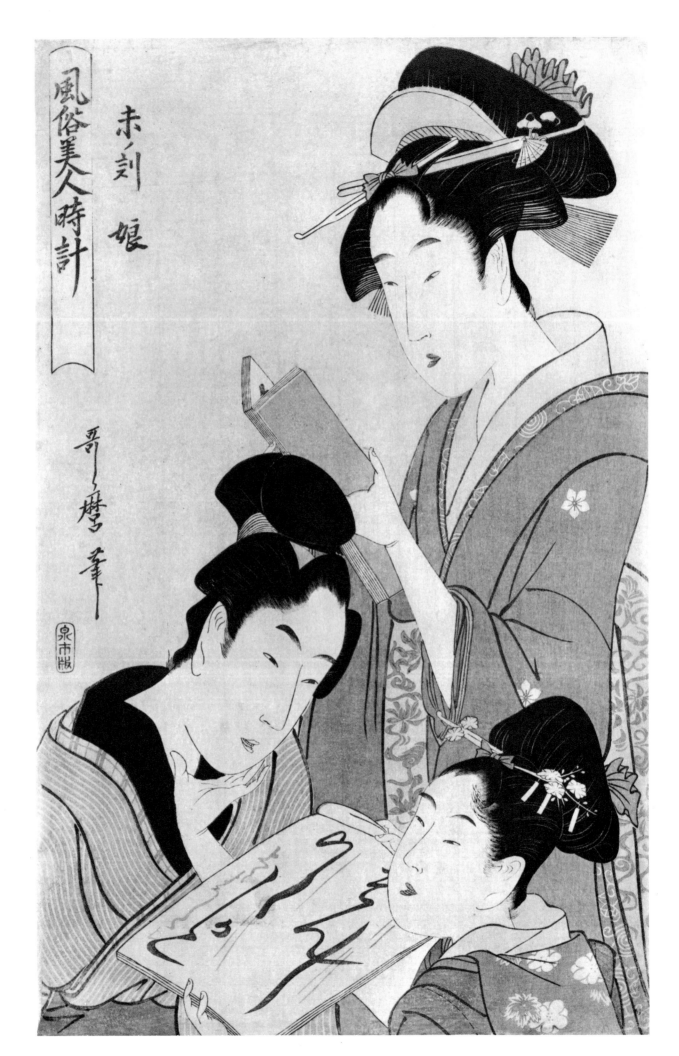

風俗美人時計

未ノ刻　娘

哥麿筆

CAT. NO. 155

155 THE CALLIGRAPHY LESSON

Ōban colour-print; 15¼×9¾ in.; *c.* 1798

A young girl in green and pink in the foreground presenting a specimen of her juvenile calligraphy to a young man in a blue-and-white-striped *kimono* who quizzes the writing, his hand to his chin, a young woman behind them standing with an open book held before her; she has a violet *kimono* with pink beneath, and her *obi* is pink with a pattern in red on it. The scene represents the Hour of the Goat (1 to 3 p.m.) in the series entitled *Fūzoku Bijin Tokei* ('The Customs of Beautiful Women by the Clock'), with the sub-title *Musume* ('Maiden'). Grey ground.

SIGNED: Utamaro hitsu.
PUBLISHER: Senichi.
PRINT PUBLISHED: Sotheby Sale Catalogue Philippe R. Stoclet, May 1965, no. 178.
FORMER COLLECTIONS: Van Roy; Stoclet.
SUBJECT REPRODUCED: Shibui, *Zuten*, p. 106, which gives eleven of the set.
ACC. 356.

Under the system in force in Japan until 1873 (when the Western chronology was introduced), the day was divided into twelve parts, named by the Zodiacal signs, each part equivalent to two hours.

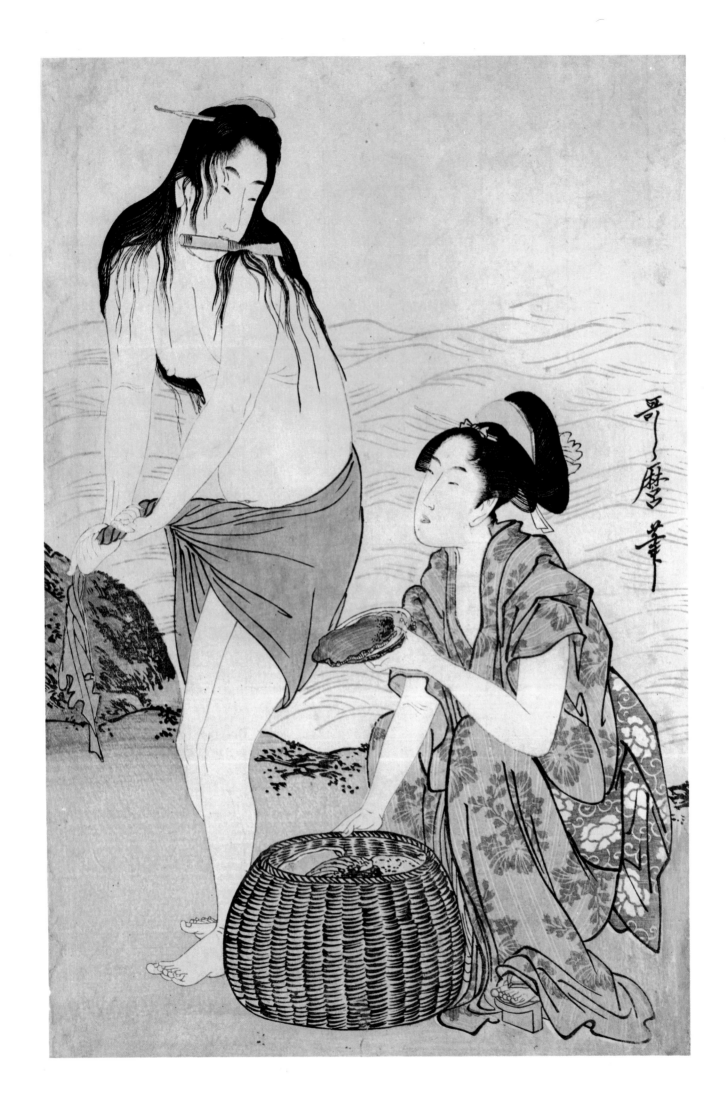

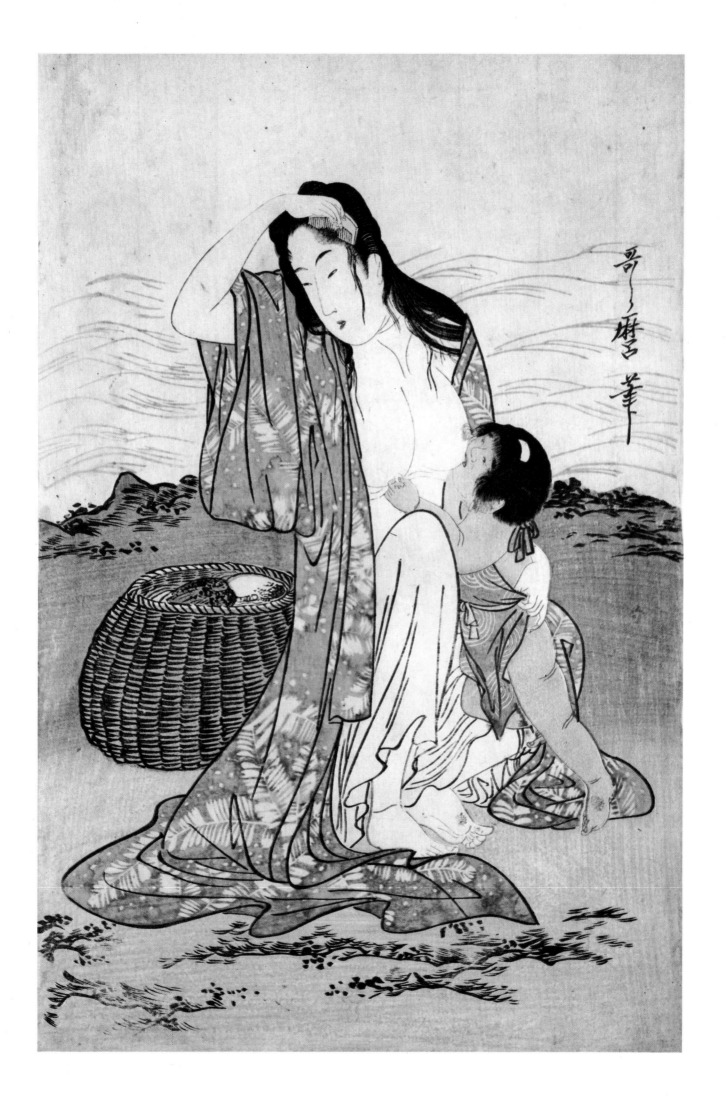

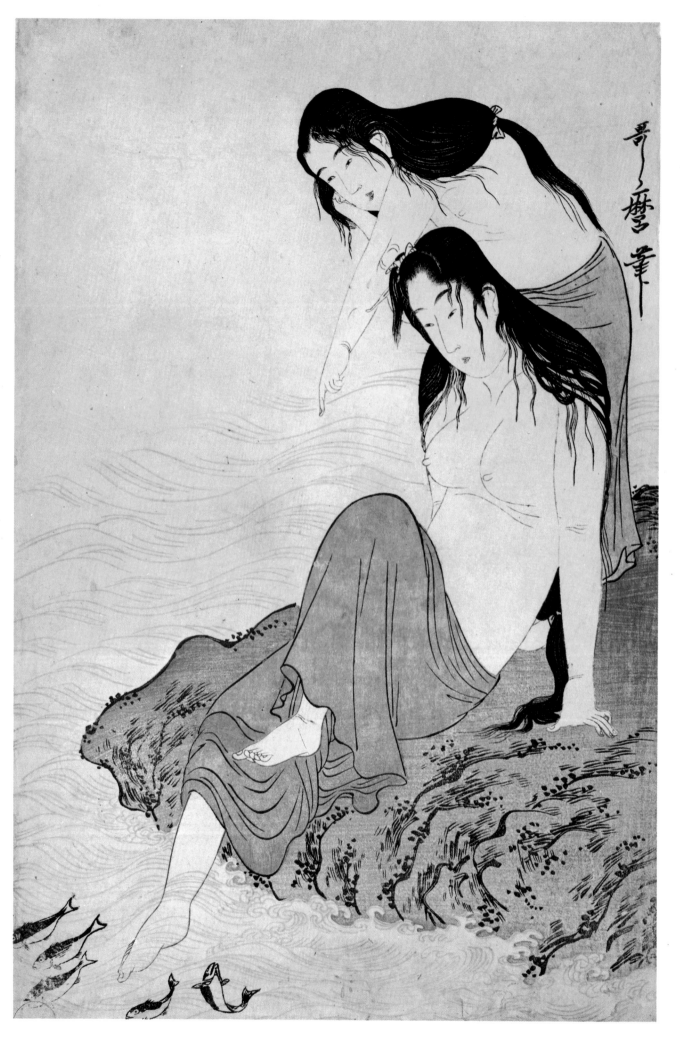

歌麿筆

CAT. NO. 156

156 THE *AWABI* DIVERS

Ōban triptych colour-print; right, 14⅝×9¾ in.; centre and left, 14¾×9¾ in.; *c.* 1798

A sea-shore scene, with girl divers for *awabi* (abalone) resting on the rocks after a spell of diving, clad only in the red skirts normal to them, and forming three groups that contrive to make each sheet independent of the others, though the shore-line and the sea and the balance of the standing figures against the central group result in a monumental overall composition: left, one girl seated on the rock and withdrawing a foot from the water away from a shoal of fish, another standing behind her pointing to the shoal; centre, a mother seated by the basket holding the catch of shell-fish, combing her hair and suckling the large boy standing between her thighs; and right, a diving-girl just emerged from the water, holding her *tegane* (prising-implement) between her teeth as she wrings out the water from her skirt, and looking down at a girl who has come to buy *awabi* and is holding up one of the shellfish to inquire the price. The flesh outlines are printed in red. The colours are few and broadly applied, the main features being the red of the skirts, the green wrap of the mother, the purple *kimono* of the customer, whose *obi* is green and white, and the blue-green of the rocks.

SIGNED: Utamaro *hitsu*.
EXHIBITED: M.I.A, 1961, no. 104.
FORMER COLLECTION: Baron Fujita.
ACC. 116.
SUBJECT ILLUSTRATED: This is possibly the most widely known and reproduced of all Japanese figure-prints. The Doucet impression is illustrated in V. & I., Paris, 1912, no. 83, pl. XXXVI, with centre sheet in colour on pl. XXXVII; the B.M. impression (ex-Burty) in their *Catalogue of Japanese and Chinese Woodcuts*, 1916, no. 105 and in Hillier, *Utamaro*, pl. XV; the Tokyo National Museum copy in Narazaki/Mitchell, *The Japanese Print*, pp. 64–6, in colour; the Yoshida reference is no. 300 and Shibui, *Zuten*, p. 14.

Outside the erotic paintings and prints, the nude occurs only infrequently in Japanese art, but the occupation and minimal dress of the *awabi* divers gave Ukiyo-e artists an opportunity to depict the nude body without offending canons of decency. Apart from that, the diving girls had a reputation for being passionate, a fact which would also have been in the mind of any Ukiyo-e artist and his audience. In fact, the first print in Utamaro's *Uta Makura*, the great erotic album of 1788, depicts two *awabi* fishers in situations less equivocal than those in which they usually appear in the broadsheets.

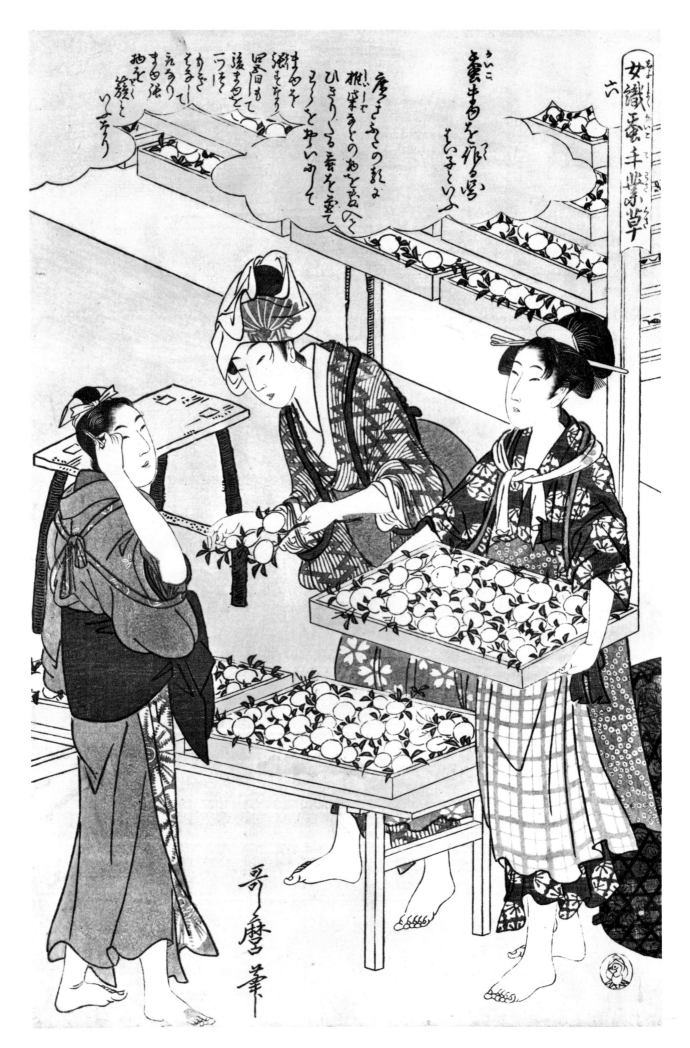

CAT. NO. 157

157 REARING SILKWORMS

Ōban colour-print; 15¼×10 in.; *c.*1800

The sixth sheet from a twelve-sheet composition showing the various stages in silkworm production, the three girls here being concerned with the cocoon stage, one girl arranging the cocoons in trays and another holding a tray full of them and lifting it to put it with the other trays on the rack behind them. A third assistant pauses to adjust a pin in her hair. The colours are those of the first issue, described by Binyon as a 'rare and beautiful one of violet, blue, green, yellow and pale grey'. The title above is *Joshoku Kaiko Tewaza Gusa* ('Silkworm Culture Handiwork of Women').

SIGNED: Utamaro *hitsu*.
PUBLISHER: Tsuru-ya.
SUBJECT ILLUSTRATED: The complete set is illustrated in *Twelve Wood-block Prints of Kitagawa Utamaro illustrating the Process of Silk Culture*, San Francisco, 1965 (Grabhorn Collection); Yoshida, nos. 447–58; Shibui *Zuten*, p. 138. Another complete set is described in the British Museum *Catalogue of Japanese and Chinese Woodcuts*, pp. 219–21.
ACC. 338

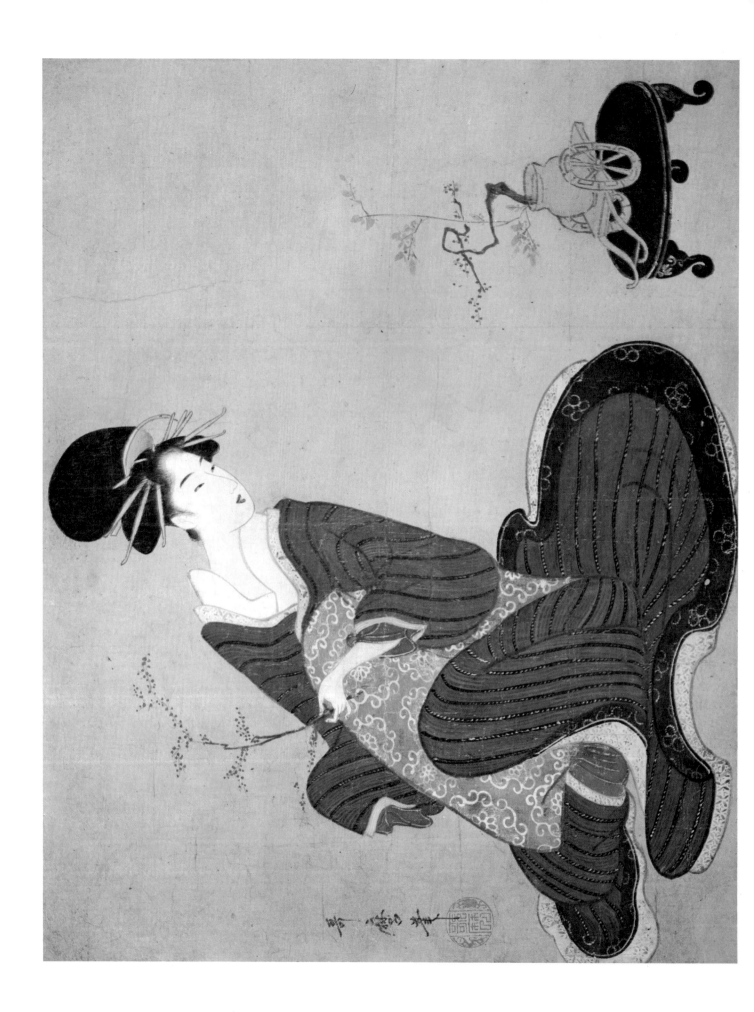

CAT. NO. 158

158 WOMAN MAKING A FLOWER ARRANGEMENT

Kakemono. Ink, colour and *gofun* on paper; 15½ × 19½ in.; *c.* 1802

A young woman, in a *kimono* predominantly brown-red in colour, seated holding a spray of *nanten* in her hand and about to complete a flower-arrangement in a pot resting on miniature wagon-wheels standing on a low three-legged table at her side.

SIGNED: Utamaro *hitsu*. SEAL: Utamaro.
PUBLISHED: *U.T.S.*, vol. 12, pl. 9 (in colour); M.I.A., 1966, Exhibition Catalogue, no. 31.
EXHIBITED: M.I.A, 1966, no. 31.
FORMER COLLECTION: Ozeki Fujiyoshi.
ACC. 292.

In his description of this painting in *U.T.S.*, Yoshida dates this painting about Kansei 8–9 (1796–7), but the hair-do and indeed the features and somewhat vapid expression of the girl seem to indicate a date after the turn of the century.

159 THE INTERRUPTED ARTIST

Ōban colour-print; 15⅜×10 in.; *c.* 1804

An artist and his lover on their knees behind a two-fold screen painted with a design of birds on a flowering tree, she holding his wrist, apparently to restrain him from continuing his work. A maid peers over the top of the screen, amused by the proceedings. The colours are muted by partial fading: the kneeling girl's *kimono*, originally purple, is now a warm buff, the pink of her *obi* is dulled, and the man's *obi* is now striped with fawn, no doubt pink originally, and white. The standing girl's *kimono*, now buff, was probably purple originally. Grey ground.

SIGNED: Utamaro hitsu.
EXHIBITED: *The Nabis and Their Circle*, M.I.A., 1962.
ACC. 35.

This print, which appears to be singularly rare and certainly not recorded in the usual catalogues, might almost be taken as an allegory of the popular notion of Utamaro's career, and the impairment of his outpu by his penchant for the company of women.

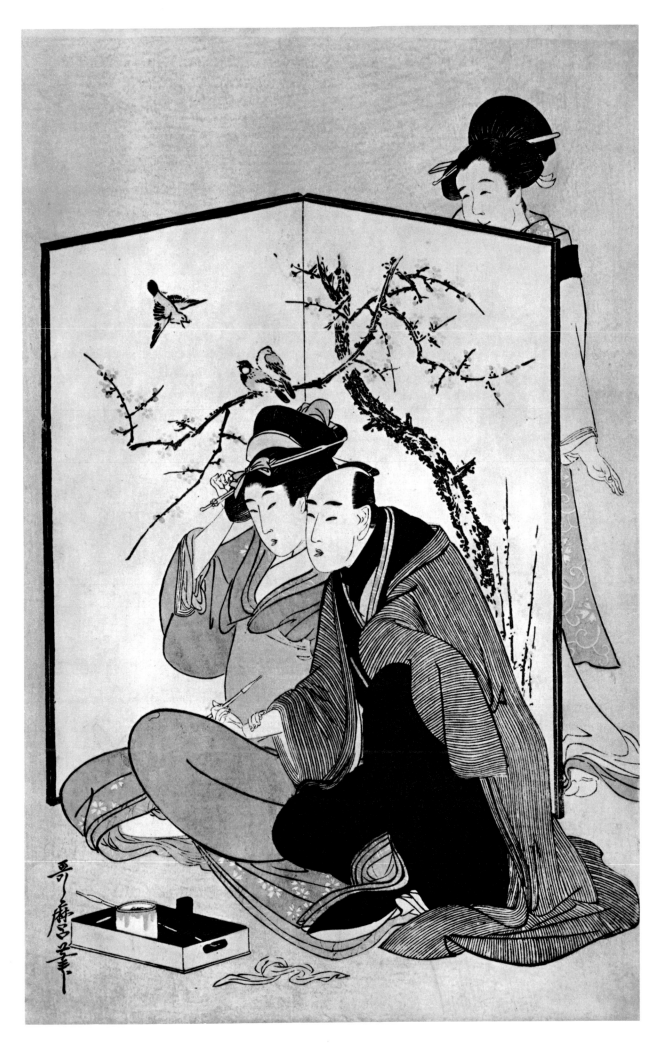

CAT. NO. 159

160 COURTESAN AND *KAMURO*

Kakemono. Ink, colour and *gofun* on silk; 34¾×13 in.; *c.*1805

Standing figure of a courtesan, resplendently dressed and with a loose *uchikake* held at her waist by her right hand, which also holds a wad of paper handkerchiefs, and beside her, her child-like *kamuro,* who is kneeling and holding a play-ball in her arms. This is a very elaborate painting, with much pretty detail on dress-pattern meticulously executed.

SIGNED: Utamaro *hitsu.* SEAL: Utamaro.
PUBLISHED: *U.T.S.*, vol. 12, pl. 21 (in colour); Yoshida, no. 842; Kaneko Fusui; *Kitagawa Utamaro no Nikuhitsu ga* in *Ukiyo-e*, no. 2, vol. 2, fig. 3.
EXHIBITED: M.I.A., 1961, no. 27.
FORMER COLLECTION: Kiyomizu.
ACC. 247.

Although a work of Utamaro's last years, this painting, with its dignity and charm, is in refreshing contrast to the rather slovenly designs of many of the later prints, and one assumes that, unlike the prints which Utamaro could hardly turn out fast enough to satisfy the publishers, this painting was made with the care and refinement demanded of an important commission.

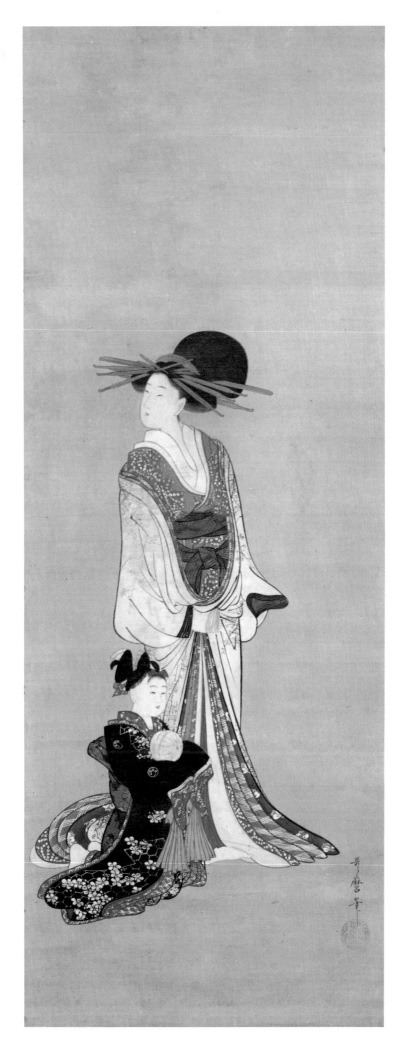

CAT. NO. 160

KŌKASAI FUJIMARO

(Active Early Nineteenth Century)

Of this artist, known only by a number of *bijin-ga* datable to the early years of the nineteenth century, nothing has been recorded. On the evidence of his style and the second character of his name, it is assumed that he was a pupil of Utamaro. His style is, however, a curious mixture, the figures invariably being carefully worked out in opaque colours and in unmistakably Ukiyo-e style, whereas the landscape settings, animals and accessories generally are quite often painted in transparent washes of a *Kanō* or even *Nanga* character. He is one of the best painters of *bijin-ga* in the rather lean years at the beginning of the century.

161 TWO *OHARAME* ON THE BANK OF A STREAM

Kakemono, Ink. colour and *gofun* on silk; 37½×13¼ in.; *c*.1800

Two *Oharame* strolling with bundles of faggots on their heads beneath cherry trees on the bank of a stream. There is a soft harmony of colour, and a sensitive touch in the handling of details. Against this *mélange* of subdued colour, the black *obi* with the brocaded leaves of the girl at left, the dash of red of the cloth which supports the faggots on her head, and the bright blue and red at hem and neck of the other girl's clothes, are most telling. Poem above: 'The white complexions of the *oharame* are more noticeable than the black brushwood they are balancing on their heads.'

SIGNED: Fujimaro hitsu. SEAL: Kōkasai.
EXHIBITED: M.I.A., 1961, no.19.
ACC.227.

Oharame were girls who brought in faggots for charcoal from Ohara, a village near Kyoto. They seem to have been particularly attractive to Ukiyo-e artists, and figure in many prints and paintings.

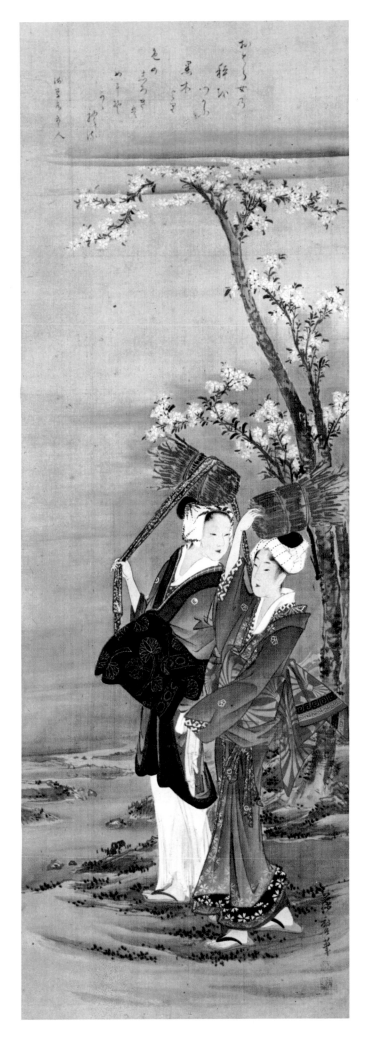

CAT. NO. 161

CHŌBUNSAI EISHI

(1756–1829)

Eishi is that rarity, a *samurai* trained in the Kanō school who seceded to the Ukiyo-e. His name was Hosoda Tokitomi, and he was the first son of Tokuyuki, a nobleman in the service of the Shōgun. He took the name Eishi from his Kanō master, Eisenin (it is said, in fact, to have been conferred on Eishi by the Shōgun Ieharu, under whom Eishi served as official painter until his apostasy), and retained it when he turned to Ukiyo-e in the mid-1780s.

Like almost every Ukiyo-e artist of the period, Eishi came under the all-pervading influence of Kiyonaga, and until the early 1790s, his *bijin* had obvious kinship with those of the later Kiyonaga prints: their mien is a little over-sweet, their stature is diminutive, and they have little of the majesty of the women depicted by Kiyonaga in his central period. The elegance and refinement of Eishi's art became evident later in the mid-1790s in a series of prints, some on *mica* ground, in which the girls are drawn out to an extremity of height only matched in some of Utamaro's most extravagant prints. Indeed, between Utamaro and Eishi there was a kind of exchange of gifts, and it is difficult sometimes to decide who is the influencer and who the influenced.

Eishi was a superbly assured draughtsman, and his paintings are among the finest of the Ukiyo-e school. He gave up print-designing near the turn of the century and devoted himself entirely thereafter to painting. He was fortunate in his pupils, or perhaps an excellent master, for Eishō, Eiri and Eisui are among the best of what are rather inadequately termed the 'minor' masters of this golden decade of 1790–1800.

162 A WOMAN AS THE POET BUNYA NO YASUHIDE

Ōban colour-print; 15⅛ × 10⅜ in.; c. 1795

A woman kneeling on one knee and holding up ceremoniously, on a red cloth, a black *eboshi*, her outer *kimono* purple with a pattern of cherry-blossom and cranes in white. She represents the poet Bunya no Yasuhide, whose poem from the anthology, *Hyakunin Isshu*, 'when once the wind begins to blow, tree and bush in the field strip themselves bare; and stormiest is the wind that blows from Mube mountain', is in the square cartouche above; alongside is the title cartouche, *Fūryū Ryaku Rokkasen* ('The Six Immortal Poets Epitomized *à la mode*': this numbered 2 in the series). Yellow ground; mica on the collar of the white under-*kimono*.

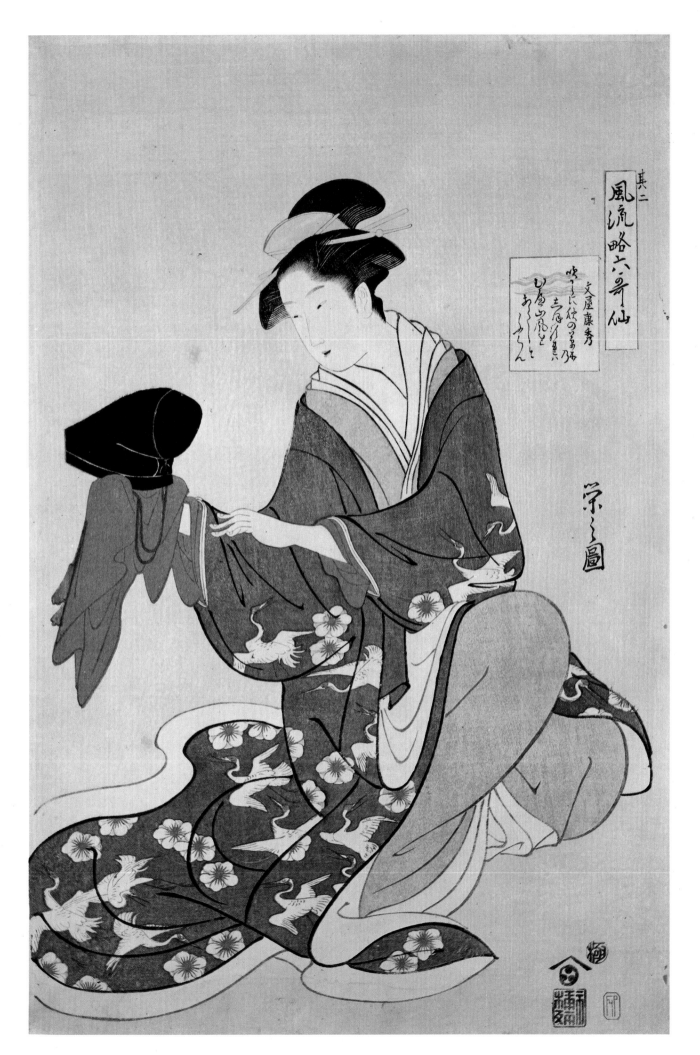

CAT. NO. 162

SIGNED: Eishu zu. Unidentified collector's seal (F.Y.P.) CENSOR'S SEAL: *Kiwame*.
PUBLISHER: Eijūdō.
EXHIBITED: M.I.A., 1961, no. 106.
SUBJECT ILLUSTRATED: *U.T.S.*, vol. 11, pl. 13 (in colour); *Ukiyo-e zenshū*, vol. 3, fig. 87.
ACC. 148.

163 JAPANESE POETRY PERSONIFIED

Ōban colour-print; 15½ × 10⅛ in.; *c.* 1796

A seated girl, wearing antique costume, her white outer-garment with a gauffraged pattern, her sash and skirt a bright red, holding a *tanzaku* (poem-strip) in one hand and a brush in the other, and evidently about to inscribe a poem. The screen hanging from the brass-tipped bamboo support is purple with a white pattern below and white above, with a decorative cock in yellow, red and green. On the floor beside the girl are an ink-stone and a small water-kettle. From the set with the title *Fūzoku Ryaku Rokugei* ('The Six Arts in Everyday Life Epitomized'), the sub-title to this print being *Waka* ('Japanese Poetry'). Circular title-cartouche with plum-blossom decoration. Yellow ground.

SIGNED: Eishi zu. CENSOR'S SEAL: *Kiwame*.
PUBLISHER: Eijūdō.
ACC. 181.

This seems a particularly rare print, and it has not been possible fo find the subject illustrated anywhere.

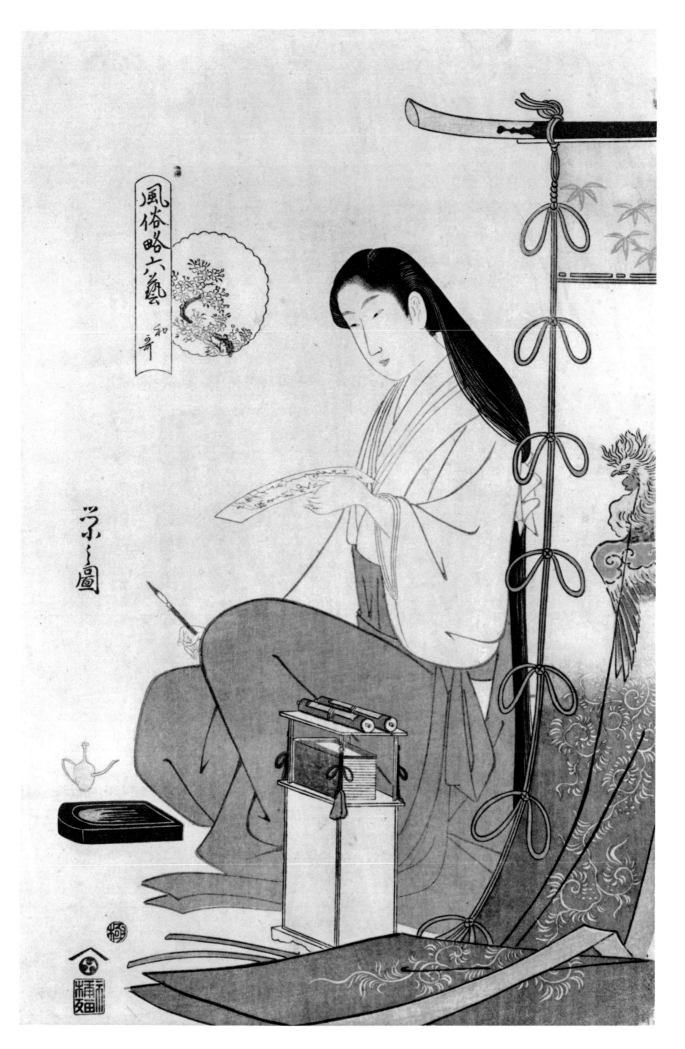

CAT. NO. 163

164 COURTESAN BENEATH A CHERRY TREE

Kakemono. Ink and colour on silk; $32\frac{3}{16} \times 11\frac{5}{16}$ in.; *c.*1796

A courtesan standing beside a small flowering cherry tree. Around her voluminous *kimono* she is wearing an *obi* of brocade decorated with a golden Chinese dragon pattern. The outer *kimono* is red, with a peony and gold fan pattern; the under white, with pink chrysanthemums and green foliage.

SIGNED: Chōbunsai Eishi. SEAL: Hosoda.
EXHIBITED: Exhibition of Ukiyo-e Paintings, *Tokyo Shimbun Kai*, no.2034; M.I.A., 1961, no.28.
ACC.221.

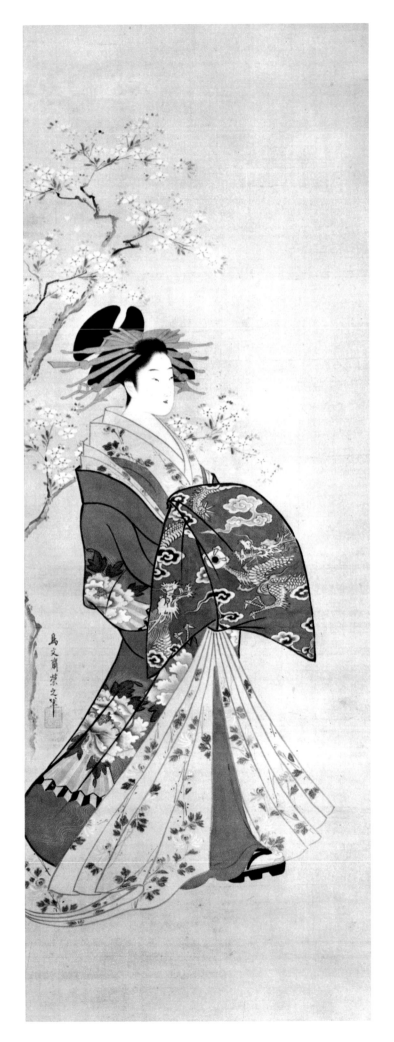

CAT. NO. 164

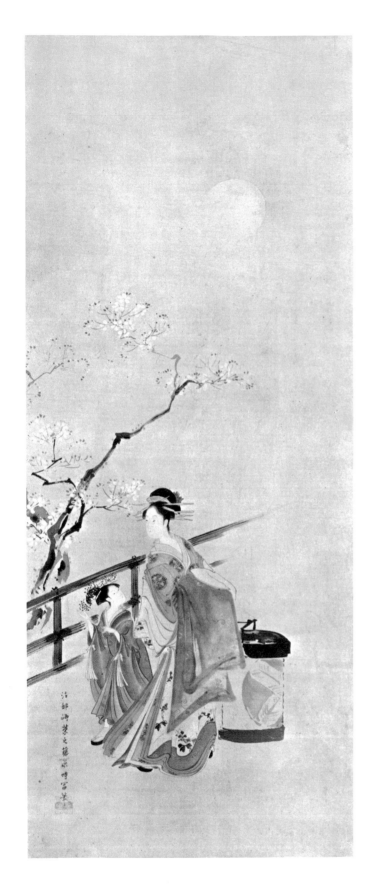
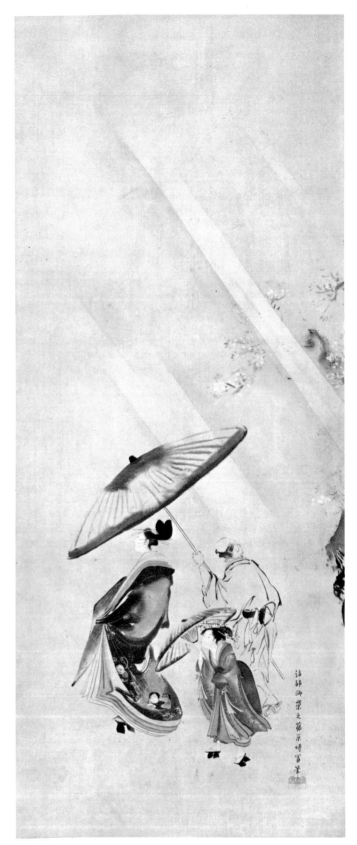

CAT. NO. 165 (*a*, *b*)

165 A BEAUTY BY MOONLIGHT, ANOTHER IN THE RAIN: A PAIR OF PAINTINGS

Pair of *Kakemono*. Ink and slight colour on silk; each 31½ × 13½ in.; *c.* 1798

(*a*) A beauty standing under a cherry tree with her *kamuro* by moonlight. A large Oda-wara lantern stands beside her.

(*b*) A beauty walking in the wind, protected from the slanting rain by an umbrella held by a man-servant, and followed by a diminutive *kamuro*, who holds her own umbrella against the wind.

The colour in both these paintings is applied in free, transparent washes and is both subtle and unfaded. In the painting (*a*) the colour is confined to the blue of the immense *obi*, the green and red of the under *kimono* of the courtesan, the red and green of the *kamuro's* clothes. In painting (*b*) the courtesan's outer robe is black with fine gold orna-ment, her *obi* red, and her undergarment shows a touch of green. The *kamuro* is in red and green with a blue *obi*, whereas the servant is in outline, reinforced in places with blue.

EACH IS SIGNED: Jibukyō Eishi Fujiwara Tokitomi hitsu. SEAL: Eishi.
PUBLISHED: M.I.A., 1966, no. 33–4.
EXHIBITED: Takaoka City Museum, 1961; M.I.A., 1966, no. 33–4.
ACC. 320–1.

The authenticating certificate by Dr Narazaki states: 'Especially in hand-paintings produced by commission from upper-class Japanese, Eishi brought out nobler and more dignified effects by using pigment of the best quality on which only a well-to-do painter could afford to lavish money. It may well be said that Eishi is one of the best Ukiyo-e painters. This diptych is an excellent example of Eishi, with his full artistic name in-scribed on each painting.'

HAYASHI RŌEN

(Active Early Nineteenth Century)

Hayashi Shin, *azana* Nisshin, familiar name Shūzū, using art-names Rōen and Shōrei, was a pupil of Gogaku (1730–99) and so in the direct line from the great *Nanga* master, Taigadō. Yet in the branch of painting in which he most excelled, figure-painting, his style and technique are certainly not orthodox *Nanga*, and, instead, one senses that Rōen had also studied the works of Settei, an Osaka man like himself, and also of Maruyama Ōkyo. The painting in this collection is considered one of his finest and most typical works.

166 TWO WOMEN AND A GIRL

Kakemono. Ink, colour and *gofun* on paper; 48¾×17⅝ in.; *c*.1800

Two beauties: one, left, carrying a round fan with 'moon and grass' design, the other with gold-brocaded *obi*, seen from the rear, also carrying a round fan, and a younger girl in front seen in profile, her *obi* decorated with a flamboyant design of butterflies and grasses, carrying an insect cage on a red cord.

SIGNED: Rōen Hayashi no Shin. Two seals, incompletely impressed.
PUBLISHED: M.I.A., 1966, no.44.
EXHIBITED: Setagaya, Exhibition of *Nihon Fūzoku*, 1962; M.I.A., 1966, no.44.
ACC.342.

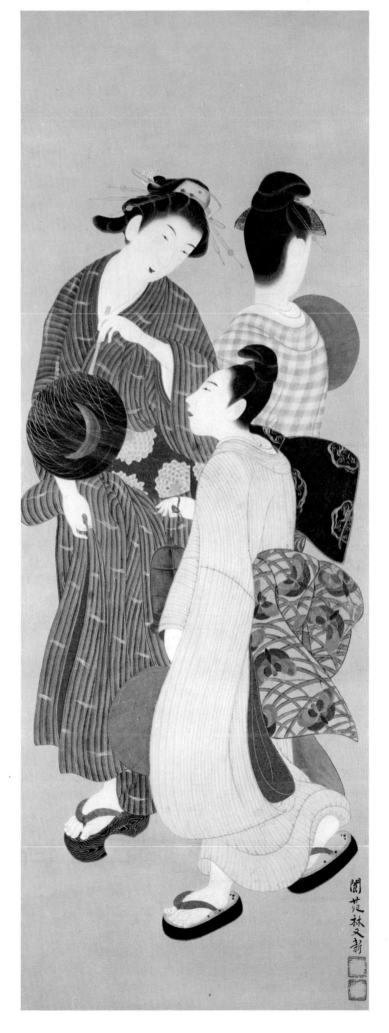

CAT. NO. 166

ŌTSU-E

A form of folk-art, Ōtsu-e were pictures produced at Ōtsu, the last staging-post on the Tokaidō from Edo to Kyoto. They were made for tourists and other travellers, were mass-produced and crude, and often have the sort of strength that accompanies primitive art. Originally the subjects were Buddhist or semi-religious, but as time went on the number of types narrowed down to ten, mostly of good-omen or talismanic kind. Some of the early seventeenth-century Ōtsu-e had parts printed from wood-blocks or stencilled, and it was these no doubt that gave rise to the notion, held at one time, that Ōtsu-e were the forerunners of the Ukiyo-e woodcut.

167 FALCONER

Kakemono. Ink and colour on paper; 16⅛×10⅞ in.; *c*. 1800

A falconer with a bird on his wrist. There is a long inscription at the side to the effect that falcon-hunting affords a pretext (for the upper class) to go out to the fields and mountains and find out how the humble people live.

ACC. 363.

Kiyoshi Yokoi, in his *Early Ōtsu-e*, Tokyo, 1958, explains that the 'Falconer' was a favourite subject with the Ōtsu painters and was a charm for a good harvest. He illustrates a 'Falconer' so close in every respect to the one in this collection that there can be little doubt that both derive from the same model.

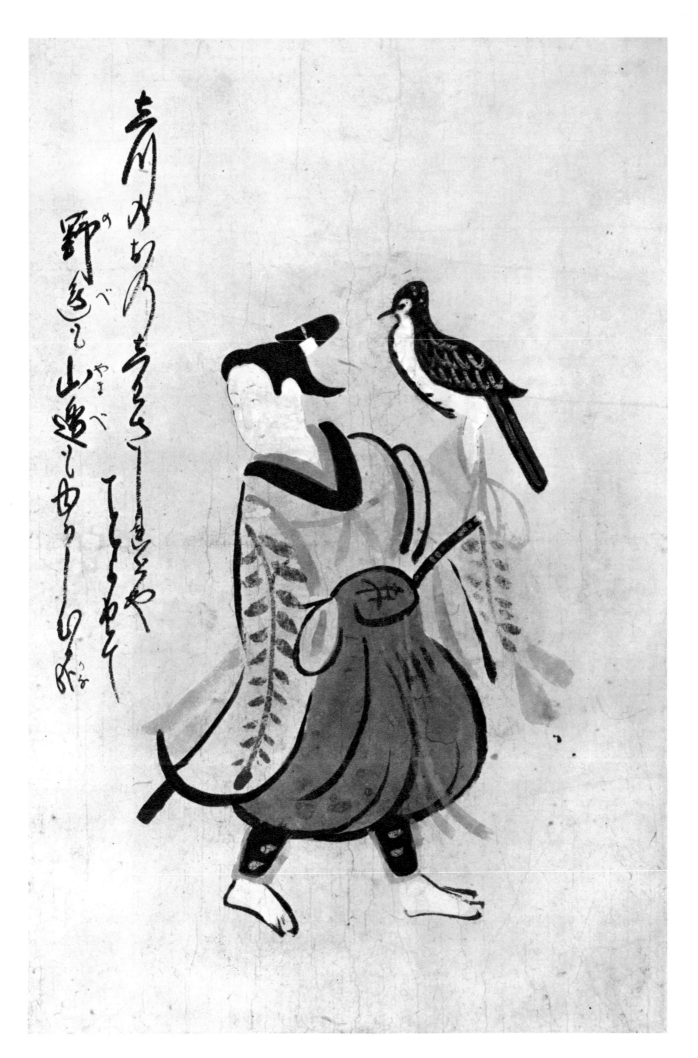

CAT. NO. 167

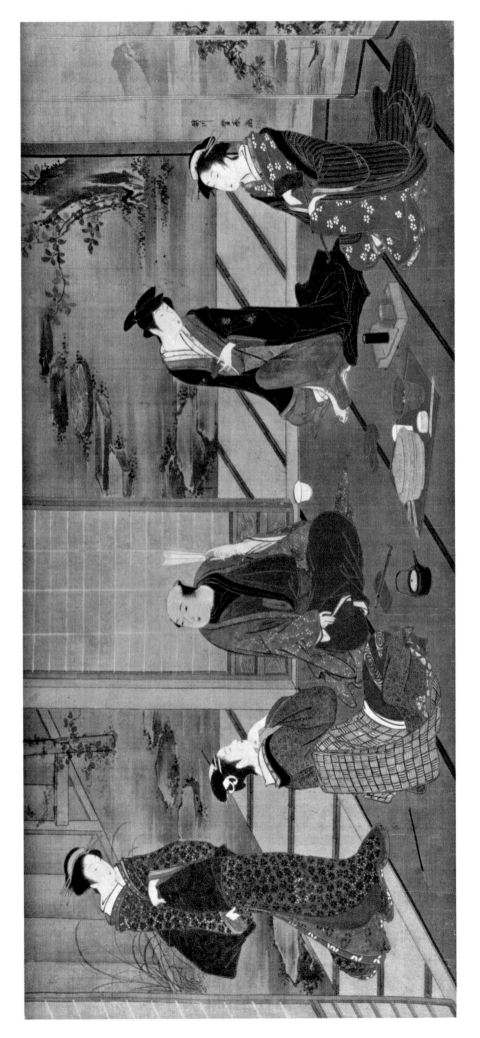

CAT. NO. 168

UTAGAWA TOYOHARU

(1735–1814)

Toyoharu, both by virtue of his own paintings and prints and also his founding of the Utagawa School, is indisputedly one of the most important Ukiyo-e artists of the latter third of the eighteenth century. Various contradictory versions are given of his early days, some holding that he was Kanō trained, others that Shigenaga or Sekien or Toyonobu was his master. Nothing, in any case, seems verifiable. Established facts are that he came to Edo about 1763, that his name was originally Tajimaya, later Shinemon, and that his art-names were Utagawa and Ichiryūsai. His first Ukiyo-e prints of the period 1766–70 show clearly the influence of Harunobu, but in the next decade he began to produce *Uki-e*, perspective pictures, of a different type from those of forerunners like Okumura Masanobu, which were fundamentally architectural. His own *uki-e* developed more in the direction of landscape, and not only did he incorporate Western techniques and perspective, which were, of course, in the nature of *uki-e*, but actually on occasion used Western topographical prints as a basis for his own very curious compositions. In the 1780s he devoted himself far more to painting in an orthodox Ukiyo-e style, and achieved outstanding success as a painter of *bijin-ga*. As a painter he ranks with Shunshō and Eishi among the most accomplished of the last half of the eighteenth century. He was officially recognized, and was in charge of the group of painters who carried out repairs at the Tokugawa Mausoleum at Nikkō in 1796. Toyoharu had as pupils Toyohiro and Toyokuni. Toyokuni specialized in the actor-print field, but Toyohiro not only matched his master's accomplishment as a painter, but also furthered the development of landscape and became the master of Hiroshige.

168 SEGAWA KIKUNOJŌ III AT A PARTY

Kakemono. Ink, colour and *gofun* on silk; 13×29$\frac{3}{16}$ in.; *c.*1784

At a corner of a room open to a garden, an evening party is in progress, two men and two girls kneeling around a tray of food and another girl approaching left, across the *engawa*. The girl at the right is in a striped brown *kimono* over red, with a white floral pattern; the other girls are predominantly in blue, with touches of red at neck and skirt. The younger of the men wears the distinctive purple cap whose use was enjoined upon Kabuki actors, and the butterfly *kae-mon* (usually reserved for private attire) on his black *uchikake* identifies him as Segawa Kikunojō III. The old man is also presented with the sort of circumstantial detail as to face and figure that suggests a portrait, and possibly he may

have been a Kabuki-lover who commissioned the painting. He is in grey-blue over brown. At right is a tall screen painted with a landscape in the Kanō style. Through the open *shōji* can be seen stepping-stones leading into the garden.

SIGNED: Utagawa Toyoharu. SEAL: Toyoharu.
PUBLISHED: *Nikuhitsu Ukiyo-e Taikan*, 1933, pl.46.
EXHIBITED: Ukiyo-e Exhibition, Kyoto Museum, 1933.
FORMER COLLECTION: Sato Shotarō.
ACC.232.

169 A GAY PARTY AT A TEAHOUSE BY THE SEA

Kakemono. Ink, colour and *gofun* on silk; 33¼×13¾ in.; *c*.1794

A man is seated with a girl at the side of a room where the *shōji* have been drawn back, giving a view of Shinagawa Bay, with moored craft, the sails of plying junks, and a distant mountain range. He is holding a *sake* cup to the lips of his already tipsy girl companion, and glances up at another tall courtesan standing, with wad of paper handkerchiefs in her hand, beside him. A *samisen* and the utensils of a meal lie in the foreground. There is a rich harmony of colour, based on the dark green of the standing girl, the warm brown of the other girl and the dark blue and black of the man's costume.

UNSIGNED.
PUBLISHED: Shizuya Fujikake, *Seshoku Ukiyo-e Hyaku Sugata* vol.1, 1927, (colour plate); *U.T.S.*, vol.10, no.22; *Ukiyo-e Kessaku-shū* (*Nihon Bijutsu Hanga Kenkyūkai*), 1941
EXHIBITED: M.I.A., 1961, no.26.
FORMER COLLECTION: Kuwabara.
ACC.228.

This painting has the rare distinction of having been twice secured from Japan. Dr Fujikake, writing in the *U.T.S.* (vol.10), said: 'This picture was once in the possession of a Westerner,' (the later *Ukiyo-e Kessaku-shu* goes further and makes the criminal an American) 'and the picture was regrettably trimmed all round, resulting in the loss of the artist's signature and seal. However, the characteristic features of Toyoharu's paintings are evident, especially in the facial expression of the beauties, and there is no doubt about the author of the painting, namely, it is Toyoharu.' The illustration in *Ukiyo-e Kessaku-shū* seems to show the painting before it had been cut down, but there is still no sign of a signature.

The painting of the landscape through the open *shōji* is remarkably anticipatory of the kind of painting we are familiar with in Hiroshige's work.

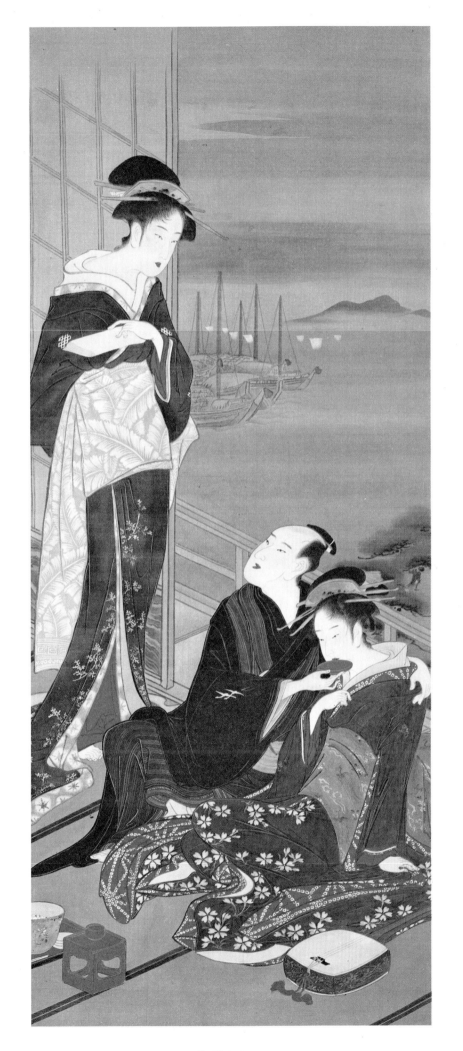

CAT. NO. 169

UTAGAWA TOYOHIRO

(1763–1828)

Okajima Tojirō was the personal name of this artist, but after joining Toyoharu's studio about 1782, he was given the brush-name of Utagawa and was permitted to use the *gō* Ichiryūsai. He was an altogether gentler and less extrovert personality than his brother, Toyokuni, one evidence of which was his avoidance of any connection with the stage. He collaborated with his brother, it is true, in a famous series of triptychs, but these are normal Ukiyo-e genre in subject. Toyohiro designed a few other unusually distinguished prints, including some landscape series that point the way to Hokusai and Hiroshige, but he is possibly more remarkable as a painter, since he excelled in the brush medium. Fortunately, a fair number of his paintings, dating from the mid-1780s onwards, have survived, but after about 1800 he seemed to concentrate more and more on book and *ehon* illustration, and, like so many other artists of the period, suffered a decline in his later years.

170 A NIGHT-CAP

Kakemono. Ink, colour and *gofun* on silk; 38 × 17 in.; *c.* 1796

A courtesan stands holding a wrap around her–a lovely blue garment patterned with birds in flight, picked out in darker blue and gold–and looks down questioningly at her lover, who is seated by a charcoal brazier, *sake* cup in hand. He is dressed in black *uchikake* over a *kimono* predominately red-brown in colour. Behind the couple is a tall screen, painted with bamboo, discreetly hiding a bed.

SIGNED: Ichiryūsai Utagawa Toyohiro ga.
PUBLISHED: M.I.A., 1961, Catalogue, no. 34, fig. 17.
EXHIBITED: M.I.A., 1961, no. 34.
ACC. 219.

An outstanding work of the artist, painted with elaborate care for detail. There is immense effect in the contrast of the uncompromising lines of the grey-and-black-patterned back of the screen with the rippling lines and warm colour of the tall girl's garments.

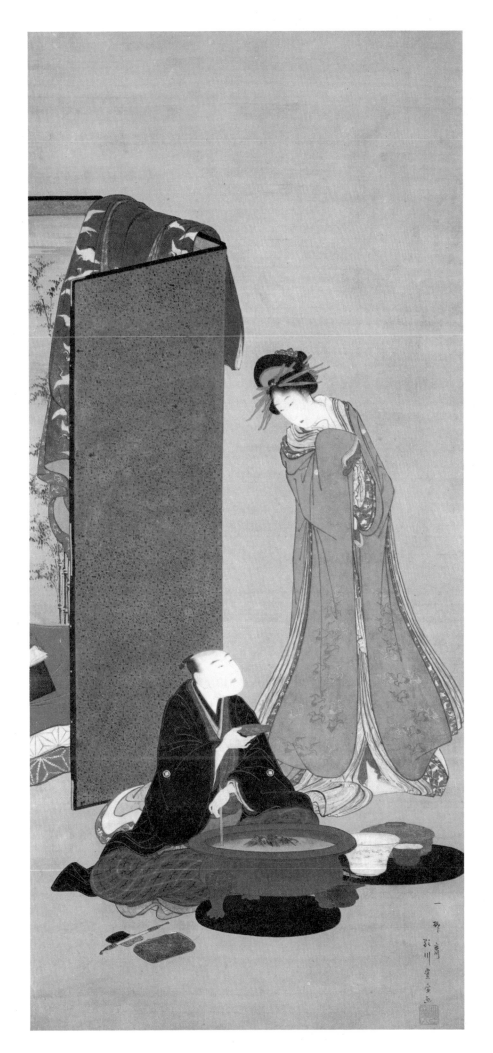

CAT. NO. 170

UTAGAWA TOYOKUNI

(1769–1825)

Like the theatrical or music-hall star whose image is ruined because of a refusal to retire at the height of his powers, Toyokuni's reputation has suffered because he continued to turn out shoddy designs at an increasing rate when his art had become debased through over-exploitation and other causes. In his mature period–say, from 1794 to 1796–he produced prints which are among the finest in Ukiyo-e. There are many masterpieces among the forty or fifty prints comprising the famous set, 'Portrait of Actors on the Stage', and certain of his non-theatrical prints, triptychs among them, are of great merit. It is true he was an inveterate plagiarist, and from his earliest work as a pupil of Toyoharu in the mid-1780s onwards gave a succession of prints that are like slightly coarsened versions of those by Kiyonaga, Eishi, Shunman, Utamaro, Shunei, Shunkō and Sharaku. But the fact is that, when he completely assimilated his models, his own genius came through, and in paintings and prints he is at times unmistakably one of the great artists of the 1790s. In that decade he had one great pupil, Kunimasa. After about 1805, when he was acting as master to the pupils who were themselves to become major artists–Kunisada and Kuniyoshi among them–his work went steadily downhill. He designed a number of fine *ehon* concerned with stage personalities, and as late as 1802 a picture-book of more general subject-matter, the 'Modern Figures of Fashion' (*Ehon Imayō Sugata*), which is one of the best colour-printed books of the period.

171 COURTESAN WITH *SAKE* CUP

Kakemono. Ink, colour and *gofun* on silk; 34½×12 in.; *c.* 1794

The head and shoulders of a courtesan holding a *sake* cup and covering her mouth with her hand. She is in a transparent black gauze *kimono* over red, her hands and face an opaque white (*gofun*), whilst her *obi* is black, decorated with green *asarum* leaves. Above, there is a poem by Shōshoshi complaining of the rapidity with which night changes into day.

SIGNED: Toyokuni ga. SEALS: Ichiryūsai and Toyokuni.
PUBLISHED: *U.T.*, vol. 10, no. 1.
EXHIBITED: M.I.A., 1966, no. 41.
ACC. 252.

This painting comes from the period of the artist's finest prints of *bijin-ga*, such as the 'Five Cardinal Virtues', with a strong leaning still towards Kiyonaga and Utamaro.

348

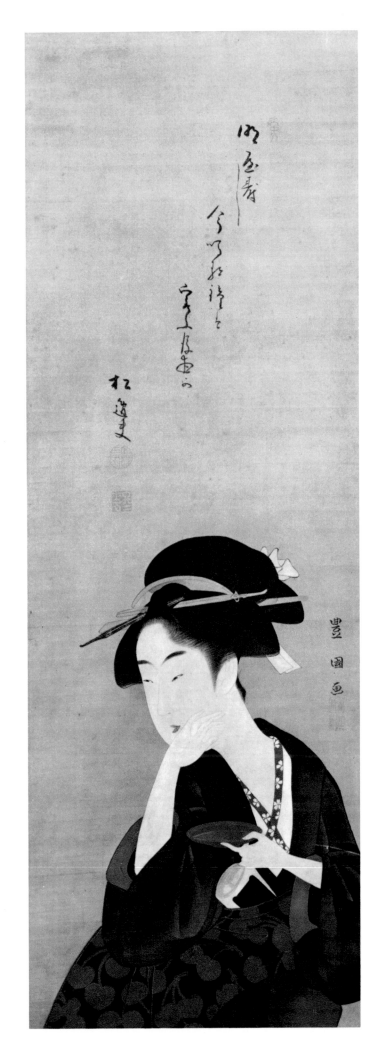

CAT. NO. 171

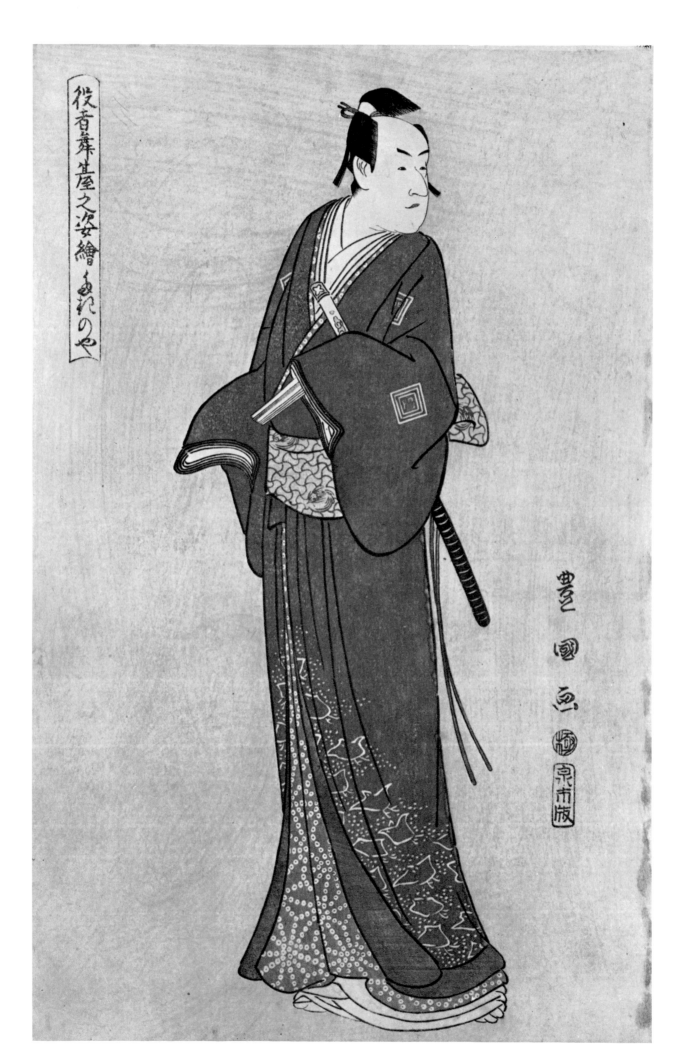

CAT. NO. 172

172 ICHIKAWA MONNOSUKE II AS SOGA NO JŪRŌ

Ōban colour-print; 14⅞×9¾ in.; 1794

Ichikawa Monnosuke II as Soga no Jūrō in the play, *Go-hiki Hana Aikyō Soga*, performed at the Kawarasaki-ya in the first month of 1794; full-length study. He stands with body turned half left and head turned right over his shoulder, holding a fan half-hidden within his left sleeve. He wears a purple *kimono* with *chidori* pattern in white and a green lining, and a red under-*kimono* with white star pattern. Mica ground. Series title: *Yakusha Butai no Sugata-e* ('Pictures of Actors on the Stage'), with sub-title, Takinoya, the actor's *ya-gō* professional name.

SIGNED: Toyokuni ga. CENSOR'S SEAL: *Kiwame*.
PUBLISHER: Senichi.
FORMER COLLECTIONS: Ragault; Bess.
SUBJECT REPRODUCED: Van Caneghem Sale Catalogue, 1921, New York, no. 79; Haviland Sale Catalogue, II, June 1923, no. 395; *Kabuki-e Taisei* (Kansei period), 1930, no. 37; *Ukiyo-e* magazine, no. 27, 1966, article by Teruji Yoshida on the *Yakusha Butai* set, fig. 1.
ACC. 381.

This seems to be the first in date of this series of prints, generally acknowledged as Toyokuni's crowning achievement in the field of *yakusha-e* (actor-prints). The date has some relevance to the controversy which exists as to whether or not Sharaku drew inspiration from Toyokuni, and, in particular, this set, or whether, going further, a master/pupil relationship existed between the two. Sharaku's earliest prints, it is well known, were produced for a play that was performed in the fifth month of 1794, somewhat later than the earliest of the Toyokuni series, and, furthermore, when both Toyokuni and Sharaku portrayed actors in the same performances there is a marked similarity between the representations of the two artists which even so level-headed a critic as the late Robert Paine thought could hardly be the result of coincidence. Robert Paine wrote an absorbing article on the prints in question in the *Bulletin of the Museum of Fine Arts, Boston*, entitled 'Toyokuni's Pictures of Actors on the Stage', vol. LX, no. 321, 1962.

173 MATSUMOTO KŌSHIRŌ IV AS KOKOGAWA HONZŌ

Ōban colour print; 15½×10¼ in.; 1795

Matsumoto Kōshirō IV (Kōrai-ya) as Kokogawa Honzō in the garb of a *komusō* in the 1795 Kawarazaki-za performance of *Kanadehon Chūshingura*. He has a purple outer garment edged with yellow flowers on grey, tied at the waist with a green sash, and has a green-and-white under-*kimono*, the end of the *obi* that is visible being red with a yellow dragon motif. Pale grey ground. From the series *Yakusha Butai no Sugata-e* ('Pictures of Actors on the Stage'); sub-title: Kōrai-ya.

SIGNED: Toyokuni ga.
PUBLISHER: Izumi-ya.
PRINT PUBLISHED: Ledoux, 1950, no. 50.
FORMER COLLECTIONS: Hamilton Field (whose seal is on the print); Ledoux
SUBJECT REPRODUCED: Jacquin Catalogue, no. 653; Michener/Lane *Japanese Prints*, no. 206.
ACC. 153.

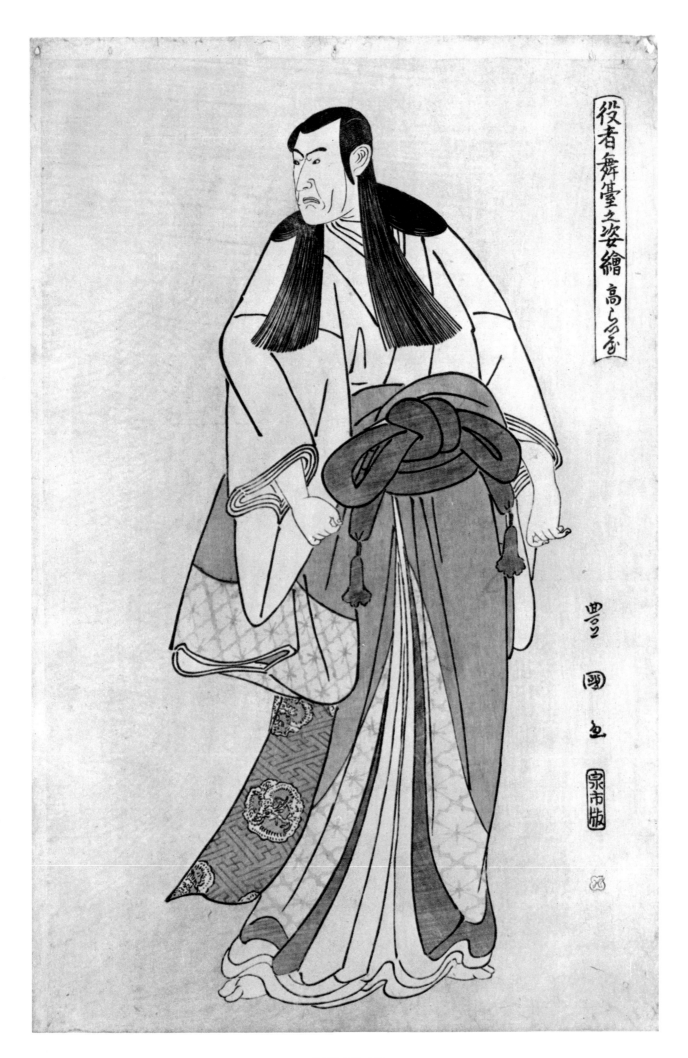

役者舞臺之姿繪 高らいや

豊
國画
泉市版

CAT. NO. 173

174 ONOE MATSUSUKE AS YURANOSUKE

Ōban colour-print; $15\frac{7}{8} \times 10\frac{1}{2}$ in.; 1795

Onoe Matsusuke (Otowa-ya) as Ōboshi Yuranosuke, the leader of the Forty-seven Rōnin, in the *Kanadehon Chūshingura* performed at the Kawarazaki-za in the fifth month of 1795. He makes a majestic figure, his green *kimono* forced into a dramatic curve by the projecting sword, his head leaning to the right and a purple-and-white fan held in his right hand. The yellow under-*kimono* is decorated with a pink fern motif. This is an exceptionally fine impression, showing the delicate pink tint about the eyes and the shadow of a beard. Grey ground. From the series *Yakusha Butai no Sugata-e* 'Pictures of Actors on the Stage'; sub-title: Otowa-ya.

SIGNED; Toyokuni ga; CENSOR's SEAL: *Kiwame*
PUBLISHER: Senichi.
PRINT PUBLISHED: Harold P. Stern, *Master Prints of Japan*, 1969, no. 147 (in colour).
SUBJECT REPRODUCED: *Ukiyo-e, op. cit.*, fig. 30; Michener/Lane '*Japanese Prints*', no. 211.
EXHIBITED: University of California, Los Angeles, *Master Prints of Japan*, 1969.
ACC. 115.

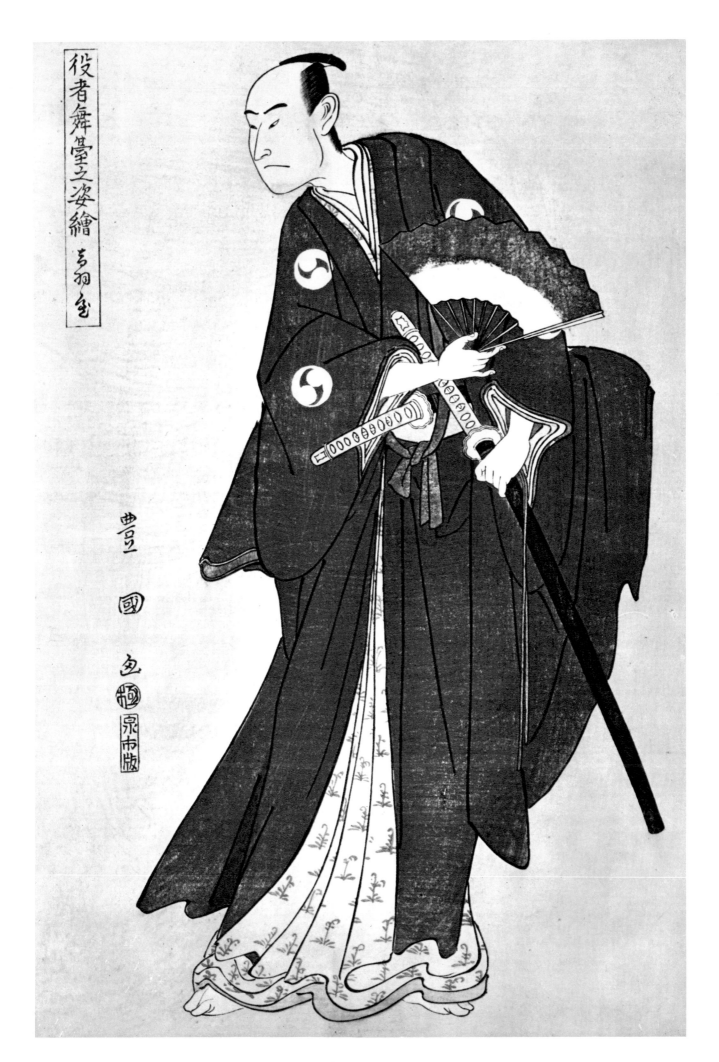

CAT. NO. 174

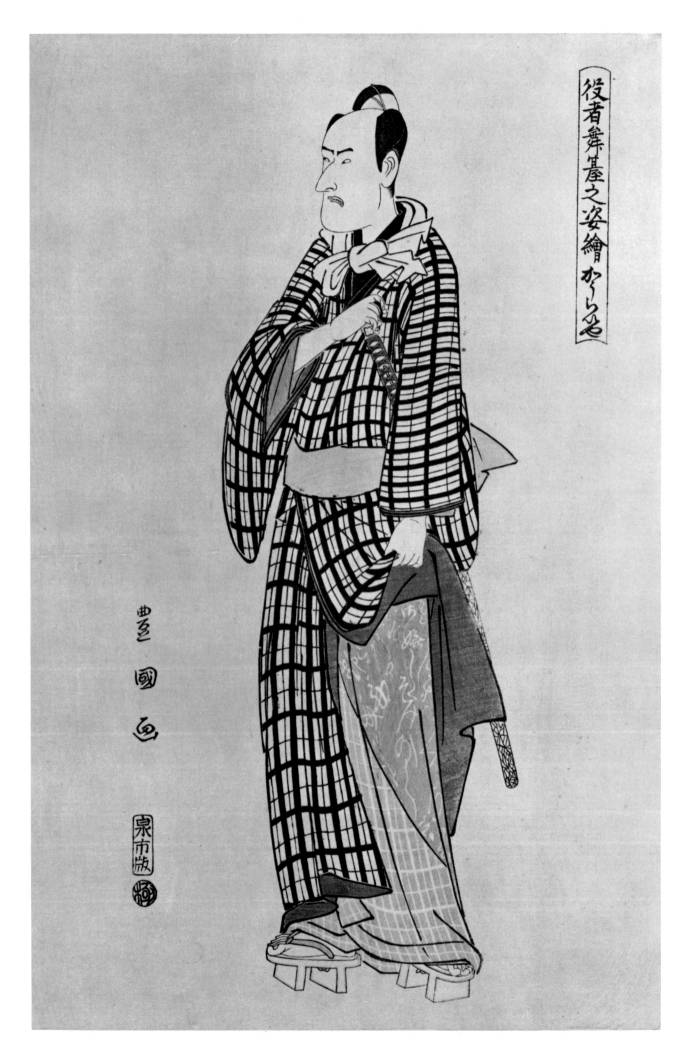

CAT. NO. 175

175 MATSUMOTO KŌSHIRŌ IV IN CHARACTER

Ōban colour-print; 15 × 10 in.; 1794–5

Matsumoto Kōshirō IV (Kōraiya), full-length, standing with one hand on the hilt of his sword, whilst with the other he lifts the skirt of his black-and-white-checked *kimono* and reveals the red under-*kimono* patterned with white calligraphy. He has on a further light purple, white-checked *kimono*, and a yellow sash. Series cartouche: *Yakusha Butai no Sugata-e* ('Pictures of Actors on the Stage'); sub-title: Kōraiya. Pale grey ground.

There is some doubt about the role of the actor in this print. Ledoux gives it as Danshichi Kurabei in the play, *Zensei Azuma no Kiyara*, of the eleventh month of 1795 (Kawarazaki-za); in the van Caneghem Sale Catalogue it is given as Bazuiin no Chobie in the play, *Shimekazari Kichiri Soga*, given at the Kawarazaki-za in 1795; and the last word, in the *Ukiyo-e* magazine article referred to already in this catalogue, identifies the role as Sakana-ya Gorobei in a drama entitled *Katakiuchi Noriai Banashi* in the fifth month of 1794.

SIGNED: Toyokuni ga. CENSOR'S SEAL: *Kiwame*.
PUBLISHER: Senichi.
PRINT PUBLISHED: Ledoux, 1950, no. 49.
FORMER COLLECTION: Ledoux.
SUBJECT REPRODUCED: Van Caneghem Sale Catalogue, 1921, New York, no. 74; *Ukiyo-e, op. cit.*, fig. 7.
ACC. 241.

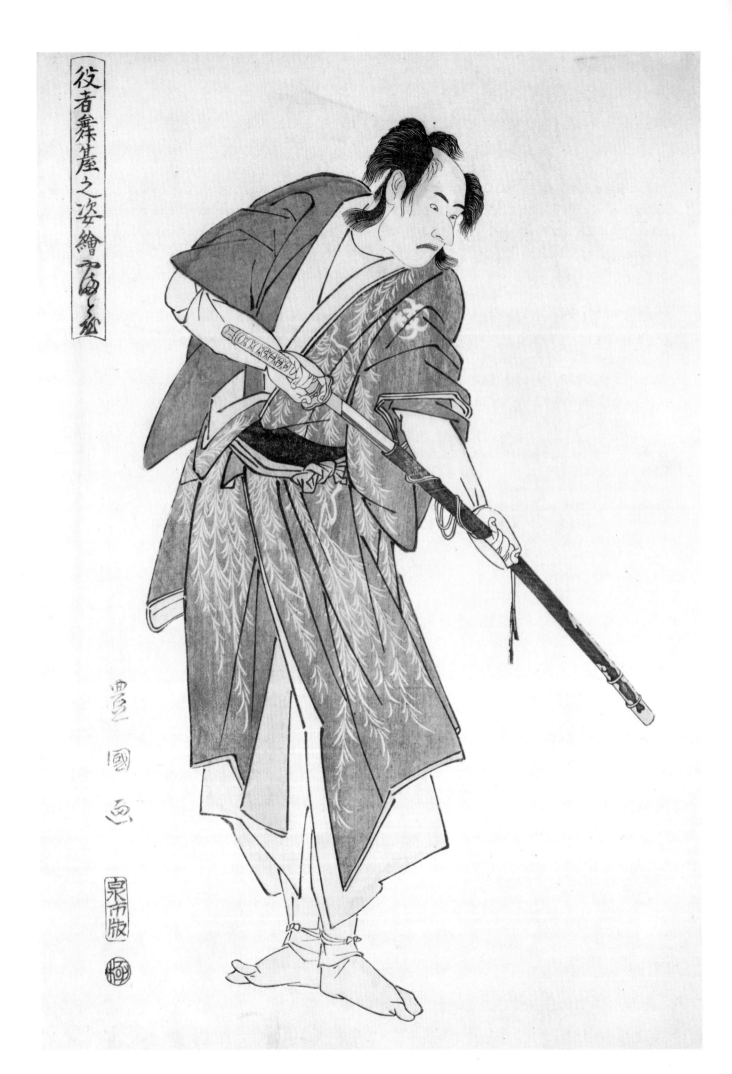

役者舞臺之姿繪市川八百蔵

豊國画

泉市版

CAT. NO. 176

176 BANDŌ MITSUGORŌ II AS ISHII GENZŌ

Ōban colour-print; 14¾ × 10¼ in.; 1794

The actor Bandō Mitsugorō II (Yamato-ya) full-length, turning towards his left and in the act of drawing his sword. He has thrown off the *kimono*, green with decoration of willow branches in white, from his right shoulder to free his sword arm, revealing the rose under-*kimono*. He is in the part of Ishii Genzō in the play, *Hana-ayame Bunroku Soga*, performed at the Miyako-za in fifth month of 1794. Mica ground. From the set *Yakusha Butai no Sugata-e* ('Pictures of Actors on the Stage'); sub-title: Yamato-ya.

SIGNED: Toyokuni ga. CENSOR'S SEAL: *Kiwame*.
PUBLISHER: Senichi.
PRINT PUBLISHED: Grolier Catalogue, pl. 27; Ledoux, 1950, no. 53.
EXHIBITED: Grolier Club, New York, 1924; M.I.A., 1961, no. 111.
FORMER COLLECTION: Ledoux.
SUBJECT REPRODUCED: *Ukiyo-e op cit*. fig. 5; Paine, *op. cit.*, fig. 3.
ACC. 135.

This is one of the instances where a direct comparison with a Sharaku design is possible, Sharaku's print portraying the actor in bust only, but in the act of drawing his sword (Sharaku's print is Henderson and Ledoux, no. 6).

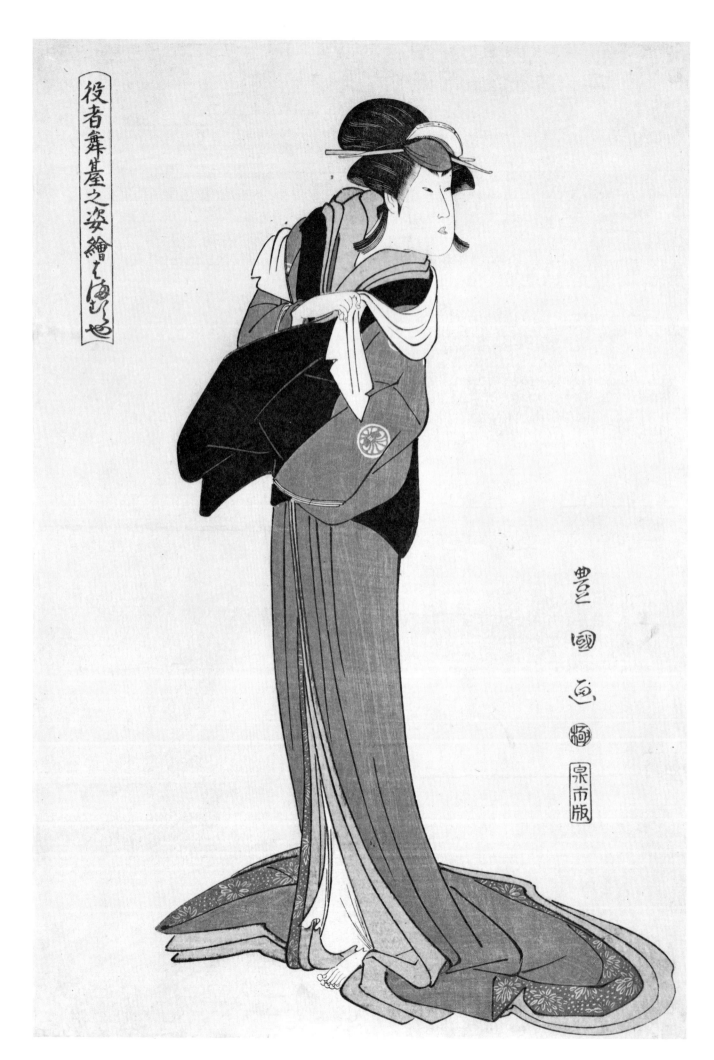

CAT. NO. 177

177 SEGAWA KIKUNOJŌ III AS OSONO

Ōban colour-print; 15⅜×10½ in.; 1795

Segawa Kikunojō III (Hamamuraya) as Osono in the play, *Kanadehon Chūshingura*, per-
formed in the fourth month of 1795, wearing an olive-green *kimono* which sweeps in
sheer lines to the pool of curves at her feet, bound with a black *obi*, overprinted with a
pattern in black. She holds one end of the *tenugui*, or towel, draped around her shoulders.
Dull mica ground. Series title: *Yakusha Butai no Sugata-e* ('Pictures of Actors on the Stage');
sub-title: Hamamura-ya.

SIGNED: Toyokuni ga. CENSOR'S SEAL: *Kiwame*
PUBLISHER: Senichi.
PRINT PUBLISHED: Grolier Catalogue, 1924, pl. 26; Ledoux, 1950, no. 51
EXHIBITED: Grolier Club, New York, 1924; M.I.A., 1961, no. 112.
SUBJECT REPRODUCED: *Ukiyoye no Kenkyū*, vol. II, no. 1, November 1922 (article by Inoue on Toyokuni's
 set), fig. 4; *Ukiyo-e* magazine, *op. cit.*, fig. 28.
ACC. 193.

This is another instance where the interpretation of the role performed by the actor has been changed from
the earlier one given by Ledoux. He identified it as that of Otsuta in a different play produced in the third
month of 1794, but it seems safer to adopt the later, Japanese, view.

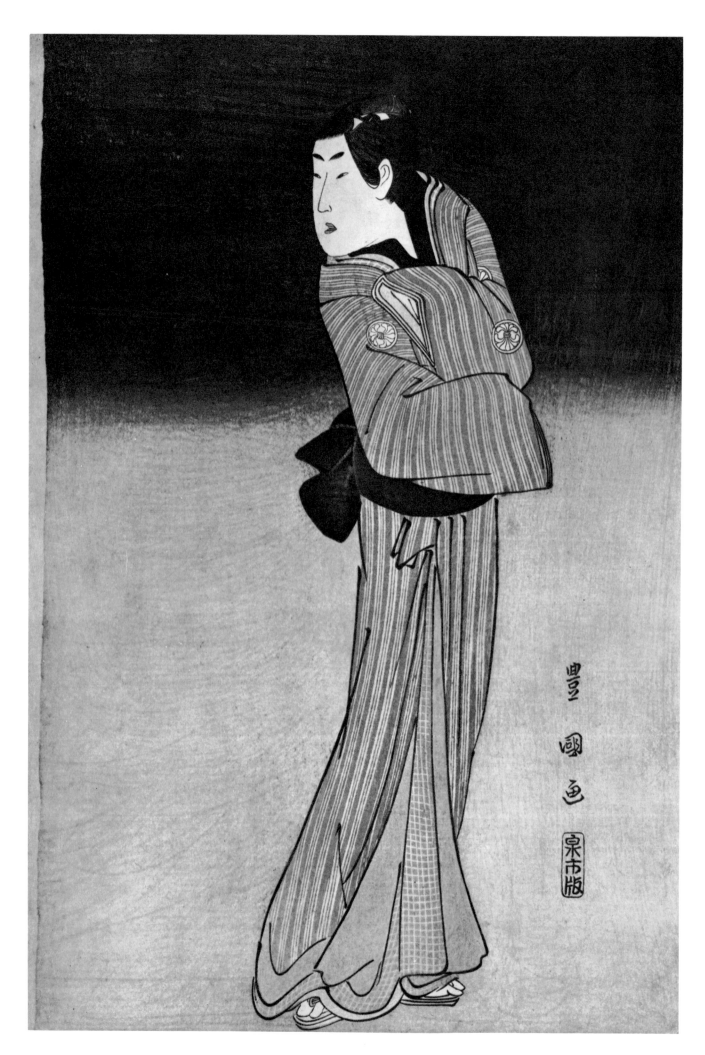

CAT. NO. 178

178 SEGAWA KIKUNOJŌ III AS NAGAYOSHI

Ōban colour-print; 15 × 10⅜ in.; 1796

Segawa Kikunojō as the character Detsuchi Nagayoshi in the play, *Sumida no Haru Geisha Katagi*, performed at the Kiri-za in the first month of 1796. The tall, slender lines of the figure are accentuated by the purple-and-white stripes of the *kimono*; beneath are garments of blue and of indian red with yellow. She wears a black *obi* and has both arms wrapped against the body. There is a black night sky, gradated into grey in the lower two-thirds of the background.

SIGNED: Toyokuni ga.
PUBLISHER: Senichi.
SUBJECT REPRODUCED: *Ukiyo-e* magazine, *op. cit.*, fig. H.
ACC. 144

This print is so similar in character to the 'Pictures of Actors on the Stage' set, and belongs exactly to the same period, that it might be thought that it comes from an edition lacking the title (others of the set are known both with and without a title-cartouche). However, no impressions are known with a title-cartouche, and it is also perhaps significant that this print lacks the censor's seal, which appears on prints with the title. As a composition, it ranks with the finest of the *Yakusha* set. A companion print, also with a night sky, is of Sawamura Sōjūrō III in a male role from the same play, illustrated in colour in Michener/Lane, *Japanese Prints*, no. 205.

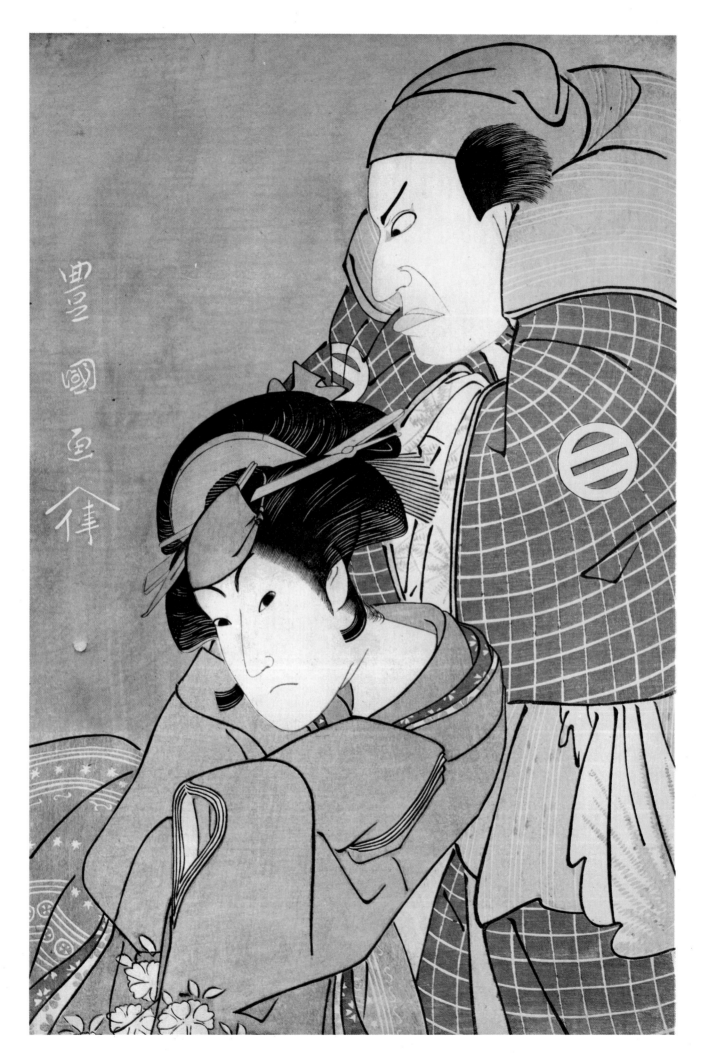

CAT. NO. 179

179 IWAI HANSHIRŌ IV AND KATAOKA NISAEMON VII IN A PLAY

Ōban colour-print; 14⅞ × 10 in.; 1796

Half-length figures of two actors, Iwai Hanshiro IV as the girl Kojorō Kitsune with arms crossed across her breast, and Kataoka Nizaemon VII as Iyanotarō, standing menacingly behind her with hands thrust dramatically within his sleeves; a scene from the play, *Seiwa Nidai Genji*, performed at the Miyako-za in the eleventh month of 1796. Grey ground.

SIGNED IN WHITE RESERVE ON GREY: Toyokuni ga.
PUBLISHER: Yamaden.
SUBJECT REPRODUCED: Vignier and Inada, *Toyokuni, Hiroshige*, no. 55, pl. XIII; *Kabuki-e Taisei* (Kansei period), 1930, no. 39; *U.T.*, vol. 10, no. 157.
ACC. 258.

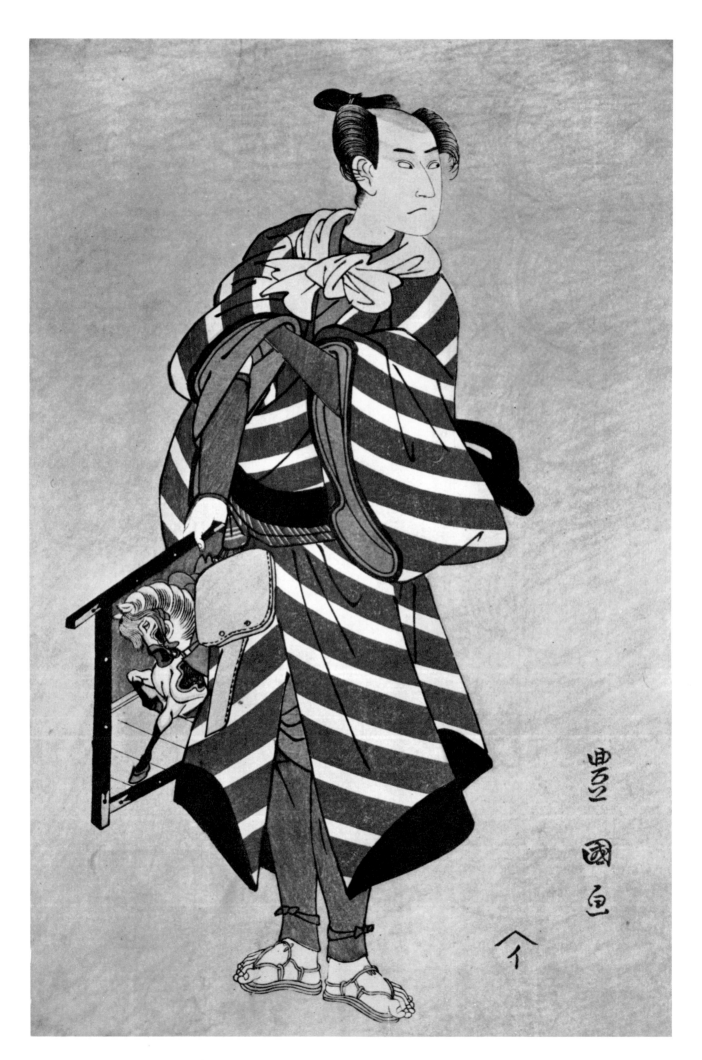

CAT. NO. 180

180 SAWAMURA SŌJŪRŌ III AS UMA NO SAMURAI

Ōban colour-print; 15 × 10⅜ in.; 1797

The actor Sawamura Sōjūrō III as Uma no Samurai in the play *Miyamairi Musubi no Kamigaki*, performed at the Kiri-za in the ninth month of 1797. He is depicted standing full-length, feet together, holding in his right hand a votive tablet (*ema*) painted with a picture of a prancing horse. He is in a striking *kimono* patterned with broad purple stripes on white and lined with red. His trousers and sleeves are blue. Grey mica background.

SIGNED: Toyokuni ga.
PUBLISHER: Enshūya Matabei.
PRINT PUBLISHED: Harold P. Stern, *Master Prints of Japan*, 1969, no. 148.
SUBJECT REPRODUCED: Jacquin Sale Catalogue, January 1921, no. 152; Binyon and Sexton, *Japanese Colour Prints*, 1923, pl. XL.
EXHIBITED: University of California, Los Angeles, 'Master Prints of Japan', 1969
ACC. 152.

The problem of identification of the actor, and his role, are discussed by Dr. Stern in his *Master Prints of Japan*, p. 278.

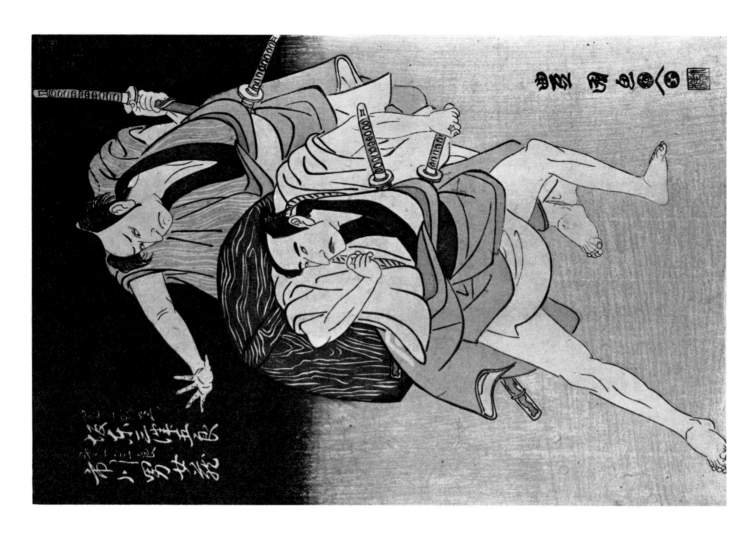

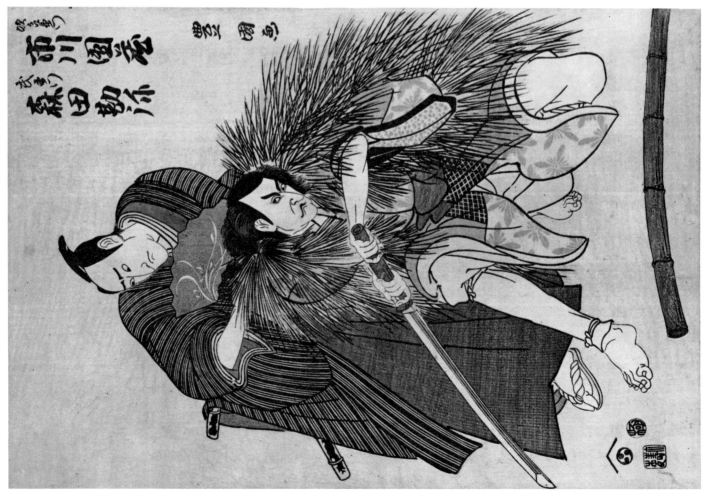

CAT. NOS. 181, 182

181 ICHIKAWA DENZŌ AND MORITA KANYA IN A SCENE FROM A PLAY

Ōban colour-print; 14¾×10⅛ in.; 1798

Ichikawa Denzō as Shundō Jirōemon, wearing a straw coat and kneeling on one knee as he prepares to draw his sword, seems to defend Morita Kanya as Takaichi Buemon, standing behind, cowering behind his red fan. Kanya has on a brick-red-and-yellow-striped outer-robe over his green *hakama*. A scene from the play *Tsuzure no Nishiki*, performed at the Morita-za in the spring of 1798. Grey ground.

SIGNED: Toyokuni ga. CENSOR'S SEAL: *Kiwame*.
PUBLISHER: Eijūdō.
PRINT DESCRIBED: In Huguette Bères, *Portrait d'acteurs Japonais du* XVII^e *au* XIX^e *siècles*, n.d., no. 109, and illustrated there by a line-drawing from the print.
SUBJECT ILLUSTRATED: Tokyo National Museum Catalogue, vol. 3, no. 2560.
ACC. 158.

The block for this print was utilized for another print illustrating a later play involving the same two characters, the *Ori Awase Yamato Nishiki*, performed at the Nakamura-za in the spring of 1800. On the later occasion, Matsumoto Kōshirō IV took over the part of Takaichi Buemon previously played by Morita Kanya. It is a testimony to the rather business-like economy ruling the production of Kabuki prints that, instead of a new print being designed, the figure of Kanya was cut out from behind Danzō and a new figure, that of the substitute, plugged in, the rest of the block remaining unaltered. An impression of the later print is reproduced in Muneshige Narazaki, *Odaka's Collection of Ukiyo-e*, 1961, no. 89.

182 ICHIKAWA OMEZŌ AND BANDŌ MITSUGORŌ IN A SCENE FROM A PLAY

Ōban colour-print; 14⅝×9¹³⁄₁₆ in.; 1798

Ichikawa Omezō and Bandō Mitsugorō II as two swordsmen in a scene from the *kyōgen*, *Mio Tsukushi Naniwa no Kagame*, performed at the Kiri-za in the fifth month of 1798, the two actors following one another with exaggerated stealth under a night sky, the leader with a large brown box supported on ropes over his shoulders. The colours of their *kimonos* are a little faded, and now consist of tones of grey-blue and fawn, with red details.

SIGNED: Toyokuni ga. CENSOR'S SEAL: *Kiwame*.
PRINT DESCRIBED: In Huguette Bères, *Portrait d'acteurs Japonais du* XVII^e *au* XIX^e *siècles*, n.d., no. 107.
ACC. 157.

183 ACTOR IN A NIGHT SCENE FROM A DRAMA

Ōban colour-print; 15¼× 9¹⁵⁄₁₆ in.; 1806

An actor, not identified by *mon*, as a two-sworded man standing in yellow *geta*, his black outer-garment purple-lined, his sash purple, and the scabbards of his swords pink in black casings. Under a grey night sky, he is holding up in his left hand an Odawara lantern and in the other a closed yellow umbrella.

SIGNED: Toyokuni ga. SEAL DATE for the Year of the Tiger (1806).
ACC. 71.

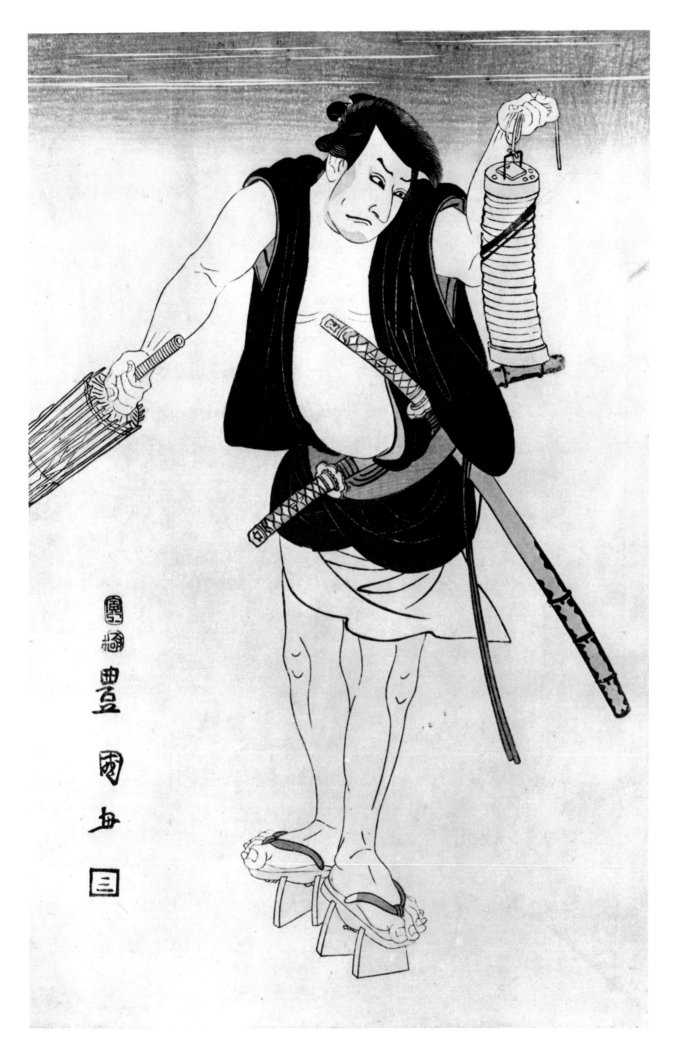

CAT. NO. 183

184 ONOE MATSUSUKE IN A GHOST SCENE

Ōban colour-print; 14×9½ in.; *c.* 1812

Onoe Matsusuke as the ghost of a man, his face blood-bedabbled, rising from the flames of supernatural fire beneath green willow branches, across which the rain is slanting in white rods against the dark sky. He is clad in a sombre grey garment with white sash.

SIGNED: Toyokuni ga. CENSOR'S SEAL: *Kiwame.*
PUBLISHER: unidentified.
PRINT PUBLISHED: M.I.A., Exhibition Catalogue, 1961 no. 116, fig. 18.
EXHIBITED: M.I.A., 1961, no. 116.
ACC. 159.

Onoe Matsusuke seems to have made a name as a portrayer of ghosts, and took such roles in a number of plays. Several prints by Toyokuni depict the actor in different ghost roles.

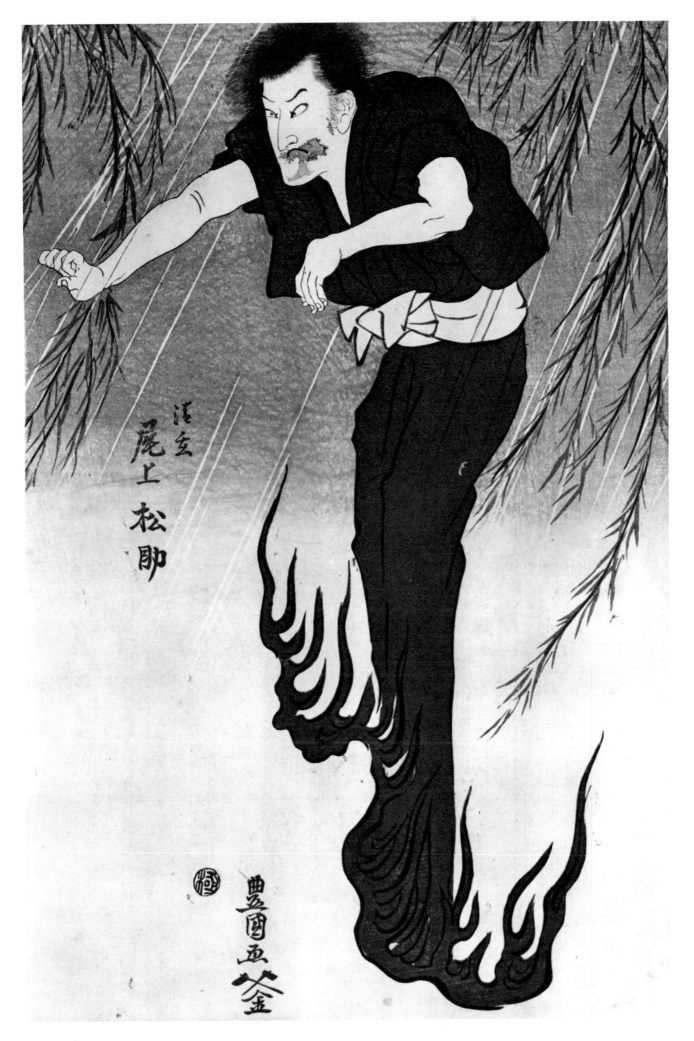

CAT. NO. 184

TŌSHŪSAI SHARAKU

(Active 1794-5)

If, as we believe, Sharaku gave up his career as artist because of the unpopularity of his actor-prints with the contemporary public, the Japanese of today are making ample amends. As their indoctrination with Western art and the development of an art of their own that is no longer nationally isolated has developed, so their admiration for Sharaku has increased, and today he has possibly a higher standing among the *cognoscenti* there than any other Ukiyo-e artist, though possibly the rarity of his prints and their status value to any collection may have aided and abetted this trend to some extent.

There has been, as a consequence, an almost feverish search for facts concerning this enigmatic artist, and a proliferation of theories concerning him, each one wilder than the last (e.g. that he was Enkyō, or Ōkyo, or Chōki or Jūsaburō or even Hokusai!) We are forced to content ourselves with the bare statements of contemporaries: that his portraits of Kabuki actors were unpopular because of an excessive realism; that he ceased to work in a year or two; that he served the Lord of Awa as a Nō actor and that his brush-strokes were noteworthy for their strength and elegance. Nothing has been discovered to explain the phenomenon of an artist who appeared only when his art was perfected, whose first prints appeared in the fifth month of 1794 fully mature, compelling in their originality and masterly in their technique; and whose last prints were issued in the first two months of 1795; a total *oeuvre* of something like 150 prints. The penetrating power of his close-up, the biting, almost caricatural line, were something new to Kabuki prints, or to Japanese art as a whole for that matter.

Influences, if not a master, can be deduced. Something may be owed to Bunchō, Shunshō, Shunkō, Shunei, and more to Toyokuni. On the basis of similarities between Sharaku prints and Toyokuni's 'Portraits of Actors on the Stage', the late Robert Paine, in a penetrating article in *The Museum of Fine Arts Bulletin, Boston*, vol. LX, 1962, no. 321, came out strongly in favour of a master/pupil relationship. But Sharaku seems to have been a genius prompted, fostered and jealously guarded by the master publisher, Tsutaya Jūsaburō, whose mark appears on every print designed by Sharaku; indeed, one of the less-improbable guesses in the game of 'Who was Sharaku?' is that he was Tsutaya himself.

Sharaku, for all his unpopularity with the masses, had a powerful effect on his contemporary artists – on Enkyō, Kunimasa, the Osaka artists Ryūkōsai and Shōkōsai, and, curiously enough, on Shunei and Toyokuni, from whom he had derived elements of his own style.

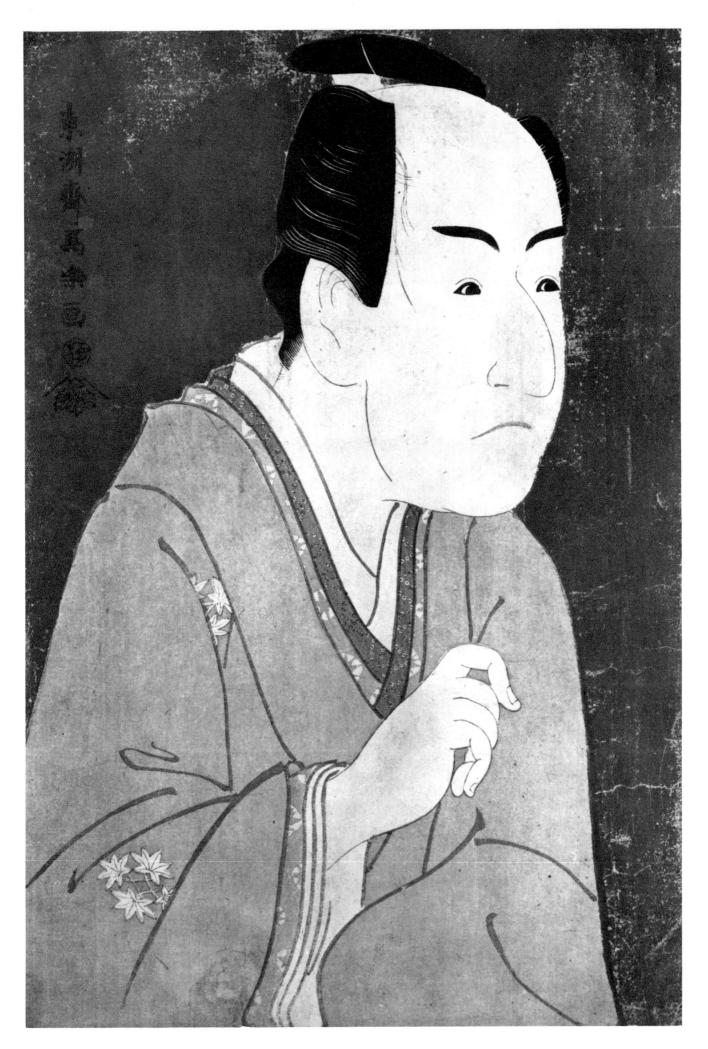

CAT. NO. 185

185 ICHIKAWA MONNOSUKE II AS DATE NO YOSAKU

Ōban colour-print; 14¼×9½ in.; 1794

Bust portrait of the actor Ichikawa Monnosuke II in the role of Date no Yosaku in the play, *Koinyōbō Somewake Tazuna,* performed at the Kawarazaki-za in the fifth month of 1794. His outer *kimono* is pale violet, and under-*kimono*, showing at neck and sleeve, are white, rose and green. The tonsure, which would originally have been blue, is of the buff tone to which the blue fades. Dark mica ground.

SIGNED: Tōshūsai Sharaku ga. CENSOR'S SEAL: *Kiwame.*
PUBLISHER: Tsuta-ya.
EXHIBITED: M.I.A., 1961, no. 107.
FORMER COLLECTION: Colburn.
SUBJECT ILLUSTRATED: Henderson and Ledoux, no. 13; V. & I., Paris, 1911, no. 283; Rumpf, no. 14; Yoshida/ Adachi, *Sharaku,* vol. 1, no. 24.
ACC. 32.

186 ICHIKAWA EBIZŌ IV AS SADANOSHIN

Ōban colour-print; 14¾×9¾ in.; 1794

Ichikawa Ebizō IV (Danjūrō V) in the role of Takemura Sadanoshin in the same play as no. 185. He is dressed mainly in red-orange; the *kamishimo,* visible at the left shoulder, is blue. The background is dark mica. Teeth are outlined in the partially opened mouth.

SIGNED: Tōshūsai Sharaku ga. CENSOR'S SEAL: *Kiwame.*
PUBLISHER: Tsuta-ya.
EXHIBITED: M.I.A., 1961, no. 109.
FORMER COLLECTIONS: K. Matsuki; Le Gallais.
SUBJECT REPRODUCED: There are variants of this print, both as to line-block and colour, but all are considered to have been issued within a short period of each other, perhaps because of an unexpected popularity of the print, or, more possibly, because of faults developing in the first blocks. However that may be, there is no certain way of deciding which is the 'first' issue, and it is doubtful if Henderson and Ledoux could justify the choice of their illustrated specimen as the first, even though they cite identity with other impressions in the Art Institute of Chicago, the Bigelow Collection, Museum of Fine Arts, Boston, and the Metropolitan Museum of Art. What might be termed the 'standard variant' from the Henderson and Ledoux print is illustrated in V. & I,. Paris, 1911, no. 264, pl. LXV; *U.T.S.* 5; *Ukiyo-e Zenshū,* vol. 5, pl. 52 (Tokyo National Museum) and Michener/Lane, *Japanese Prints,* no. 168 (Honolulu), all of which (and others that could be cited) tally with the print in this collection. Yoshida/Adachi ref., *Sharaku,* vol. 1, no. 19.
ACC. 201.

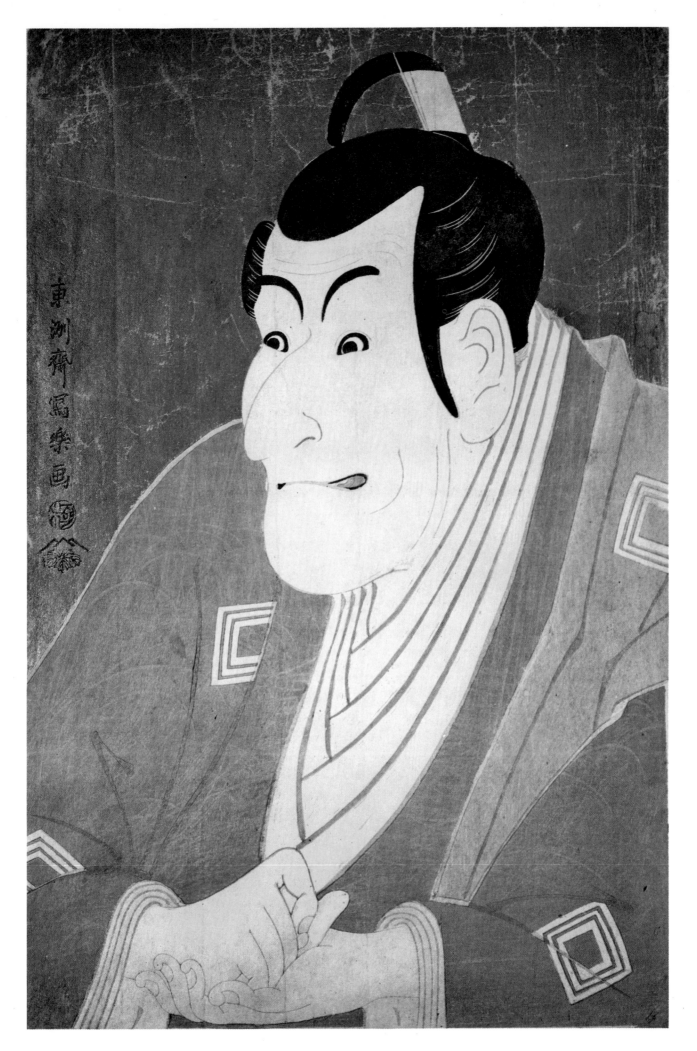

CAT. NO. 186

187 OSAGAWA TSUNEYO II IN CHARACTER

Ōban colour-print; 15×10 in.; 1794

Bust portrait of the actor Osagawa Tsuneyo II, probably in the role of Sakuraji, the wife of Takemura Sadanoshin depicted in no. 186, and in the same play. The outer *kimono* is blue, the inner one rose and the *obi* black. Dark mica ground. Silver mica on the white collar.

SIGNED: Tōshūsai Sharaku ga. CENSOR'S SEAL: *Kiwame.*
PUBLISHER: Tsuta-ya.
EXHIBITED: M.I.A., 1961, no. 108.
FORMER COLLECTIONS: Garland; Levinson.
SUBJECT REPRODUCED: V. & I., Paris, 1911, no. 282; Henderson and Ledoux, no. 21; Yoshida/Adachi, *Sharaku* vol. 1, no. 25.
ACC. 145.

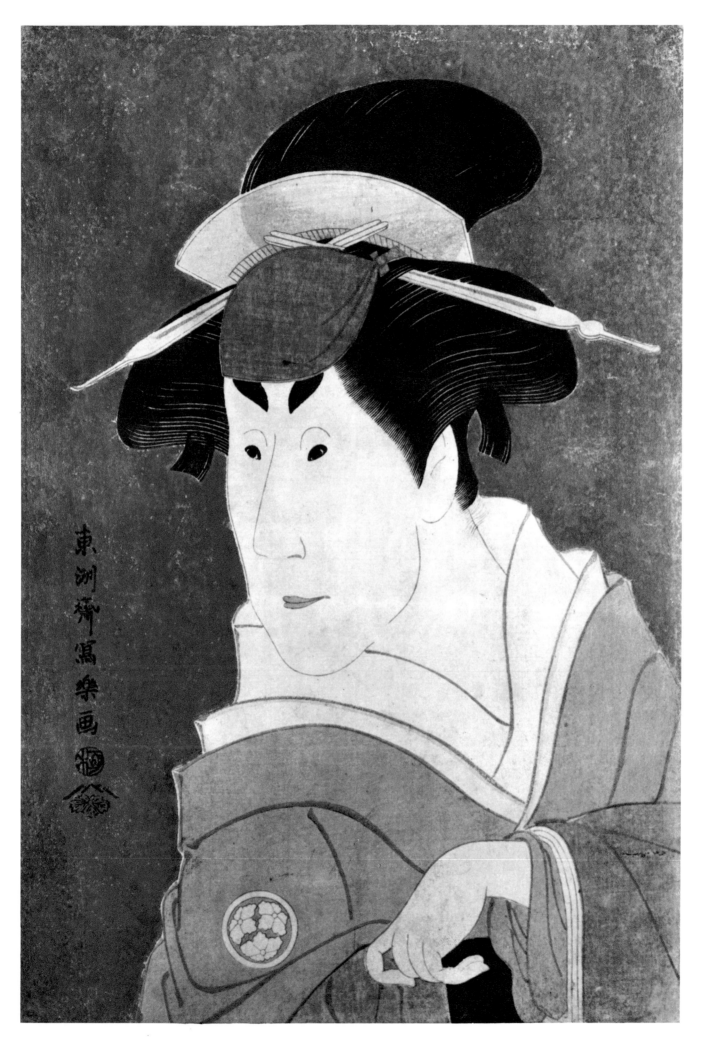

CAT. NO. 187

188 THE ACTOR NAKAYAMA TOMISABURŌ IN A FEMALE ROLE

(Attributed to Tōshūsai Sharaku)
Kakemono. Ink and colour on paper, silver ground; 43½×16 in.; *c.* 1794–5

Full-length figure of the *onnagata* Nakayama Tomisaburō as a woman seen facing three-quarters left, with arms crossed over the body and the outer garments falling in stiff folds from this focal point. The outer *kimono* is black above and patterned below with a cherry-blossom and blue stream motif, and it is worn over a pink garment decorated with roundels and lined with red. The silver background is tarnished and darkened.

UNSIGNED.
PUBLISHED: Sherman E. Lee, *Japanese Decorative Style*, 1961, no. 103; M.I.A., Exhibition Catalogue, 1961, fig. 16.
EXHIBITED: Japanese Decorative Style, Cleveland, 1961; Chicago, 1962; M.I.A., 1961.
FORMER COLLECTION: Kaneda.
ACC. 200.

In the absence of any body of paintings by Sharaku with which comparison can be made, the attribution to Sharaku needs substantiation, and the possibility of it being a counterfeit also has to be considered.

Although there are no other paintings in *kakemono* form, there exist for comparison a number of prints by the artist figuring Nakayama Tomisaburō, and the head in the painting bears a recognizable resemblance, in particular, to the *okubi-e*, Henderson and Ledoux, no. 24. In a painting such as this there is no need to pre-suppose that it commemorated a particular performance, but we can assume that it dates from Sharaku's period of intensive activity from 1794–5.

The silver ground, used in screens as an alternative to gold for the backgrounds from Momoyama onwards, is exceptional in *kakemono* painting of the Ukiyo-e school, and one can either see in its use a reflection of that curious predilection for mica backgrounds which is a marked feature of a large number of Sharaku's prints, or the sinister ruse of a counterfeiter to further the plausibility of his imposture; or, given the work were a genuine Sharaku, the ground might have been added by someone later, intent on clinching the attribution. But scientific analysis at the Smithsonian Institution Freer Gallery has failed to detect any anomalies, either in the silver ground or in the pigments generally (apart from some retouching of repairs in the lower part of the painting), and the conclusions drawn there are that the painting and the ground are of the period of Sharaku.

If, then, the painting is accepted as of the period of Sharaku, who else other than Sharaku could have painted it? There are some artists whose prints approximate in style at times to Sharaku's - Shunei, Enkyō, Toyokuni, Kunimasa, Shunkō. No paintings by Enkyō are known, but existing paintings by the other artists do not offer sufficient resemblance to the painting under discussion to allow an alternative attribution to any one of them. Enkyō remains an unknown quantity as a painter, but the seven *okubi-e* by which he is known do not suggest that he could have been the painter of the Tomisaburō portrait.

The painting, or colour-transparencies of it, has been submitted to a number of Western and Japanese authorities, and although there has been a reluctance for anyone to commit himself to a confident assertion in favour of Sharaku as the painter (only the late Ichitarō Kondō vetoing completely), no one, including Kondō, has been able to produce argument or evidence against the ascription.

We are left with conflicting feelings. On the one hand, the head, especially the emphatic eyebrows, and the curiously awkward pose suggest Sharaku very forcibly, whereas the somewhat stiff and not al-together happy lines of the lower folds of the garments do not exactly match up to our conception of

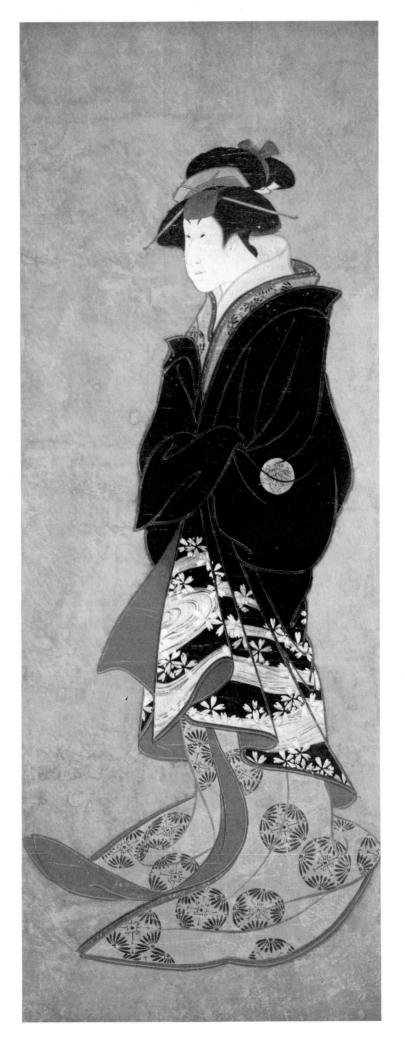

CAT. NO. 188

Sharaku as a draughtsman, though even there it must be conceded that several print-designers of merit are much less impressive as painters, and that Sharaku, judging by what remains, produced very few *nikuhitsu*, and was perhaps ill at ease in handling the medium. No other paintings by Sharaku are recorded apart from the two, questionable, fans illustrated by Henderson and Ledoux, and if the portrait of Tomisaburō was his only painted portrait, one could perhaps expect a certain tentativeness and uncertainty in his handling.

In the upshot, one cannot do better than quote Henderson and Ledoux, writing of one of the fan-paintings mentioned above and using words which can equally well be applied to the painting of Tomisaburō: '...a catalogue must sometimes seek safety in equivocation and qualifying clauses, and the drawings of actors made to be cut in wood blocks give insufficient evidence as to the quality of Sharaku's original brushwork to enable anyone to say with certainty that the painting now under consideration... is by him'.

189 ARASHI RYŪZŌ IN CHARACTER

Hoso-ban colour-print; 12⅞×6 in.; 1794

Full-length figure of Arashi Ryūzō in the part, probably, of Otomo no Yamabushi in the play, *Urū Toshi Meika no Homare*, performed at the Miyako-za in the eleventh month of 1794. He stands with his left hand within his right sleeve, and gesticulates with his right hand, a branch of flowering plum above his head, with the background left plain. There are colour details in the pink of an under-*kimono*, of the sword hilt and the plum-blossom, the purple of sash and *kimono* hem, and the yellow of the *tsuba*, but the great strength of the print lies in the predominant black of the actor's *kimono*, relieved by the floral roundels in white reserve.

SIGNED: Sharuku ga. CENSOR'S SEAL: *Kiwame*.
PUBLISHER: Tsuta-ya.
PRINT PUBLISHED: Sotheby Sale Catalogue, Philippe R. Stoclet Sale, May 1965, no. 165.
FORMER COLLECTION: Stoclet.
SUBJECT REPRODUCED: V. & I., Paris, 1911, no. 296, pls. LXXXIII (in colour) and LXXXII; Henderson and
 Ledoux, no. 111.
ACC. 355.

Probably the right-hand sheet of a triptych of which only the centre and right-hand sheets are known (Henderson and Ledoux nos. 110–11).

Henderson and Ledoux discuss the problem of identification of the role played by Arashi Ryūzō, and also point out the extreme rarity of this print. Two impressions are known in America (Grabhorn Collection and Boston Museum of Fine Arts), and a third (Vever) is illustrated in the V. & I. Catalogue. All known reproductions appear to have been from these three prints.

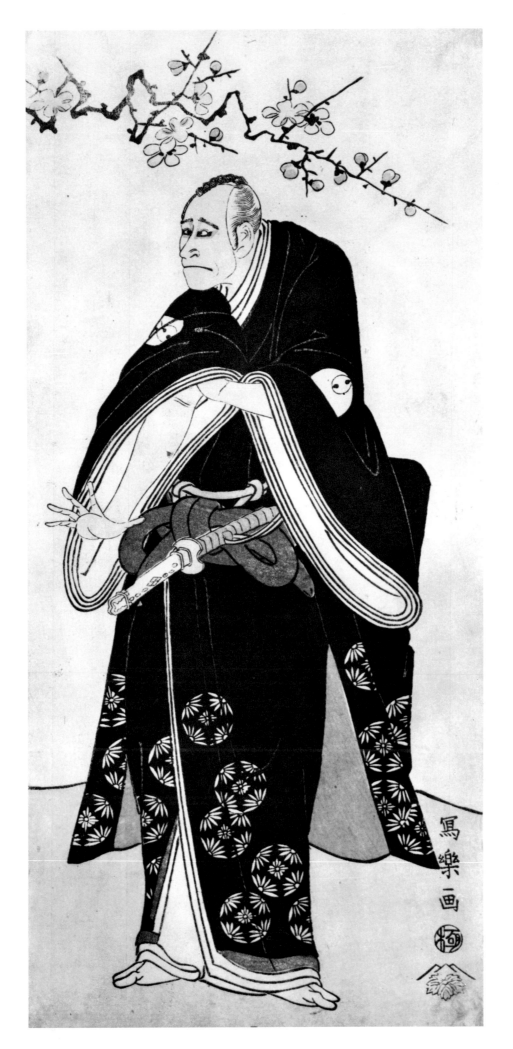

CAT. NO. 189

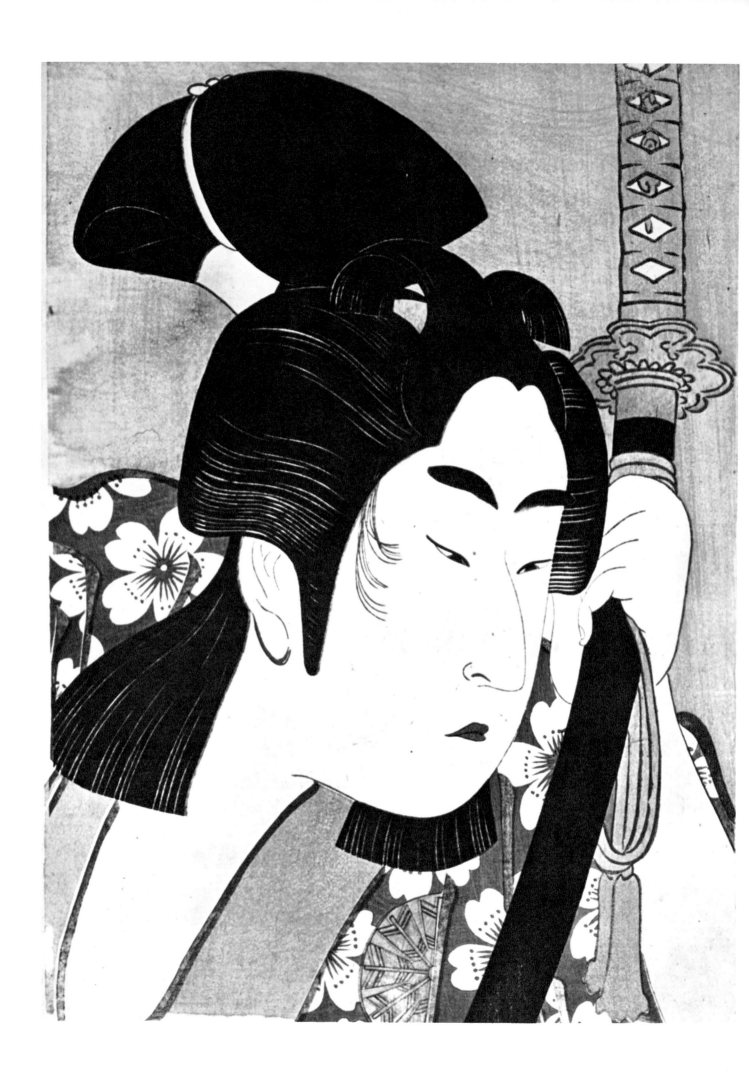

CAT. NO. 190

KABUKIDŌ ENKYŌ

(Active 1795–6)

Seven prints are known all that are known by this artist, six signed either 'Kabukidō' or 'Kabukidō Enkyō' and one unsigned, all produced for plays performed from autumn, 1795, to spring, 1796. If anything, even less is known of him than of Sharaku, but the mystery of his career is less surprising, since he was patently an amateur closely imitating one type of Sharaku's output, the large head, *okubi-e*. Nor is it so surprising that his period of activity was so short-lived. Various theories have been propounded in attempting to identify him with this or that literary or artistic figure:* but we can only accept the probability that he was an amateur with a deep admiration for Sharaku's art who, having a flair himself, was possibly encouraged by friends to produce a few prints privately. It is at least noticeable that none of his prints bears the mark of a publisher.

190 NAKAMURA NOSHIŌ II AS SAKURA-MARU

Oban colour-print; 14$\frac{3}{16}$×10$\frac{1}{2}$ in.; 1796

Bust portrait of the actor Nakamura Noshiō II in the role of Sakura-maru in the play *Sugawara Denjū Tenarai Kagami* performed at the Miyako-zu in the sixth month of 1796. He is depicted holding up his sword in its scabbard. His outer *kimono* is pink with a white blossom pattern; the under one is grey-blue. The *mon* is yellow on grey-blue; the sword-fittings are yellow. The dominant colour, however, is black, in the elaborate hair-do and the curve of the scabbard. Grey ground.

UNSIGNED.
PRINT PUBLISHED: *Ukiyo-e Fūzoku-ga Meisaku Ten* (The Olympic Shiroki-ya Ukiyo-e Exhibition, 1964, Catalogue), no. 194.
EXHIBITED: M.I.A., 1961, no. 97; Shiroki-ya Olympic Ukiyo-e Exhibition, Tokyo, 1964.
SUBJECT REPRODUCED: *Ukiyo-e Zenshū*, vol. 5, fig. 127.
ACC. 271.

Prints were also produced for this play by Utagawa Kunimasa (who, incidentally, has been put forward as one of those likely to have designed the Enkyō prints), and it is interesting to compare the two artists' versions of the same actors in identical roles. Kunimasa's portrait of Noshio II in this role is illustrated in *Sammlung Theodor Scheiwe, Münster, Japanische Holzschnitte*, 1957, no. 167A.

A word must be said concerning the superb state of this and the two following prints by Enkyō. They seem to have been preserved under cover since they were issued and the colours are pristine.

* The strongest probability is that he was the dramatist Nakamura Jūsuke (1744–1803), for whom a case is made by Naonari Ochiai in *Ukiyoye no Kenkyū*, no. 17, 1926.

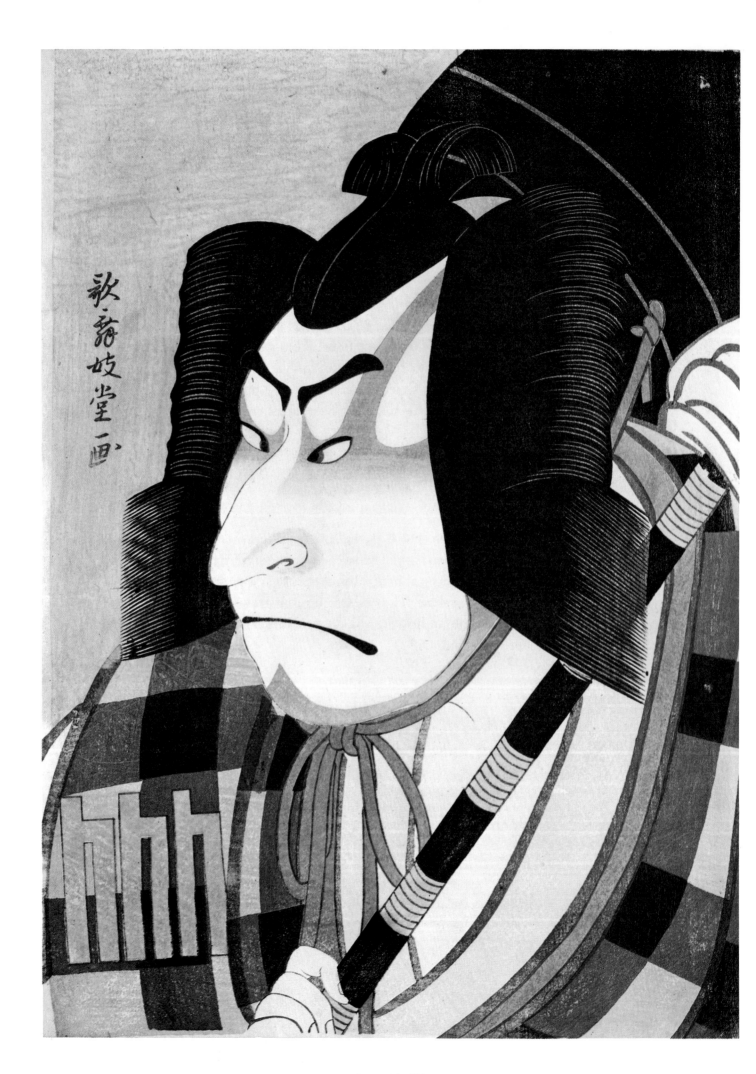

CAT. NO. 191

191 THE ACTOR NAKAZŌ II AS MATSUŌ-MARU

Ōban colour-print; 14¾₆ × 10 in.; 1796

Head and shoulders of Nakamura Nakazō II in the part of Matsuō-maru in the same play as that referred to in no. 190. He is carrying what appears to be a baton, or a covered lance, and wears a high *eboshi*. Grey background.

SIGNED: Kabukidō ga.

PRINT PUBLISHED: Adachi, *Selected Masterpieces of Ukiyo-e*, part 1, no. 20; Harold P. Stern, *Master Prints of Japan*, 1969, no. 97.

SUBJECT REPRODUCED: *Ukiyoye no Kenkyū*, no. 17, fig. 4 (in illustration to an article on Enkyō by Naonari Ochiai); Grabhorn, *Ukiyo-e 'The Floating World'* San Francisco, 1962 no. 23; *Ukiyo-e Zenshū*, vol. 5, fig. 129.

EXHIBITED: M.I.A., 1961, no. 95; University of California, Los Angeles, 'Master Prints of Japan', 1969.

ACC. 272.

The analogous print by Kunimasa is illustrated in Sotheby Sale Catalogue, 7th June 1966, Madame Michèle Stoclet, no. 197.

192 ICHIKAWA YAOZŌ III AS UMEŌ-MARU

Ōban colour-print; 14⅜×10½ in.; 1796

The actor Ichikawa Yaozō III as Umeō-maru in the same play as that referred to in the two previous prints by Enkyō, head and shoulders only, his left hand on his right fore-arm, and his right hand gesticulating by his face, which is made up with bold red markings. His outer *kimono* is light red, decorated with white blossom, and beneath is a blue garment. The *mon* is yellow and red. A great feature is the intense black of the hair. Grey ground.

SIGNED: Kabukidō ga.
PRINT PUBLISHED: M.I.A., Exhibition Catalogue, no.96, fig.12.
EXHIBITED: M.I.A., 1961, no.96.
SUBJECT REPRODUCED: Ochiai, *Ukiyoye no Kenkyū*, no.17; *Ukiyo-e Zenshū*, vol.5, fig.128.
ACC.273.

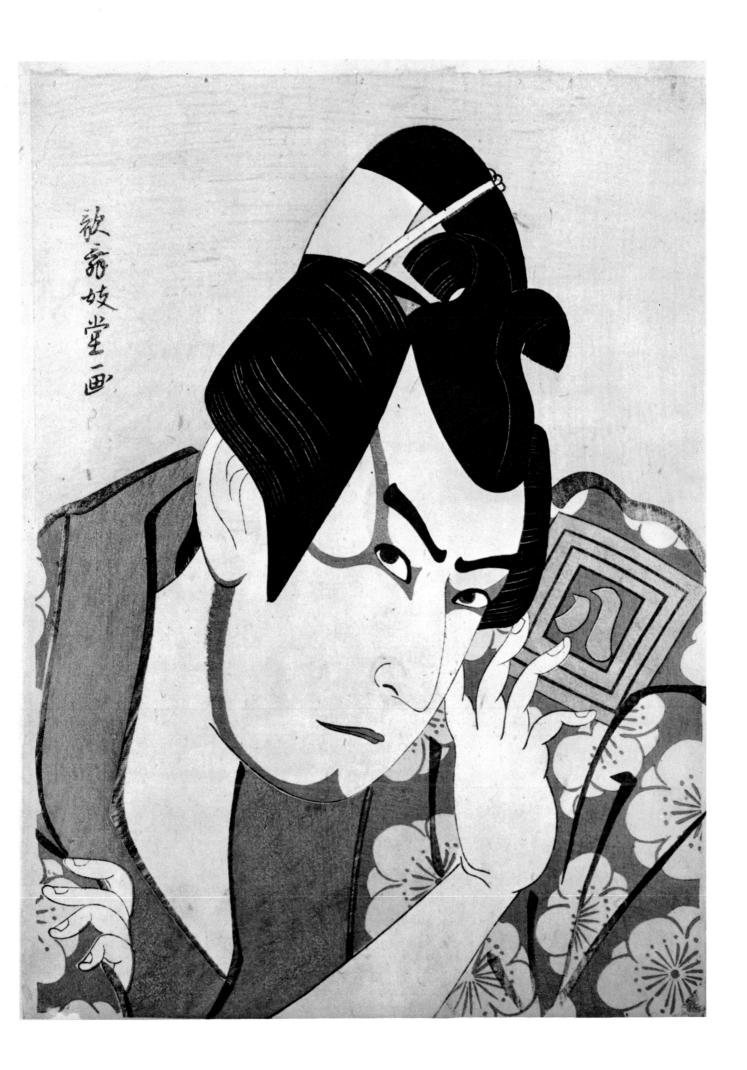

CAT. NO. 192

RYŪKŌSAI JOKEI

(Active c. 1784–1809)

Ryūkōsai was an Osaka artist, and occupied an important place as one of the founders of the separate Osaka school of actor-print artists, whose style was recognizably different from that of the contemporary Edo print-designers. His first known dated work is the *ehon, Yakusha Mono Iwai* of 1784, and from that date onwards until 1809, the date of the last-known illustrated work by him, he was concerned with a number of similar theatrical books, and also designed a number of *hoso-e ichimai-e* actor-prints. One *ehon*, the *Gekijō Gashi* of 1803, is of particular note, since Hokusai used the designs as the basis for a book published in 1818, the *Hyōsui Kiga*, for which the Ryūkōsai blocks were re-used with new figures, drawn by Hokusai, and plugged into the blocks.

Although mainly influenced by the Katsukawa artists of Edo, Ryūkōsai's style also shows traces of the mannerisms of a fellow-Kamigata artist of whom practically nothing is known, Suifutei, whose striking book, *Suifutei Gigafu*, appeared in 1782. There is a quality of penetrating, biting insight in Ryūkōsai's portraits that has led some students to draw comparisons with Sharaku, and to suggest that Ryūkōsai was possibly Sharaku's master, or even Sharaku himself, a most improbable theory.

193 SEVEN GREAT ACTORS IN FAVOURITE ROLES

Makimono. Ink, colour and *gofun* on gold-splashed silk; 7¼×49½ in.; late 1780s

Standing figures of seven actors in star roles, the names of the players and their parts, together with the play-titles and their dates, reading from left to right, being as follows:

Arashi Sangorō II as Yamato no Sukekuni, in the *kyōgen* play, *Keisei Yamato Zōshi*, performed at the New Year, 1784, at the Arashi-za, Osaka.

Yamashita Kinsaku II as the courtesan Katsuragi in the *kyōgen, Monogusa Tarō*, performed in the ninth month of 1782 at the Fujikawa-za, Osaka.

Ichikawa Danzō IV as Matsunaga Danjō in the *kyōgen, Otsuginasai Ioote Konoshiki*, performed in the seventh month of 1785 at the Onoe-za, Osaka.

Onoe Shinshichi as Oboshi Yuranosuke in the *kyōgen, Kanadehon Chūshingura*, performed in the ninth month of 1785 at the Hoteiya-za, Kyoto.

Yamashita Yaozō as the courtesan Okaru in the same *kyōgen*.

Asao Tamejūro as Kyōgoku Takumi in the *kyōgen, Taikō Shinken Ki*, performed in the third month of 1787 at Bantō-za, Osaka.

Arashi Hinasuke as Keyamura Rokusuke in the same *kyōgen*.

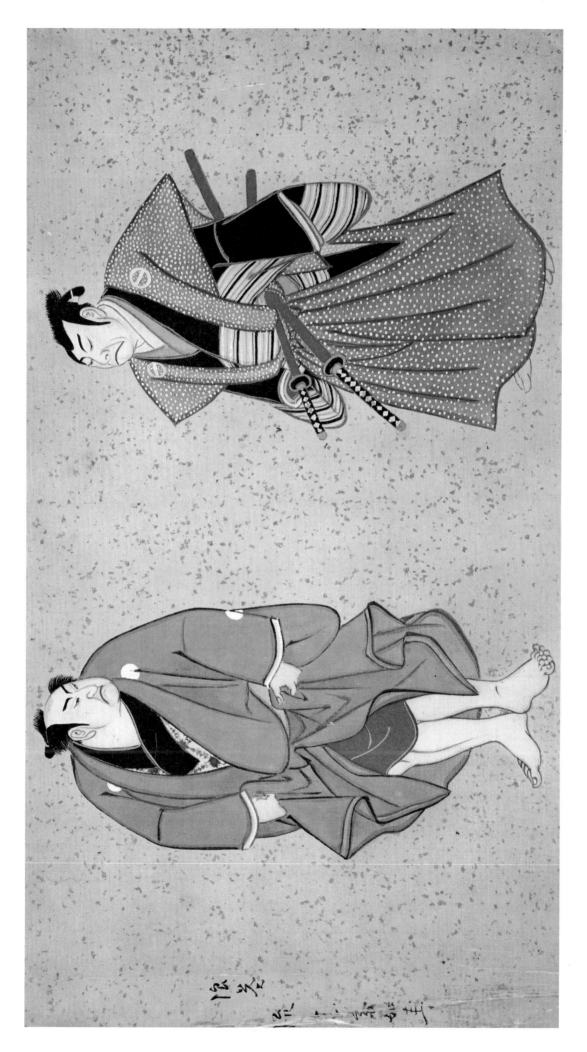

CAT. NO. 193

SIGNED: Naniwa Ryūkōsai Jokei. Two seals too faint to read.
EXHIBITED: M.I.A., 1961, no. 20.
ACC. 212.

It can be presumed that Ryūkōsai painted this scroll at a date not much later than the last of the performances recorded, viz. the third month of 1787. There is no evident reason why just these actors, in these specific roles, should have been selected, but they were all well-known actors, and Ryūkōsai must have decided, or have been commissioned, to paint them in characterisric roles made memorable in the preceding five or six years·

The work of this artist is scarce in both *ichimai-e* and *nikuhitsu* form. Other paintings by him showing points of resemblance to this *makimono* are illustrated in *Kabuki-e Taisei* (Kansei period), Tokyo, 1931, pls. 58–9; and *Nikuhitsu Ukiyo-e*, vol. 2, text fig. 105.

194 THE ACTOR NAKAYAMA RAISUKE IN CHARACTER

Hoso-e colour-print; 12½ × 5¾ in.; *c.* 1800

The actor Nakayama Raisuke as a *Samurai* in a grey *kimono* over his armour, standing among stooks of rice with a hand upon the hilt of each sword; the actor's name above.

SIGNED: Ryūkōsai, with *kakihan*.
PRINT PUBLISHED: Sotheby Sale Catalogue, 17 June 1968, no. 43.
ACC. 395.

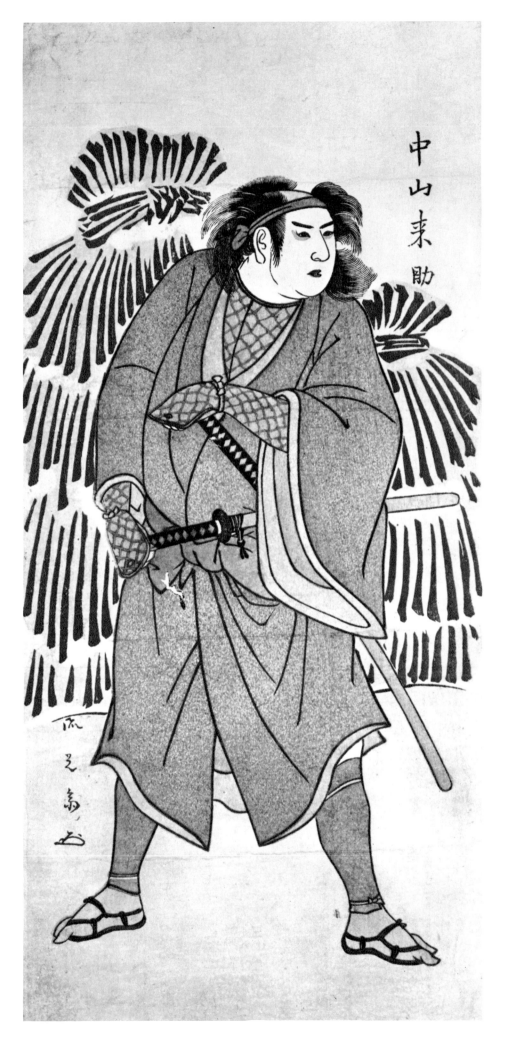

中山来助

CAT. NO. 194

KATSUSHIKA HOKUSAI

(1760–1849)

From a number of points of view, Hokusai was one of the most remarkable artists in the history of Japanese art. Beginning, whilst still in his teens, as a follower of a strictly Ukiyo-e sub-school–that of Katsukawa Shunshō–he ran through a gamut of styles and media of expression–*kakemono*, drawing, *surimono*, actor-print, landscape-print, poetry and novel illustration–and, after an immensely long and active career, ended by painting in a manner and with an expressiveness that is no longer of any particular school, as inimitable in its context in the painting of Japan as the last quartets of Beethoven in the music of Europe.

His earliest actor-prints, occasional prints of beauties and book illustrations of the 1780s, published under a variety of art-names, but principally Shunrō, show clear influence of Shunshō and Kiyonaga; from the mid-1790s to about 1805, when he was using the names Hokusai, Sōri and Kakō, a certain poetic sweetness tinges much of his work, and his *bijin-ga* at this period are among the most appealing of his paintings, whilst his *surimono* and poetry-album prints brought something new in exquisiteness to both those forms. The next ten years were given over largely to book illustrations–the prolix novels of Bakin especially–and *ehon* (picture-books), including three that portrayed outdoor genre scenes in which landscape played an ever-increasing part.

Throughout the whole of his maturing years he had studied and tried his hand at a variety of painting styles–Chinese, Tosa, Kanō, the decorative school of Kōrin (via one of its minor practitioners, an earlier Sōri, whose name Hokusai himself employed for some years) and even European. In 1814 the first volume of the *Manga* appeared, and intermittently for the rest of his life, and even posthumously, these volumes of miscellaneous sketches were published, reflecting his gargantuan appetite for life in all its forms, for the beauty of Nature, the world of Japanese men and women, their humanity and inhumanity, their work and play, industry and skills, triumphs and foibles. By 1814, he was using the name Katsushika Hokusai and also Taitō, a name he later, about 1819, passed on to his pupil, Genryūsai Hokusen, but with the adoption of the name I-itsu about 1819–20 he reached a period of stability in his development, a high plateau of accomplishment, during which he designed the colour-prints by which he was first, and is still, best known: the 'Thirty-Six Views of Fuji', the 'Bridges', the 'Waterfalls', the two sets of Flowers, the great *kakemono-e* set of the 'Images of the Poets of Japan and China' and the 'Ocean of 1,000 Images'. In the last decade of his life, during which he invariably signed his works, using the names Manji and Gakyōrōjin ('The Old Man Mad

395

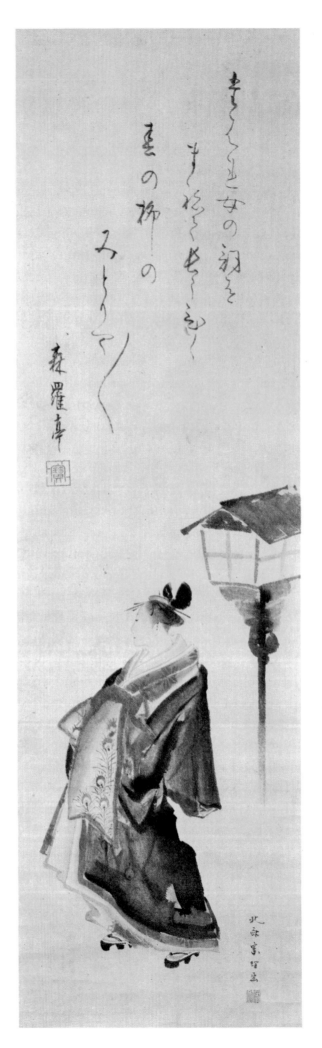

CAT. NO. 195

about Drawing'), he designed his last important set of prints – the 'One Hundred Poems Retold by the Nurse' (of which twenty-seven only were published), but in the main confined himself to painting and drawing in a style now uniquely his own, at times creating what we feel are great works of art of universal appeal.

195 STROLLING COURTESAN

Kakemono. Ink and colour on paper; $37\frac{1}{8} \times 10\frac{7}{8}$ in.; *c.* 1798

A courtesan in her finery walking past a lantern on a post. Above is a poem signed Shinratei, sealed Takara (probably Shinra Banshō II):

> 'The words of a loose woman
> Fall like the green wands
> Of a willow in spring.'

SIGNED: Hokusai Sōri ga. SEAL: Kanchi.
PUBLISHED: Yoshida; *Ukiyo-e Kusagusa*, Tokyo, 1942 (colour plate). pp. 144–5.
ACC. 336.

In his lengthy note on this painting, Yoshida in *Ukiyo-e Kusagusa* expresses a preference for Hokusai's paintings of this early period, stating that he believes them to be finer artistically speaking than those produced later under the name of I-itsu. Of the 'Strolling Courtesan' he says that it shows skilful brushwork and a rich sense of colour: 'The tie of the clog worn by the courtesan is painted befittingly in bright red to evoke amorous feeling.'

196 DAIMYŌ AND RETAINERS RETURNING FROM A VISIT TO A SHRINE

Ōban yoko-e colour-print; 15 × 10 in.; *c.* 1800

A daimyō in purple-patterned grey clothes riding a chestnut horse is caught in a rain-storm among the brown cryptomerias of a shrine, and is being protected from the rain by an immense yellow-and-black umbrella held over him by a foot-retainer, another holding the horse's head and carrying the nobleman's sword, a third carrying on his back the daimyō's son wrapped in a red cloth patterned with yellow diamonds, beneath a second umbrella. A *torii* support, left.

UNSIGNED.
SUBJECT REPRODUCED: *Landscape Prints of Old Japan* (Grabhorn Collection), San Francisco, 1960, no. 15.
ACC. 250.

Of the Grabhorn impression, the cataloguer wrote: The present example is one of a number of similar type issued about 1800. Several have the title in seal characters in an oval cartouche; the majority are signed or sealed 'Gakyōjin' ('Man Mad about Painting'), a pseudonym used by Hokusai at this period.... The technique seems to be akin to that employed in the poetry-albums.... It is often characterized by the use of pastel shades paler than the colours employed for the broadsheets, and by a certain crayony texture of the printed surfaces which also contributes to the generally soft and gentle aspect.

There is, in fact, a gentleness and sweetness about Hokusai's work at this period which were replaced by other, manlier traits later.... Prints like this have the appeal of youthful poetry.'

CAT. NO. 196

CAT. NO. 197

197 RESSHI IN THE WIND

Kakemono. Ink and slight colour on silk; 37½×15 in.; *c.*1815

The Chinese sage Resshi (Ch. Lieh Tsze) riding on a swirling wind which billows out his robe and scatters red maple leaves. The painting is in ink, except for a flesh tint and the red of the maple leaves.

SIGNED: Totō (Edo) Katsushika Hokusai Taitō. SEAL: Kishitsu Kisoku.
PUBLISHED: Catalogue of M.I.A., Exhibition 1966, no. 38.
FORMER COLLECTION: Gyokutan-dō.
EXHIBITED: M.I.A., 1966, no. 38.
ACC. 323.

Lieh Tsze is supposed to have lived shortly after the time of Confucius and was believed to have the power to travel on a rain-cloud. Hokusai has created a superbly sweeping design based on this legend, the old sage riding the storm, his back to the wind and his sleeves and the skirt of his robe streaming like banners.

198 MANZAI DANCERS

Kakemono. Ink and colour on silk; 32½×13 in.; *c.*1816

A lively *pas de deux* between two *tsuzumi* players, one dancing with upraised leg, his fellow behind him holding a fan to his face. They are in light blue garments with a darker blue floral pattern superimposed, and these tones of blue, and touches of grey for under-garments, swords and hats, are the only colours in the painting.

SIGNED: Tōto Hokusai Taitō. SEAL (reticulated lines within a square): Fuji-no-yama. ACC.365.

Authentification inside the box-lid by Muneshige Narazaki dated Showa 41 (1966).

The Manzai dance had its origin in country districts, pairs of travelling dancers giving performances at the New Year, moving from house to house and village to village, conveying good wishes for longevity and prosperity in the coming year to the onlookers, who were expected to contribute a small sum in return. Two performers were involved: the *manzai*, who normally sang to an accompaniment on the *tsuzumi*, played by the other, called a *saizō*, but, as in Hokusai's picture, quite often both danced and played the drums.

The signature and seal give a fairly reliable dating to the painting. Hokusai took over the name Taitō about 1812 and relinquished it in 1819, and the seal Fuji-no-yama appears on one of the most famous of Hokusai's series of drawings, the 'Day and Night' series, datable to the period 1815–19.

CAT. NO. 198

199 FISHERMAN CARRYING HIS NET IN THE SNOW

Kakemono. Ink and colour and *gofun* on paper; 10$\frac{3}{16}$×14$\frac{1}{8}$ in.; *c.*1821

A fisherman with a net over his shoulder, his broad hat and his straw cape thick with snow, battling against the driving snow, which is realistically depicted with spattered *gofun*. The only positive colour is the brown of the straw hat and cape, the flesh-tint, a streak of blue of an under-garment, and touches of yellow and blue for the bamboo.

SIGNED: Hokusai I-itsu. SEAL: Fuji-no yama (or Yoshino-yama).
PUBLISHED: Catalogue of the M.I.A. 1966 Exhibition, no. 39.
EXHIBITED: M.I.A., 1966. Dallas, 1969 (no. 80 in the Catalogue, illustrated.)
ACC.326.

CAT. NO. 199

CAT. NOS. 200, 201

200 HORSE-MONEY: A *SURIMONO*

Chūban colour-print; 8×7 in.; 1822

Koma senzan, Horse-money; a brocade key-and-cash case with gold and black lacquer-gourd *netsuke*, a pot with pink pattern and black lid on a gold and black lacquer tray and some black beans. Title in cartouche, *Uma tsukushi* ('Horse Series'); Sub-title, *Koma senzan*.

SIGNED: Fuzenkyō I-itsu hitsu.
PRINT PUBLISHED: Philippe R. Stoclet Sale Catalogue, Sotheby, May 1965, no.225.
FORMER COLLECTION: Stoclet.
ACC.357.

This is one of a set of *surimono* issued for the Horse Year (1822) bearing the general title *Uma tsukushi* ('Horse Series'). Each print is a still-life that has an allusion, direct or punning, to the horse, with poems above. The full set comprised twenty-five prints, with which went a triptych of the Sumidagawa, each sheet the size of the *surimono*. The Preface, which has survived with at least one set, states: 'Whatever pleasure one gets from a single theme, it is made a real delight when it is made into a long series of coloured prints, as of this Horse of Springtime' (see Hillier, *Hokusai: Paintings, Drawings and Woodcuts*, 1955, pp.80–1). Technically, these prints represent the *ne plus ultra* of colour-printing so far as *surimono* are concerned. The dating is exact, since one of the prints in the set depicts a Yoshiwara critique for the first month of the Horse Year Bunsei 5 (1822).

201 STILL-LIFE: A *SURIMONO*

Chūban colour-print; 8×7 in.; 1822

Another print from the same *Uma tsukushi* ('Horse Series') as no.200, with sub-title *Uma yokeri*, depicting a basin, ewer and towel-stand in black lacquer with *kinji* (gold) land-scape decoration, the towel with a blue-and-white landscape pattern, which also decorates the plant-bowl containing *nanken, fukujusō* and dwarf pine.

SIGNED: Fuzenkyō I-itsu hitsu.
FORMER COLLECTION: Stoclet.
ACC.358.

202 MAN BRANDISHING A LONG STAFF

Drawing. Ink on paper; 38×17⅞ in.; *c.* 1825

A man, probably intended for a Lohan, brandishing a long staff and frightening three plovers who fly above.

UNSIGNED. A collector's (?) seal top right has been obliterated by a piece of paper pasted over it. ACC. 390.

The sheet of paper on which this drawing was made consists of a number of pieces joined together. The drawing has the appearance of being a preliminary sketch for a *kakemono*.

CAT. NO. 202

203 GROSBEAK AND *OSHIROI*

Chūban colour-print; 9½×7 in.; late 1820s

A grosbeak, a grey and purple bird with yellow beak (*kikaruga*), is perched on a spray of *oshiroi* (*Mirabilis jalaba*) with flowers of crimson, and yellow spotted with crimson, and deep green leaves. A red flush at top of print. The verse above is 'The flower of the *oshiroi* blooms on the other side of the hedge from the peony' (Waley). From the set of 'Small Flowers'.

SIGNED: Zen Hokusai I-itsu hitsu. CENSOR'S SEAL: *Kiwame*.
PUBLISHER: Eijūdō.
ACC. 43.

If anything, the prints of the 'Small Flowers' (so-called to distinguish them from the *kachō-e* in the *ōban yoko* format) are rarer than the 'Large Flowers'. Yet two and possibly three distinct editions were published: the first by Eijūdō with the seal in red as shown in this and the two following prints and a separate Censor's *Kiwame* seal; the second edition without the Eijūdō seal, but with a seal divided diagonally, one section having the Manji seal, the other the censor's *Kiwame*. Some prints are known without either seal, and presumably constitute a third edition. (See Will H. Edmunds, 'The Identification of Japanese Colour-prints, II' in the *Burlington Magazine* March 1922).

204 BUSH-WARBLER AND ROSES

Chūban colour-print; 9⅝×7 in.; late 1820s

A yellow bird (*uguisu*), a bush-warbler, known as the Japanese nightingale, on a spray of roses, red and red-and-white, with a blue-and-white sky behind. From the set of 'Small Flowers'. The verse is translated by Waley: 'The house on the hill opens when the rose scatters her petals', which is sufficiently ambiguous to permit a dozen interpretations.

SIGNED: Zen Hokusai I-itsu hitsu. CENSOR'S SEAL: *Kiwame*.
PUBLISHER: Eijūdō.
SUBJECT REPRODUCED: Tokyo National Museum Catalogue, vol. 3, no. 3, 849.
ACC. 138.

205 CANARY AND PEONY

Chūban colour-print; 10×7$\frac{7}{16}$ in.; late 1820s

A canary in flight among the blossoms of the *yoshu* or *shakuyaku* (a species of peony). The flowers are of pale red, deepening in colour at the outer edges of the petals, the leaves are grey-green, and the sky is vivid blue. One of the set known as the 'Small Flowers'. The Chinese verse reads: 'This *yoshu* of many leaves is queen of the flowers of the later spring.'

SIGNED: Zen Hokusai I-itsu hitsu. CENSOR'S SEAL: *Kiwame*.
PUBLISHER: Eijūdō.
PRINT PUBLISHED: Harold P. Stern, *Master Prints of Japan*, 1969. no. 139.
SUBJECT REPRODUCED: Seidlitz, English edition, 1910, p. 170 (colour); Narazaki; *Hokusai Ron*, no. 227; *Ukiyo-e Zenshū* vol. 4, pl. 56.
EXHIBITED: University of California, Los Angeles, *Master Prints of Japan*, 1969.
ACC. 42.

CAT. NO. 205

206 POPPIES IN THE WIND

Ōban yoko-e colour-print 9¾×14½ in.; *c.*1830

Poppies blown to the right in a strong wind. They are pink with red markings or white streaked with pink, and the leaves are blue-green shadowed with black. Blue background.

SIGNED: Zen Hokusai I-itsu hitsu. CENSOR'S SEAL: *Kiwame.*
PUBLISHER: Eijūdō.
FORMER COLLECTIONS: Mutiaux; Bess.
SUBJECT ILLUSTRATED: V. & I., Paris, 1913, no. 310, pl. XCI (the Camondo print now in the Musée Guimet); Tokyo National Museum Catalogue, vol. 3, no. 3,815.
ACC. 373.

The set of 'Large Flowers' (so-called to distinguish it from the *chūban* set of ten prints known as the 'Small Flowers') contains what are generally conceded to be Hokusai's finest *kachō-e*, but, unaccountably, individual prints are rare, and only three or four complete sets are known. Indeed, it has even been a matter of conjecture as to how many prints were in the set. The prints themselves bear no indication; they are, in fact, without title or inscription; but on the analogy of the 'Small Flowers', whose number has been established as ten, and also on the probability of that canonical number, from Goncourt onwards it was accepted that there were ten 'Large Flowers'. Vignier gave the total as ten in his catalogue of the Paris Exhibition of 1913, and eight were exhibited from the Camando set then in the Louvre (now in the Guimet) (the 'Chrysanthemums and Bee' and the 'Kikyō and Dragon-fly' were lacking). In their *Japanese Colour Prints* of 1923, Binyon and Sexton first proposed that there were at least eleven in the set, but in listing the ten prints in the Louvre, they included a print of 'Narcissus' which does not belong to the set; and in adding the 'Kikyō and Dragon-fly' (wanting in the Camando set) they did in fact simply complete the ten.

There seems, then, no doubt that the ten catalogued here constitute the complete set, and such is their rarity that this is believed to be the first time that a complete set has been illustrated. The Tokyo National Museum *Catalogue of Ukiyo-e Prints*, vol. 3, illustrates ten prints, but the last (no. 3,818, 'Poppies and Butterfly') clearly does not belong to the set, and is probably not by Hokusai at all, but by Kunitora. (Apart from the stylistic difference, it is unsigned, and lacks Eijūdō's seal, which appears on each of the accepted ten of Hokusai's set.)

Prints from a set by Taitō II with a forged Zen Hokusai I-itsu signature are sometimes mistaken for the true Hokusai 'Large Flowers' (e.g. *Sammlung Theodor Schweiwe Japanische Holzschnitte*, 1959, p. 105). This is a set of twelve prints, *Ōban yoko-e*, the subjects drawn from Taito's *Kachō Gaden*, Osaka, 1848–49, the birds and flowers being reversed or transposed, and the flowers generally enlarged. Four are illustrated in the Sotheby Sale Catalogue, Hilditch Collection, 1916, pl. XIII. The weakness of the compositions as well as less attractive colour, immediately distinguish them from the prints in the Hokusai set.

Complete sets of the 'Large Flowers' are known to exist in the Museum of Fine Arts, Boston, and in the Musée Guimet, Paris, but it is in attempting to locate illustration of subjects in other collections that the rarity of these prints becomes apparent: the same prints, especially those in Japan, are reproduced time and time again, and it has not been thought necessary to give more than one source for a print that has been illustrated a number of times. Most of the major collections, East or West, are apparently without a single print from the set.

CAT. NO. 206

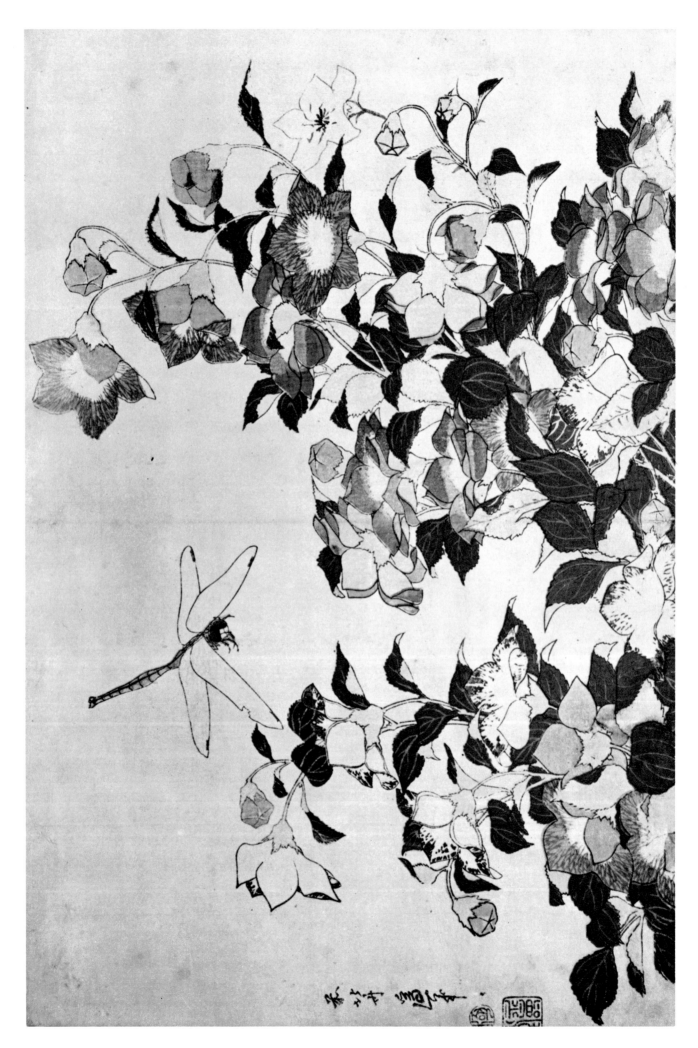

CAT. NO. 207

207 *KIKYŌ* AND DRAGON-FLY

Ōban yoko-e colour-print; 9¾×14¼ in.; *c.* 1830

Kikyō flowers, the Chinese bell flower (*Platycodon grandiflorum*), white at the centre and purple or blue at the outer edge of the petals, blowing in the wind, and a red-bodied dragon-fly planing down towards them. The leaves are dark-green above, pale below. Yellow ground.

SIGNED: Zen Hokusai I-itsu hitsu. CENSOR'S SEAL: *Kiwame*.
PUBLISHER: Eijūdō.
FORMER COLLECTIONS: Mutiaux; Bess.
SUBJECT REPRODUCED: Hillier, *Hokusai*, pl. 73 (B.M. impression); *Ukiyo-e Hanga Zenshū* (Kawaura Catalogue), 1918, no. 411; Tokyo National Museum Catalogue, vol. 3, no. 3,814.
ACC. 371.

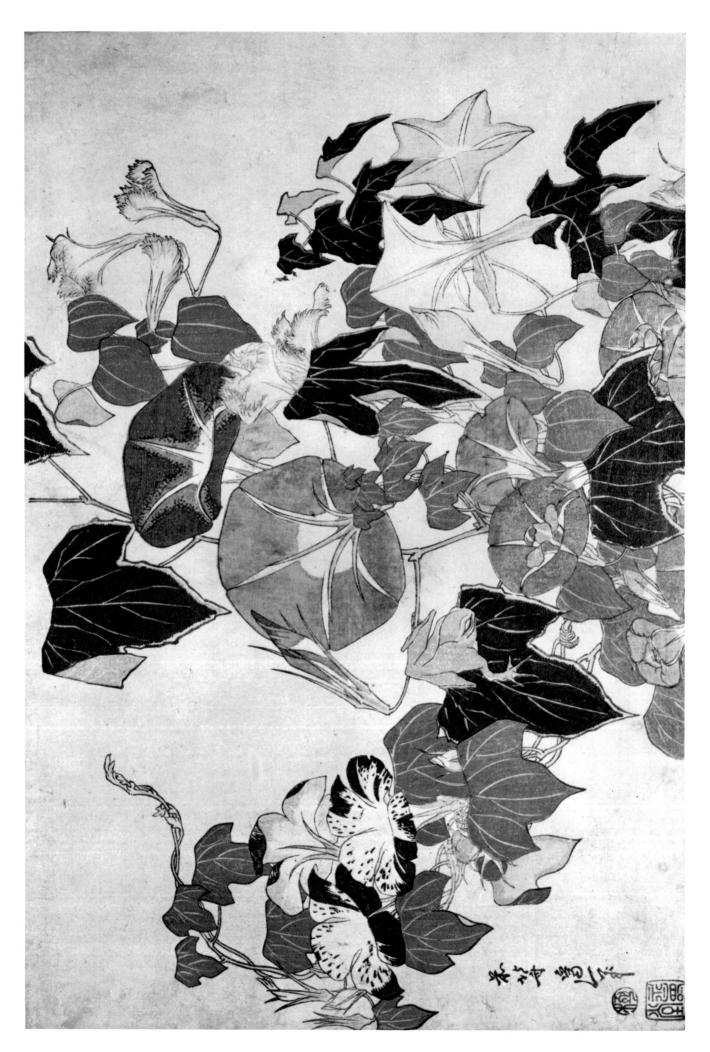

CAT. NO. 208

208 ## CONVOLVULUS AND TREE-FROG

Ōban yoko-e colour-print; 9¾×14¾ in.; *c.* 1830

Leaves and variegated purple or blue trumpet-flowers of a climbing convolvulus, with a green tree-frog perched upon one of the leaves. The larger leaves are dark green, the smaller lighter in hue. Yellow ground.

SIGNED: Zen Hokusai I-itsu hitsu. CENSOR'S SEAL: *Kiwame.*
PUBLISHER: Eijūdō.
FORMER COLLECTIONS Mutiaux; Bess.
SUBJECT REPRODUCED: V. & I., Paris, 1913, no. 304, pl. LXXXIX; Binyon and Sexton, pl. XV (colour); Tokyo National Museum Catalogue, vol. 3, no. 3,810.
ACC. 379.

209 ORANGE ORCHIDS

Ōban yoko-e colour-print; 9¾ × 14¼ in.; *c.* 1830

Two stems of an orchidaceous flower springing from dark-green leaves. The colour of the flowers is orange, to which oxidization has added a bronzing effect. Blue ground.

SIGNED: Zen Hokusai I-itsu hitsu. CENSOR'S SEAL: *Kiwame.*
PUBLISHER: Eijūdō.
FORMER COLLECTIONS: Mutiaux; Bess.
SUBJECT REPRODUCED: V. & I., Paris, 1913, no. 307, pl. XC; Tokyo National Museum Catalogue, vol. 3, no. 3,811.
ACC. 376.

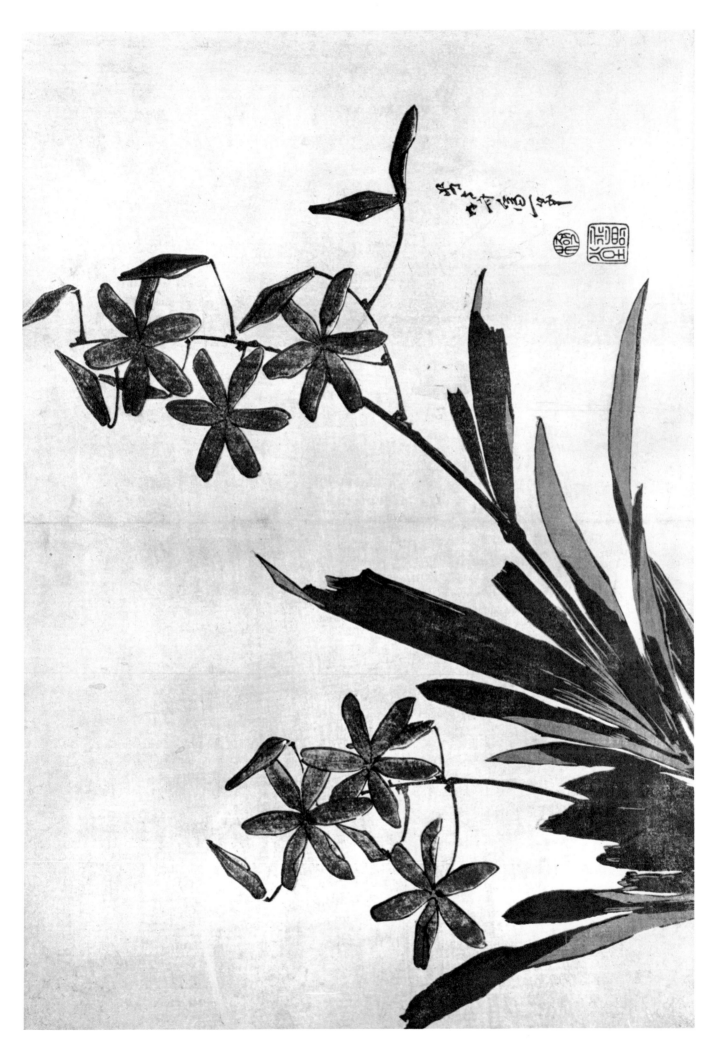

CAT. NO. 209

210 CHRYSANTHEMUMS AND BEE

Ōban yoko-e colour-print; 14½×9¾ in.; *c.* 1830

Chrysanthemums of a variety of species and colour and a bee flying down to them. Light-blue ground.

SIGNED: Zen Hokusai I-itsu hitsu. CENSOR'S SEAL: *Kiwame.*
PUBLISHER: Eijūdō.
FORMER COLLECTIONS: Mutiaux; Bess.
SUBJECT REPRODUCED: Hillier, *Hokusai*, pl. XI (colour, B.M. impression); Duffy, *Japanese Colour Prints*, no. 75
 (V. & A. impression); Tokyo National Museum Catalogue, vol. 3, no. 3,812.
ACC. 372.

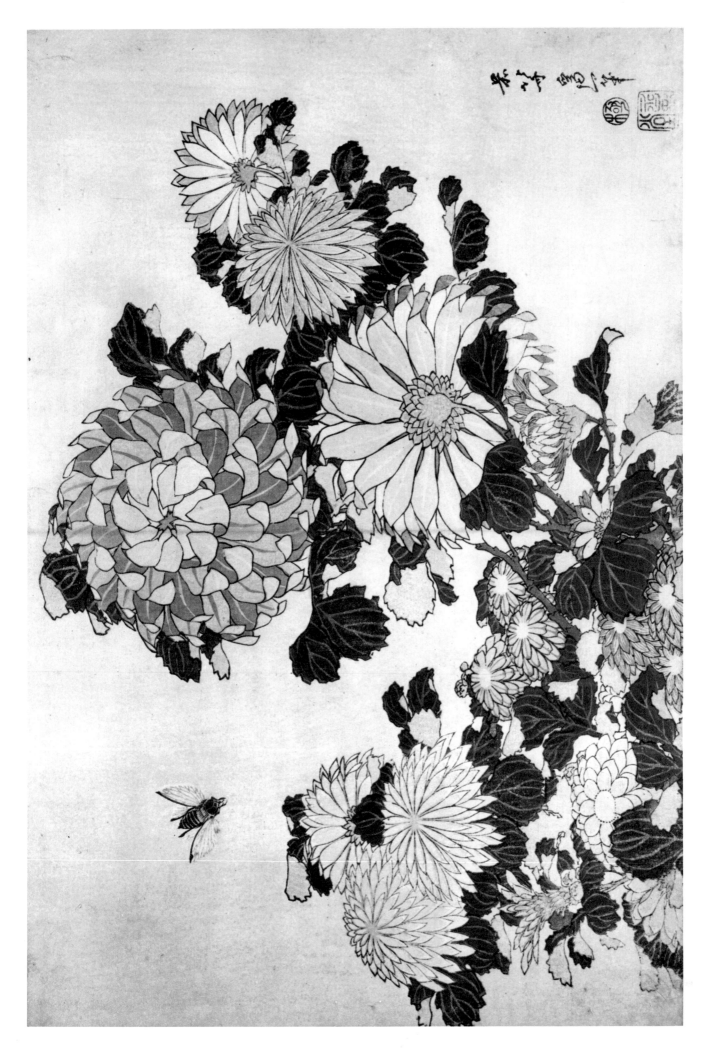

CAT. NO. 210

211 TREE PEONIES AND BUTTERFLY

Ōban yoko-e colour-print; 10×14⅝ in.; *c.* 1830

Flowers of the tree peony, white, pink-freaked, and red and pink, blown to the left in a strong wind, and a purple and white butterfly feeling the force of the gust as it struggles above the flowers. The leaves are light green above, dark below. Yellow ground.

SIGNED: Zen Hokusai I-itsu hitsu. CENSOR'S SEAL: *Kiwame*.
PUBLISHER: Eijūdō.
FORMER COLLECTIONS: Mutiaux; Bess.
SUBJECT REPRODUCED: V. & I., Paris, 1913, no. 303, pl. LXXXVII; Tokyo National Museum Catalogue, vol. 3, no. 3,813.
ACC. 380.

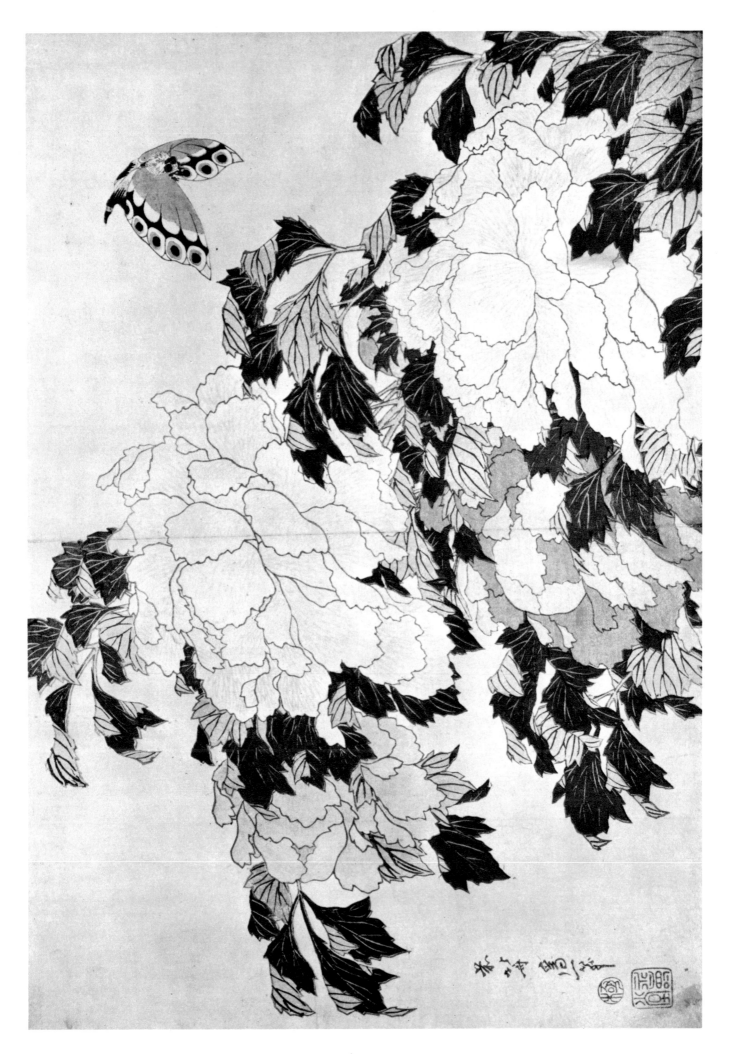

CAT. NO. 211

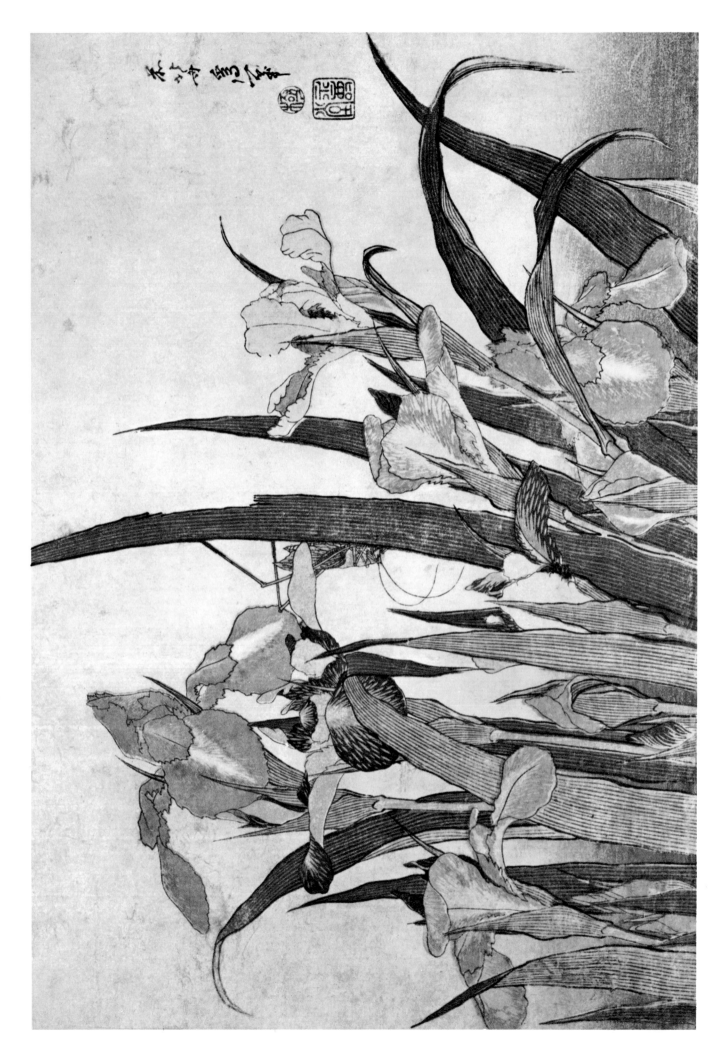

CAT. NO. 212

212 IRIS FLOWERS AND GRASSHOPPER

Ōban yoko-e colour-print; 9¾×14¼ in.; *c.*1830

A clump of purple and blue iris flowers with leaves of variegated green, a grasshopper, green with brown markings, making its way head-first down one of the leaves. The background is blue at the base of the print, fading out at the level of the lowest leaf-tips.

SIGNED; Zen Hokusai I-itsu hitsu.

PUBLISHED: Eijūdō.

FORMER COLLECTIONS: Mutiaux; Bess.

SUBJECT REPRODUCED: V. & I., Paris, 1913, no. 306, pl. LXXXIX; Narazaki. *Hokusai Ron*, no. 221 (formerly Saitō, now Hiraki Collection); Tokyo National Museum Catalogue, vol. 3, no. 3,817; H. Brasch, *Farbholzschnitte aus Japan* (Catalogue of the Rietberg Museum Collection, Zürich), no. 106.

ACC. 377

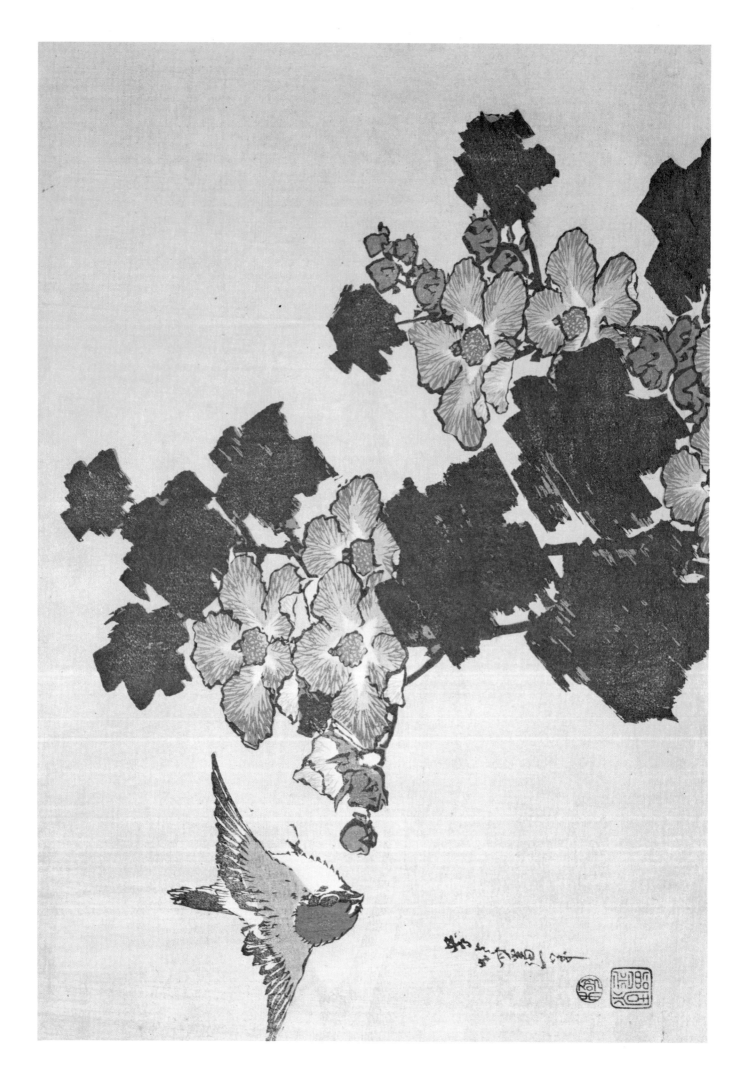

CAT. NO. 213

213 ## HIBISCUS AND SPARROW

Ōban yoko-e colour-print; $9\frac{7}{8} \times 14\frac{3}{8}$ in.; *c.* 1830

A sparrow flying down to a hibiscus in flower. Blue background.

SIGNED: Zen Hokusai I-itsu hitsu. CENSOR'S SEAL: *Kiwame*.
PUBLISHER: Eijūdō.
FORMER COLLECTIONS: Mutiaux; Bess.
SUBJECT REPRODUCED: V. & I., Paris, 1913, no. 309, pl. XCI; Narazaki, *Hokusai Ron*, 1943, no. 222 (then Saitō, now Hiraki Collection); Tokyo National Museum Catalogue, vol. 3, no. 3, 809.
ACC. 374.

214 LILIES

Ōban yoko-e colour-print; 9¾×14³⁄₁₆ in.; *c.*1830

Tiger lilies, the orange and pink flowers and dark-green leaves and stems, against a blue background.

SIGNED: Zen Hokusai I-itsu hitsu. CENSOR'S SEAL: *Kiwame*.
PUBLISHER: Eijūdō.
FORMER COLLECTIONS: Mutiaux; Bess.
SUBJECT REPRODUCED: V. & I., Paris, 1913, no. 305, pl. LXXXVIII (colour); Hillier, *Hokusai*, no. 74 (B.M. impression); Tokyo National Museum Catalogue, no. 3,816.
ACC. 378.

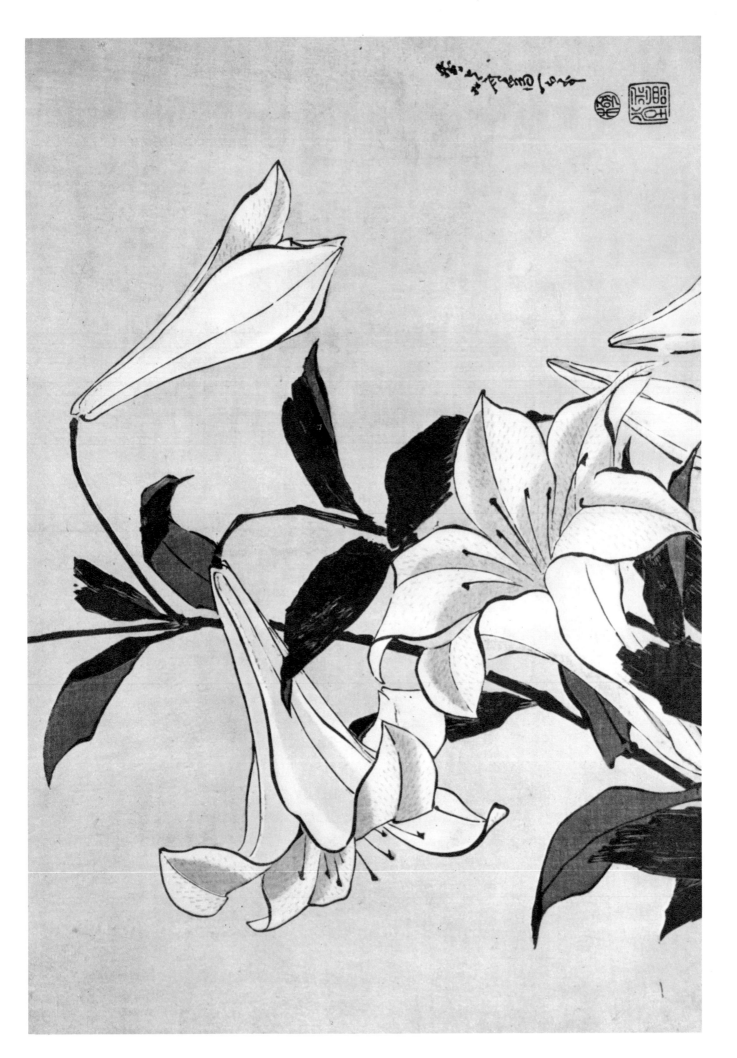

CAT. NO. 214

CAT. NO. 215

215 HYDRANGEA AND SWALLOW

Ōban yoko-e colour-print; $9\frac{7}{8} \times 14\frac{1}{4}$ in.; *c.*1830

Hydrangea blooms, tinged with pink and blue, the leaves in two shades of dark green. A swallow, black with pink gorge, hurtles down at right. Yellow ground.

SIGNED: Zen Hokusai I-itsu hitsu.

PUBLISHER: Eijūdō.

FORMER COLLECTIONS: Mutiaux; Bess.

SUBJECT REPRODUCED: V. & I., Paris, 1913, no. 308, pl. XC; Narazaki, *Hokusai Ron*, fig. 224 (re-photographed from Vignier and Inada: there seems to be no record of an impression of this print in any of the published Japanese collections).

ACC. 375.

CAT. NOS. 216, 217

216 BLOSSOM AT YOSHINO

Ōban yoko-e colour-print; 10$\frac{3}{16}$×16$\frac{15}{16}$ in.; *c.*1825–30

On a hill road, above a valley filled with clouds of pink cherry-blossom, travellers and porters are passing, one leading a horse. The green of the trees and the pink of the blossom dominate the colours, but there are bright details of blue, brown and yellow in the foreground group and in the roof-tops of the temple seen beyond the flowering trees. The title-cartouche reads *Setsugekka* ('Snow, Moon and Flowers') and in the blank circle alongside the cartouche is the name Yoshino, a place famed for its cherry trees.

SIGNED: Zen Hokusai I-itsu hitsu.
PUBLISHER: Eijūdō (the publisher's mark is on the baggage of one of the porters).
SUBJECT REPRODUCED: Sotheby Sale Catalogue, Barclay Collection, March 1916, no.296; pl.xx; *Ukiyo-e Zenshū*, vol.6, fig.44.
ACC.97.

The *Setsugekka*, the trilogy of 'Snow, Moon and Flowers', was a traditional concept that provided the subject for triptychs of paintings by classical masters as well as sets of prints by Ukiyo-e designers. The other two prints in Hokusai's set, also illustrated in the Barclay Catalogue and *Ukiyo-e Zenshū*, are 'Snow on the Sumida River', and 'Moonlight over the Yodo River'.

217 THE BRIDGE OF BOATS AT SANO

Ōban yoko-e colour-print; 10$\frac{1}{4}$×15$\frac{1}{2}$ in.; *c.*1827–30

Funabashi ('The Bridge of Boats') at Sano in the Province of Kozuke in snow, the strong tide of the River Tone forcing the boats, held together by cables, into a curve. Four travellers are crossing the bridge. The strong blue of the river, the green of the foliage, the yellow and brown on bridge, cottage and horse, and on the distant range of hills, are all enhanced, as colours invariably are, by the snow, and thrown into relief against a grey sky that deepens to black at the zenith. One of the eleven prints in the set entitled *Shokoku Meikyō Kiran* ('Novel Views of Famous Bridges in Various Provinces').

SIGNED: Zen Hokusai I-itsu hitsu. CENSOR'S SEAL: *Kiwame*.
PUBLISHER: Eijūdō.
EXHIBITED: M.I.A., 1961, no.126.
SUBJECT REPRODUCED: Hillier, *Hokusai*, pl.x (colour); Ledoux, 1951, no.6; *Landscape Prints of Old Japan* (Grabhorn Collection), no.19 (colour); Narazaki, *Hokusai Ron*, no.187.
ACC.99.

Sano in snow, as Ledoux pointed out, was a favourite subject for Japanese artists because of a famous thirteenth-century poem about a snowstorm at a ferry there. 'The Bridge of Boats' is also esteemed as the finest of Hokusai's set of 'Bridges'.

218 THE DRUM BRIDGE, TENJIN SHRINE, KAMEIDŌ

Ōban yoko-e colour-print; 10×15 in.; *c.*1827–30

The Taiko Bashi ('The Drum Bridge'), between two areas of the temple precincts at Tenjin Shrine, Kameidō. Visitors are mounting the steep sides of the almost semi-circular wooden bridge, and other pilgrims are in the vicinity. At right is a wistaria pergola. The blue of the sky is inverted in the blue of the water, the frame of the bridge is yellow, its treads brown-pink. More emphatic colour detail is in the roof-tops in the foreground and the rocky area at the left of the bridge, whilst the roof-toops in the distance are cut off by a band of pink mist. From the same set of 'Bridges' as no.217.

SIGNED: Zen Hokusai I-itsu hitsu. CENSOR'S SEAL: *Kiwame.*
PUBLISHER: Eijūdō.
EXHIBITED: M.I.A., 1961, no.125, pl.19.
SUBJECT REPRODUCED: *U.T.S.*, no.15 pl.19 (colour); Priest, *Japanese Prints from the Henry L. Phillips Collection*, no.XXXI.
ACC.80.

219 THE HANGING BRIDGE ON THE BOUNDARIES OF HIDA AND ETCHŪ PROVINCES

Ōban yoko-e colour-print; 9¼×14⅞ in.; *c.*1827–30

A man and a woman, each with a heavy load, are making what seems to be a desperately hazardous crossing of a bridge of bamboo and cord which stretches across a chasm full of pine-trees, whose tops only are visible above bands of pink mist. Pinnacles of rock of subtle, gradated yellows, fawns, greens and blues stand up at the left, and beyond is a peak of intensely deep blue against the lighter blue of the sky. From the same set of 'Bridges' as no.218.

SIGNED: Zen Hokusai I-itsu hitsu. CENSOR'S SEAL: *Kiwame.*
PUBLISHER: Eijūdō.
EXHIBITED: M.I.A., 1961, no.124.
SUBJECT REPRODUCED: *Ukiyo-e Zenshū*, vol.6, no.29; *Landscape Prints of Old Japan* (Grabhorn Collection), no.17 (colour).
ACC.73.

CAT. NOS. 218, 219

220 TEMMA BRIDGE, OSAKA:
THE FESTIVAL OF LANTERNS

Ōban yoko-e colour-print; 10×14¾ in.; *c.*1827–30

On the evening of the Festival of Lanterns, the great wooden span of the bridge is thronged with people beneath the red lanterns set along the length of the parapet, the lighted windows of the town are seen through the piers, and boats bedecked with lanterns are plying in the river. The brown timbers of the bridge are picked out against the deep blue of the water and the dark greens and browns of the crowd stationed on the bridge. The sky is a warm grey. From the same set of 'Bridges' as no. 219.

SIGNED: Zen Hokusai I-itsu hitsu.
SUBJECT REPRODUCED: Hillier, *Hokusai*, pl. 63 (the B.M. impression).
ACC. 96.

The publisher's and censor's seals, present on the B.M. and other impressions, are lacking on this print.

221 THE BRIDGE OF THE REFLECTED MOON,
ARASHIYAMA, YAMASHIRO

Ōban yoko-e colour-print; 10$\frac{1}{16}$×15¼ in.; *c.*1827–30

A segment of the crescent-arched wooden bridge across a broad river, left, and on the further shore the long line of mingled pines and cherry trees, with the double mound of Arashiyama beyond, barred with rosy bands of cloud. The yellow shore, with its bank of green pines and pink cherries, is set off against the deep blue of the river, which becomes lighter towards the near shore. From the same set of 'Bridges' as no. 220.

SIGNED: Zen Hokusai I-itsu hitsu.
SUBJECT REPRODUCED: Narazaki, *Hokusai Ron*, no. 188.
ACC. 45.

This print, like the last, lacks the publisher's and censor's seals.

438

CAT. NOS. 220, 221

222 THE BRIDGE OF THE BROCADE SASH

Ōban yoko-e colour-print; 10⅛ × 15 in.; *c.* 1827–30

A bridge of five wooden arches, the timbers yellow and brown, the three central arches supported on four grey-stone piers this, the Kintai-kyō, was 'famed throughout the length and breadth of Japan'. Here it is seen through the driving rain, and the horizon is practically spanned by a broad-based mountain peak, green at the base and luminous brown-pink above, rising through conventional pink clouds. The water is an even pale blue, the sky gradated from deep blue above to a paler colour at the horizon. From the same set of 'Bridges' as no. 221.

SIGNED: Zen Hokusai I-itsu hitsu.
PUBLISHER: Eijūdō.
SUBJECT REPRODUCED: Hillier, *Hokusai*, pl. 67; *Landscape Prints of Old Japan* (Grabhorn Collection), pl. 18; *Ukiyo-e Zenshū*, vol. 6, fig. 38.
ACC. 141.

223 FUJI FROM SHIMO MEGURO

Ōban yoko-e colour-print; 10 × 14¾ in.; late 1820s

Shimo Meguro, a small village in what was, in Hokusai's day, a suburban farming district to the south of Edo, from whence the horn of Fuji is just visible in a dip in the hills terraced for cultivation. The sunny yellow and bright greens of the slopes contrast with the dull pink of the thatched roof-tops. Blue outline. Cartouche title, *Fugaku Sanjū-rokkei*; sub-title, *ShimoMeguro*.

SIGNED: Zen Hokusai I-itsu hitsu. SEAL: Gonse (on the back). CENSOR'S SEAL: *Kiwame*.
PUBLISHER: Eijūdō.
EXHIBITED: Huguette Berès Hokusai Exhibition, July 1958, no. 93.
FORMER COLLECTION: Gonse (no. 104 in First Sale Catalogue, 1924).
SUBJECT REPRODUCED: Goncourt, no. 35; V. & I., Paris, 1913, no. 273, pl. LXXXII; Hillier, *Hokusai*, 1955, pl. VII (colour).
ACC. 204.

The 'Thirty-six Views of Fuji' contain some of the supreme masterpieces of Hokusai in the colour-print medium, and they are among the most universally admired prints, not merely of Japan, but of the world. Such prints as 'The Wave', 'Fuji in Clear Weather' and 'Fuji above Lightning' alone justify Hokusai's place, first in Western eyes and now in Japanese as well, as one of the great artists of the world.

 Although no doubt initially it was intended to keep the number in the set down to thirty-six – there were precedents for this canonical number of views of Fuji, based, without doubt and quite illogically, on the Thirty-six Poets, – the set proved popular, and ten more prints were issued, making a total of forty-six

CAT. NOS. 222, 223

CAT. NOS. 224, 225

all told, before the series was abandoned. One print in the set, the 'Lumberyard at Tatekawa', has an inscription on some of the planks of wood which has been taken to refer to a 'second edition' of the set.

There are variations in the blocks and colouring in a number of instances, and a black outline is thought to identify the later ten prints, but the matter is a complex one, not so far dealt with definitively, though Ledoux, 1951, under his no. 11, gives a useful précis of his own views. In view of the importance of the outline colour in any consideration of issues or edition, the colour has been given in this catalogue in each entry.

In the majority of cases, these prints have been illustrated many times, and it has been thought sufficient simply to give two or three references to illustration elsewhere, quoting in each instance the Goncourt reference, and the illustration in the V. & I., Paris, 1913, which reproduces all forty-six subjects.

224 FUJI FROM FUJIMIHARA, OWARI PROVINCE

Ōban yoko-e colour-print; 10×15 in.; late 1820s

In the foreground a huge tub, and inside it a cooper caulking the seams. Fuji, a minute triangle of white in a pink sky, is seen within the circle of the tub, across a wide plain of rice-fields. Foreground, and to left, is yellow; otherwise, apart from the flesh-tones and the pink of the mist, the colours are tones of green, blue and grey. Blue outline. Title, *Fugaku Sanjū-rokkei*; sub-title, *Bishū Fujimihara*.

SIGNED: Hokusai aratame I-itsu hitsu.
SUBJECT REPRODUCED: Goncourt, no. 4; V. & I., Paris, 1913, no. 240, pl. LXXIV.
ACC. 349.

Geography does not seem to have been one of Hokusai's strongest subjects. It has been pointed out that Owari Province, some 150 or more miles away from Fuji, did not give views of Fuji, even across Fujimihara the 'plain with a view of Fuji'. But probably the whole thing was a joke; any title might have been given to this picture which has no topographical features by which it could be recognized, and Hokusai was no doubt just 'drawing the long bow', as he did on other occasions.

225 THE BACK OF FUJI FROM THE MINOBU RIVER

Ōban yoko-e colour-print; 9¾×14½ in.; late 1820s

On the near bank of a surging river, the waves marked by two shades of blue, travellers with two led horses approach a *kago* carried by two porters who are going in the opposite direction along the pink-coloured highway. Across the river, rising above a thick wall of mist, is a serrated row of varicoloured peaks, and beyond them the snow-capped cone of Fuji, brown and pink on its flanks. Black outline. Series title, *Fugaku Sanjū-rokkei;* sub-title, *Minobu-gawa Ura-Fuji*.

SIGNED: Zen Hokusai I-itsu hitsu.
SUBJECT: Goncourt, no. 7; V. & I., Paris, 1913, no. 243, pl. LXXV.
ACC. 44.

226 FUJI FROM THE WATER-WHEEL AT ONDEN

Ōban yoko-e colour-print; 10×14½ in.; late 1820s

Fuji seen beyond the great water-wheel of an undershot mill, in the foreground a woman washing vegetables in a basket, another carrying a tub, and a child nearby has a tortoise tied by a string to put into the mill race. Men are carrying rice in bags towards the mill. The woodwork and roof of the building are yellow, the water two shades of blue; the rest is in shades of green, blue and grey, with Fuji marked with blue over the yellow mist band. Blue outline. Title, *Fugaku Sanjū-rokkei*; sub-title, *Onden no Suisha*.

SIGNATURE: Zen Hokusai I-itsu hitsu. CENSOR'S SEAL: *Kiwame*.
PUBLISHER: Eijūdō.
SUBJECT REPRODUCED: Goncourt, no. 15; V. & I., Paris, 1913, no. 253, pl. LXXVII.
ACC. 351.

Onden was on the Shibuya River, between Harajuku and Aoyama, and several water wheels are marked on old maps of the district.

CAT. NO. 226

227 FUJI ABOVE THE LIGHTNING

Ōban yoko-e colour-print; 10×14⅝ in.; late 1820s

A more literal translation of the sub-title of this print is 'A Sudden Shower Below the Summit'. The maroon cone of the mountain, freaked with snow at the peak, rises clear into the blue sky above the clouds, a storm raging on the lower slopes and lightning forking across the darkness. Blue outline. Title, *Fugaku Sanjū-rokkei*; sub-title, *Sanka Haku-u*.

SIGNED: Hokusai aratame I-itsu hitsu.
PRINT PUBLISHED: Ledoux, 1951, no. 11.
EXHIBITED: M.I.A., 1961, no. 122.
FORMER COLLECTION: Ledoux.
SUBJECT REPRODUCED: Goncourt no. 8; V. & I., Paris, 1913, no. 244, pl. LXXVI; *U.T.S.*, vol. 15 pl. 7; Hillier, *Hokusai*, fig. 61.
ACC. 205.

This is one of the three prints usually considered to be the outstanding triumphs of the 'Thirty-six Views', the other two being the 'Fuji in Clear Weather' (the 'Red Fuji') and 'The Wave'. There are variants of the 'lightning' subject, some the result of changes in the blocks, others that look to arise from deliberate variations in the printing. In one such printing variant, perhaps of posthumous date, the lightning appears to light up the lower half of the print and trees are visible in the foreground.

CAT. NO. 227

228 FUJI ON THE SURFACE OF THE WATER AT MISAKA

Ōban yoko-e colour-print; 10¼×15⅛ in.; late 1820s

Fuji, light brown on its lower slopes, rising behind a village of yellow thatched roofs among woodlands of deep green beyond the still waters of a lake, its image reflected on the surface in indescribable tones of purplish grey and two shades of blue. A solitary boat is being poled by a waterman at right. Blue outline. Title, *Fugaku Sanjū-rokkei*; sub-title *Kōshū, Misaka Suimen.*

SIGNED: Zen Hokusai I-itsu hitsu.
SUBJECT REPRODUCED: Goncourt, no. 17; V. & I., Paris, 1913, no. 255, pl. LXXVIII; *Ukiyo-e Zenshū*, vol. 6, fig. 20.
ACC. 156.

This reflected view of Fuji–a famous one in Japan, Fuji being seen almost in its entirety across Lake Kawa-guchi, directly to the north and mirrored 'upside down' in the water–defies other laws than those of optics: the reflection is of the usual view of the mountain *from Edo*, and the reflected peak has a covering of snow, missing from the actual peak as it is depicted.

229 FUJI FROM MISHIMA PASS IN KAI PROVINCE

Ōban yoko-e colour-print; 10×15 in.; late 1820s

Fuji, wreathed with a curling cloud at its blue summit and with other clouds along its flanks, is seen across foreground hills of light green, where a huge tree, which three men are trying to measure with extended arms, is growing. The tree is printed in blue-green; the lower slopes of Fuji are charcoal black. Blue outline. Cartouche title, *Fugaku Sanjū-rokkei*; sub-title *Kōshū Mishima-goe* ('The Pass of Mishima, Kōshū').

SIGNED: Zen Hokusai I-itsu hitsu.
PUBLISHER: Eijūdō.
PUBLISHED: M.I.A. Exhibition Catalogue, no. 117, fig. 20.
EXHIBITED: M.I.A., 1924–5; M.I.A., 1961, no. 117.
SUBJECT REPRODUCED: Goncourt, no. 18; V. & I., Paris, 1913, no. 256, pl. LXXVIII; Ledoux, 1951, no. 17.
ACC. 14.

The location of Hokusai's viewpoint is discussed in Kondō's *The Thirty-six Views of Mount Fuji by Hokusai*, 1966, no. 29. There it is stated that there is no place in the vicinity of Mount Fuji known as Mishima Pass, and therefore the location is uncertain. The suggestion is made that it may be Kagosaka Pass, but probably the conclusion that the view 'is fictitious or at least composite' is nearer the truth.

CAT. NOS. 228, 229

CAT. NO. 230

230 THE HOLLOW OF THE DEEP SEA
WAVE OFF KANAGAWA

Ōban yoko-e colour-print; 10¼×15 in.; late 1820s

A seascape, with Fuji seen, momentarily, as it were, in the trough of a great wave that
has reared in a mountainous arc, blue within and white above, and threatens to break,
with claws of foam and scattered spray, upon three boats riding in the hollows. The only
colour, apart from the varied blue of the waves, is the pink in the sky, the pinkish yellow
of the boats and the suffused dark grey at the horizon. Blue outline. Title, *Fugaku Sanjū-
rokkei*; sub-title, *Kanagawa oki nami-ura*.

EXHIBITED: M.I.A., 1961, no. 120.
SUBJECT REPRODUCED: Goncourt, no. 20; V. & I., Paris, 1913, no. 258, pl. LXXIII; Ledoux, 1951, no. 21; *U.T.S.*
 vol. 15, no. 1; Hillier, *Hokusai*, no. 65; Narazaki/Mitchell, *The Japanese Print* pl. 81, etc.
ACC. 92.

There is no need to add yet one more panegyric to the countless that have already appeared on this great
print. Suffice to say that it is one of Hokusai's noblest conceptions, and one of the most powerful of all prints
in the wood-block medium.

 The pink of the sky is very fugitive and often fades almost to extinction; and the sharpness of the im-
pression can be judged by the strength of the lines around the cartouche, which were among the first to show
signs of wear. In these and other respects, the impression in this collection is exemplary.

231 FUJI FROM ENOSHIMA

Ōban yoko-e colour-print; 10×14⅞ in.; late 1820s

Pilgrims and sightseers crossing the sand from the mainland to the small island where, above the village roof-tops, can be seen the pagoda of the Benten Shrine, Fuji being to the extreme right across the Bay. The colours–fawn, green, grey and blue–are light in tone, and the only emphatic note is on the roofs of the houses and the flank of Fuji. The dancing play of light on the shallow water is most effectively conveyed by the skill of the block-cutters and printers. Blue outline. Cartouche title, *Fugaku Sanjū-rokkei*; sub-title, *Sōshū* [Sagami] *Enoshima.*

SIGNED: Zen Hokusai I-itsu hitsu. CENSOR'S SEAL: *Kiwame.*
PUBLISHER: Eijūdō.
SUBJECT REPRODUCED: Goncourt, no.25; V. & I., Paris, 1913, no.263, pl.LXXIX.
ACC.12.

232 FUJI FROM THE SEVEN-LEAGUE BEACH IN SAGAMI PROVINCE

Ōban yoko-e colour-print; 10×14⅝ in.; late 1820s

A well-known pleasure resort, this view of Shichi-ri-ga-hama is taken from an angle that hides the beach. Instead, in a bold, asymmetrical composition, a rocky promontory, leading towards Fuji, white against the blue sky, right, shelters a village of thatched roofs, perhaps Koshigoe, with the island of Enoshima, far left. The colours are limited to blues and greens, except for the faint pink in the sky. Blue outline. Cartouche title, *Fugaku Sanjū-rokkei*; sub-title, *Sōshū Shichi-ri-ga-hama.* ('The Seven-league Beach, Sōshū [Sagami] Province').

SIGNED: Zen Hokusai I-itsu hitsu.
SUBJECT: Goncourt, no.27; V. & I., Paris, 1913, no.265, pl.LXXX; Hillier, *Hokusai*, pl.IX (colour).
ACC.13.

Generally, this print bears the publisher's and the censor's seals, lacking here. Other prints vary in colour, one variant (illustrated in colour in Hillier) is designed entirely in different shades of blue.

CAT. NOS. 231, 232

233 FUJI FROM THE LAKE AT HAKONE

Ōban yoko-e colour-print; 10×15⅛ in.; late 1820s

The deep-blue lake, with tree-fringed green and brown islets, stretches away to a boldly rounded hill, green below and brown at the summit, to the left of which is Fuji, white against the blue sky, its sharply-pointed shape in contrast to the curves of the hill, floating layers of pink mist differentiating the planes of the picture. Blue outline. Cartouche title, *Fuji Sanjū-rokkei*; sub-title, *Sōshū Hakone Kosui* ('Hakone Lake, Sagami').

SIGNED: Zen Hokusai I-itsu hitsu.
SUBJECT REPRODUCED: Goncourt, no. 28; V. & I., Paris, 1913, 266, pl. LXXX.
ACC. 93.

The lake near the Tokaidō at Hakone, Ashi-no-ko, is still a beauty spot, and Hokusai's depiction is more or less faithful to the actual topography. This is one of the four prints in the set without any figures.

234 FUJI FROM UMEZAWA

Ōban yoko-e colour-print; 9⅞×15 in.; late 1820s

Five cranes stand on the bank of the foreground stream, and two others are flying above. The majestic cone of Fuji, dark blue below and fading to white at the summit, is seen above conventional bands of pink-tinged mist. The water is blue, the birds are in the same tints, and the green of the lower slopes completes the list of the limited colours used in this print. Blue outline. Cartouche title, *Fugaku Sanjū-rokkei*; sub-title, *Sōshū* [Sagami] *Umezawa hidari*.

SIGNED: Zen Hokusai I-itsu hitsu.
PRINT DESCRIBED: Lloyd Wright Sale Catalogue, New York, 1927, no. 161.
FORMER COLLECTION: Lloyd Wright.
SUBJECT REPRODUCED: Goncourt, no. 29; V. & I., Paris, 1913, no. 267, pl. LXXX; Hillier, *Hokusai*, fig. 60.
ACC. 69.

Ichitarō Kondō, in his *Thirty-six Views of Fuji by Hokusai*, gives a possible explanation of the word *hidari* in the subtitle, meaning 'to the left of': 'The written character translated here as "to the left of" is probably a printer's error for another meaning of "fief" or "estate", and the "Estate of Umezama" is, again probably, a district of the name in the town of Ninomiya, about five miles down the coast from Tokyo'.

CAT. NOS. 233, 234

CAT. NOS. 235, 236

235 FUJI FROM THE MANNEN BRIDGE

Ōban yoko-e colour-print; 10$\frac{3}{16}$×15 in.; late 1820s

Distant Fuji seen between the tall pinkish-brown piers of the Mannen Bridge, which spans the blue river in an arc like the segment of a circle. People are on the bridge, a laden boat is on the water, and a man is fishing from a rock in the river. The sky, blue above, is pink-barred below. Blue outline. Cartouche title, *Fugaku Sanjū-rokkei*; sub-title, *Fukugawa Mannen-bashi shita*.

SIGNED: Hokusai aratame I-itsu hitsu.
EXHIBITED: M.I.A., 1961, no. 119.
SUBJECT REPRODUCED: Goncourt, no. 31; V. & I., Paris, 1913, no. 269, pl. LXXXI.
ACC. 79.

236 FUJI FROM THE TAMAGAWA, MUSASHI

Ōban yoko-e colour-print; 10×14$\frac{5}{8}$ in.; late 1802s

A morning scene, a roseate band of mist separating Fuji, blue below, white above, from the river, which, white at the near shore, passes through gradated shades of blue to deep indigo at the far bank, waves being indicated by blue lines and by gauffrage. On the near bank, beyond a tree strikingly blue in colour, a lone figure leading a horse pauses for a moment on the dark sandy bank. Blue outline. Title, *Fugaku Sanjū-rokkei*; sub-title, *Bushū Tamagawa*.

SIGNED: Hokusai I-itsu hitsu.
SUBJECT REPRODUCED: Goncourt, no. 39; V. & I., Paris, 1913, no. 277, pl. LXXIII; Perzynski *Hokusai*, p. 15; *U.T.S.*, vol. 15, pl. 5.
ACC. 350.

CAT. NO. 237

237 FUJI FROM HODOGAYA ON THE TOKAIDŌ

Ōban yoko-e colour-print; 10⅛×15⅞ in.; late 1820s

Travellers on the Tokaidō, Fuji seen through the pines lining the edge of the road. The travellers are typical of people most often seen in pictures of this famous road: there is the travelling priest, with bamboo pipe for soliciting alms, the horse-rider with groom at the head, and a lady in a palanquin (*kago*), which two coolies have set down for a moment to enable them to snatch a rest. Blue outline. Title, *Fugaku-Sanjū-rokkei*; sub-title, *Tokaidō Hodogaya*.

SIGNED: Zen Hokusai I-itsu hitsu.
PRINT PUBLISHED: Blanchard Sale Catalogue, New York, 1916, no. 191; Ledoux, 1951, no. 12.
FORMER COLLECTIONS: Blanchard; Ledoux.
SUBJECT REPRODUCED: Goncourt, no. 21; V. & I., Paris, 1913, no. 259; pl. LXXVIII; Hillier, *Hokusai*, fig. 56; Michener/Lane, *Japanese Prints*, no. 190 (also claimed on p. 274 to be the Blanchard 191, but presumably by mistake: the Michener illustration, at any rate, indicates a rather more trimmed print than that published in the Blanchard Catalogue).
ACC. 136.

Hodogaya has been swallowed up in modern Yokohama, and the tree-lined Tokaidō has in great part disappeared, though, until recently at least, a section was preserved, with its pine trees, at Totsuka.

CAT. NOS. 238, 239

238 THE WATERFALL OF ONO ON THE KISOKAIDŌ

Ōban colour-print; 15×10 in.; *c.*1830

The Ono Waterfall plunging in sheer, perpendicular lines of varied blue at the left from a cliff down to a stream, five travellers on a bridge over the stream admiring the spectacle. On a maroon and fawn crag below the fall is a small green-roofed shrine. At right a beetling cliff, similarly maroon and fawn, towers above the vapour which takes the form of a cloud against the grey-violet of the sky. One of the set entitled *Shokoku Takimeguri* ('Going the Round of the Waterfalls of the Various Provinces').

SIGNED: Zen Hokusai I-itsu hitsu. CENSOR'S SEAL: *Kiwame*.
PUBLISHER: Eijūdō.
EXHIBITED: M.I.A., 1961, no. 123.
SUBJECT REPRODUCED: Narazaki *Hokusai Ron*, 1943, no. 196; Priest, *Japanese Prints from the Henry L. Phillips Collection*, no. XXV.
ACC. 34.

239 THE WATERFALL OF AOIGAOKA

Ōban colour-print; 14¾×10⅛ in.; *c.*1830

At right a broad waterfall of no great height pours over a stone wall from a lake dotted with water-lily pads into a troubled stream below. At left a hill with houses at the summit, and men mounting the road. In the foreground, beside another house, are two coolies resting, one with tubs of shellfish on a yoke. The stone wall left of the fall is crowned with a bank of spring-green foliage, contrasting with the blue-green of the trees. The path is warm yellow; the sky, water and foreground roof-tops blue. From the same 'Waterfalls' series as no. 238.

SIGNED: Zen Hokusai I-itsu hitsu. CENSOR'S SEAL: *Kiwame*.
PUBLISHER: Eijūdō.
SUBJECT REPRODUCED: Narazaki, *Hokusai Ron*, no. 191.
ACC. 290.

240 THE KIRIFURI WATERFALL

Ōban colour-print; 15$\frac{1}{16}$ × 10$\frac{5}{16}$ in.; *c.*1830

A torrent veining down precipitous cliffs in many branching streams, three men on the foreground rocks looking up, and two others high up on the steep slope, right. From the same set, 'The Waterfalls', as no.239.

SIGNED: Zen Hokusai I-itsu hitsu. CENSOR'S SEAL: *Kiwame.*
PUBLISHER: Eijūdō.
SUBJECT REPRODUCED: V. & I., no.292, pl.LXXXVI; Narazaki, *Hokusai Ron*, no.192; Hillier, *Hokusai*, fig.66. ACC.316.

CAT. NO. 240

241 TWO CRANES ON A SNOWY PINE

Kakemono-e colour-print; 20½×9⅛ in.; early 1830s

Two cranes standing on the snow-covered bough of a great pine tree. They have wings with blue feathers and pink-and-white primaries, and vermilion polls. The pine-needles are deep blue, the tree brown where it shows beneath the snow, and the sky is gradated from a dark grey at the top to a lighter tone lower down.

SIGNED: Zen Hokusai I-itsu hitsu. CENSOR'S SEAL: *Kiwame.*
PUBLISHER: Mori-ya.
PRINT PUBLISHED: Ledoux, 1951.
EXHIBITED: M.I.A., 1961, no. 131.
FORMER COLLECTION: Ledoux.
SUBJECT REPRODUCED: V. & I., Paris, 1913, no. 320; Von Seidlitz, French edition, pl. 56; *U.T.* vol. IX, no. 188; Hillier, *Hokusai*, pl. 99.
ACC. 262.

CAT. NO. 241

242 TOBA IN EXILE

Kakemono-e colour-print; 20$\frac{3}{16}$ × 8$\frac{3}{8}$ in,. *c.* 1830–3

The title of the series of *kakemono-e* of which this is one is commonly called 'The Imagery of the Poets', though, in fact, the Japanese title, *Shika Shashin Kyō*, is capable of a number of probably more literal translations. Dr Lane (in Michener/Lane, *Japanese Prints*) translates it 'The Poetry of China and Japan: a Living Mirror'. The subject in this case is not identified by sub-title as it is in others of the series, and the traveller on horseback in the snow, followed by his retainer, could possibly be identified with several Chinese poets who have written poems appropriate to this setting. However, most writers have been happy to settle for Toba (Ch. Su Tung-Po), a poet and calligraphist of the eleventh century. Through the machinations of political enemies, he was banished to the island of Hainan, and he is traditionally depicted, as he is here, astride a mule or a horse, alone or with a single faithful retainer, in a desolate and alien landscape. He is in a light lilac robe and rides a chestnut horse. His man has a straw coat, and the snow-covered rock they stand on reaches out into blue water under a blue sky without division between.

SIGNED: Zen Hokusai I-itsu hitsu. CENSOR'S SEAL: *Kiwame.*
PUBLISHER: Mori-ya.
EXHIBITED: M.I.A., 1961, no. 129.
FORMER COLLECTION; Grist.
SUBJECT REPRODUCED: V. & I., Paris, 1913, no. 330, pl. CIII; Hillier, *Hokusai*, pl. 87; *Landscape Prints of Old Japan* (Grabhorn Collection), pl. 20; Michener/Lane, *Japanese Prints*, no. 196; *Ukiyo-e Zenshū*, vol. 6, fig. 41.
ACC. 172.

CAT. NO. 242

CAT. NO. 243

243 SHŌNENKŌ

Kakemono-e colour-print; 19⅞×8⅞ in.; *c.* 1830–3

A horseman in Chinese costume, black, blue, red and grey, with a black hood, cantering along a road on the bank of a river, using a willow-wand as a switch. There is a fresh springtime landscape with budding trees, and a solitary angler is fishing from the bank. The print gives an impression of bright, sunlit colour; the brown-pink of the road is brilliant against the deep blue of the water and the blue-green hillocks. The sorrel horse of the distant rider makes an effective contrast with the landscape.

From the same series as no. 242, with the sub-title *Shōnenkō*. By this name the Japanese designate a classic motive of Chinese poetry, 'Youth setting out on a journey', and any one of twenty or thirty versions by poets of the T'ang period would probably serve for the origin of this illustration.

SIGNED: Zen Hokusai I-itsu hitsu. CENSOR'S SEAL: *Kiwame.*
PUBLISHER: Mori-ya.
EXHIBITED: M.I.A., 1961, no. 130.
SUBJECT REPRODUCED: V. & I., Paris, 1913, no. 321, pl. XCIX; Narazaki, *Hokusai Ron,* no. 241; *Ukiyo-e Zenshū,*
 vol. 6, fig. 39.
ACC. 249.

CAT. NO. 244

244 TORU-NO-DAIJIN

Kakemono-e colour-print; 20$\frac{3}{16}$×9$\frac{1}{8}$ in.; *c.* 1830–3

Toru-no-Daijin was a ninth-century Japanese poet, the son of an Emperor, possessed with an extravagant fervour for landscape gardening. In the grounds of his Kyoto palace he constructed an imitation Shiogoma Bay, and although no particular poem of Toru's seems to be illustrated, Hokusai no doubt intends to depict the wonderful garden. Toru seems to be declaiming poetry before admiring retainers. From the same set, *Shika Shashin Kyō*, as no. 242.

SIGNED: Zen Hokusai I-itsu hitsu. CENSOR'S SEAL: *Kiwame*.
PUBLISHER: Mori-ya.
FORMER COLLECTION: Evans.
SUBJECT REPRODUCED: V. & I., Paris, 1913, no. 328, pl. CII; Hillier, *Hokusai*, fig. 96; *Landscape Prints of Old Japan* (Grabhorn Collection), no. 22.
ACC. 171.

A great feature of this print is the clever use by the printer of the grain of the block used for the sky. The cresent moon cuts into the close-set lines, which give a perfect impression of the vaulting of the sky.

245 THE SACRED FOUNTAIN OF JOGAKU

Ōban yoko-e colour-print; 10⅛×14⅞ in.; *c.* 1832–5

The Sacred Fountain at Jogaku. Water pouring from a rock into a blue pool, a rice-field left and a pine copse, through which a path leads to a gate; right, a red peak, known as the Ryūkyū Fuji, on the horizon. Apart from the peak and the blue of the sky and water, the colours are soft greens and yellows. From the set, *Ryūkyū Hakkei* 'Eight Views of the Lūchū Islands', with title in cartouche in red.

SUBJECT REPRODUCED: *Ukiyo-e Zenshū*, vol. 6, fig. 29.
ACC. 74.

Prints of this set are among the rarest of Hokusai's landscapes (it is significant that none was included in the Paris Exhibition of 1913). They are discussed fully in *Le Paysage dans l'Art de Hokusai*, by Takeshiro Nagasse, 1937. The odd difference in style which separates them from Hokusai's landscapes generally has been pointed out before, and it may well be due to the fact that, not having visited the Lū-chū Islands, Hokusai gained his inspiration for his designs from the book called *Ryūkyū Kokushi-ryaku*, published in 1831 with quasi-topographical woodcuts of places on the islands.

246 AUTUMN EVENING LIGHT AT CHŌKŌ

Ōban yoko-e colour-print; 10⅜×14¾ in.; *c.* 1832–5

A still and hazy blue sea, shot with pink, and a long stone-grey and yellow-sanded cause-way running diagonally across the foreground; beyond, green islands and the far-off brown peak of Ryūkyū Fuji rising from the haze. This is the 'Autumn Evening Light at Chōkō' (a place-name which literally means 'long rainbow' and may possibly have some reference to the long bridge or causeway). From the same set of 'Eight Views of the Lūchū Islands' as no. 245.

SIGNED: Zen Hokusai I-itsu hitsu.
PUBLISHER: Mori-ya.
PRINT PUBLISHED: Ledoux, 1951, no. 5.
FORMER COLLECTION: Ledoux.
SUBJECT REPRODUCED: Ficke Sale Catalogue, 1925, no. 265; Priest, *Japanese Prints from the Henry L. Phillips Collection* no. XXII; Narazaki, *Hokusai Ron*, no. 197; *Ukiyo-e Zenshū*, vol. 6, fig. 31.
ACC. 125.

CAT. NOS. 245, 246

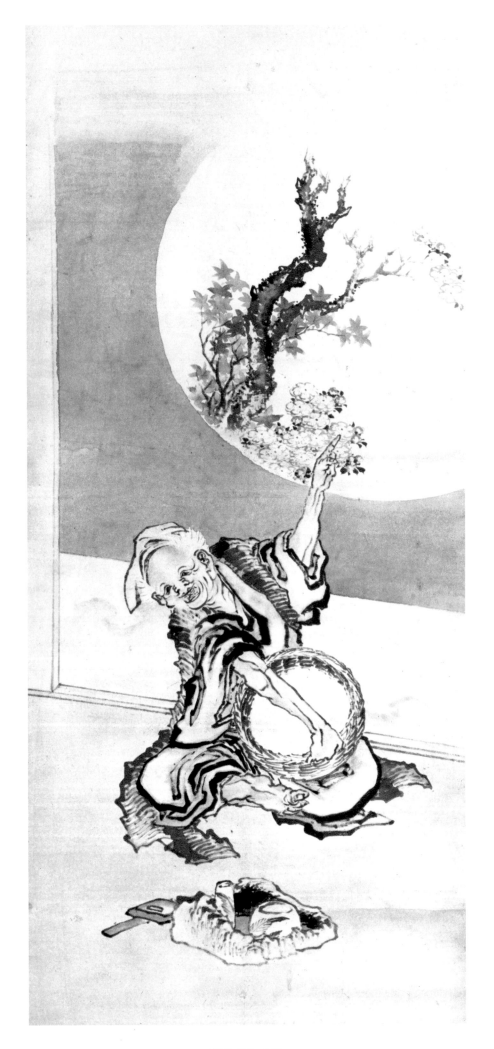

CAT. NO. 247

247 HANA-SAKA JIJI

Kakemono, Ink and colour on paper; 50×22½ in.; *c.*1830–5

Hana-saka Jiji ('the old man who made withered trees blossom') shown seated with a basket in his lap, pointing through a circular window behind him to the blossoming trees. The clothes–blue and brown-pink–are hit off with the most powerful and exciting bravura, the limbs, washed with a fairly strong tint, have all the characteristics we have come to recognize as the mature Hokusai. The wall around the circular window is grey.

UNSIGNED.
PUBLISHED: Sotheby Sale Catalogue, 18, January 1965, no. 12.
FORMER COLLECTIONS: Kyōsai; Conder.
ACC. 345.

The story of Hana-Saka Jiji is told in A.B. Mitford's *Tales of Old Japan*. It tells of an honest couple who possessed a magic dog that continually led them to treasure. It was killed by covetous neighbours, for whom it would not perform magic, but it returned to its owners after death, and on one occasion advised its old master to sprinkle ashes on withered trees. He did so and they burst into fresh life and blossomed, and a Prince, hearing of the miracle, richly rewarded the old man and his wife. In Hokusai's picture, the basket the old man is holding had presumably contained the ashes.

CAT. NO. 248

248 PLEASURE-BOATS ON A SUMMER NIGHT

Ōban yoko-e colour-print; 10¼×14½ in.; *c.* 1839

The prow of a great pleasure-boat left, lit by lanterns, bearing the legend, *Shimpen Kawaichi-maru* and with merry-makers drinking *sake* aboard. Two other boats on the river on a moonless midsummer night, a row of buildings with identical gables along the opposite bank. One of the set *Hyakunin Isshu Ubaga Etoki*, usually translated 'The Hundred Poems Explained by the Nurse', with a poem in the cartouche by Kiyowara no Fukayabu (no. 36 in the anthology): 'How short the summer night is. Dawn comes so soon after nightfall. Where is the moon I have been looking at?'

SIGNED: Zen Hokusai Manji. CENSOR'S SEAL: *Kiwame.*
PUBLISHER: Eijūdō.
EXHIBITED: M.I.A., 1961, no. 134.
SUBJECT REPRODUCED: Narazaki, *Odaka Ukiyo-e Shūshū*, 1961, no. 157; Dr. Rose Hempel, *Japanische Tage: Holzschnitte Ukiyo-e Sammlung Prof. Dr. Otto Riese*, 1967, no. 117.
ACC. 208.

Hokusai's treatment of the *Hyakunin Isshu* in this set is characteristically unpredictable. The poems of this most famous of all Japanese anthologies, with one poem each of 100 poets, compiled in 1235, were well-known, but by introducing the idea of an old woman explaining them, he gave himself licence to treat the subjects of the poems in a variety of ways, from straight illustration to pure travesty, though more often than not the events of courtly life depicted in the ancient poems are brought up to date and presented through the actions of the common folk in contemporary settings and clothes.

From the title it is evident that a series of 100 prints was projected, but only 27 prints were actually issued (a twenty-eighth is known in key-block proof only), and possibly the series, more than usually imbued with the quirks and indiosyncrasies of the old artist, proved less popular than the publisher had expected. Drawings for the remainder of the hundred seem to have been completed, and many are still extant, the largest holding being in the Freer Gallery, Washington.

249 A MOUNTAIN HUT IN WINTER

Ōban yoko-e colour-print; 9⅞ × 14¾ in.; *c.* 1839

A winter scene, with hunters and foresters warming their hands at a log-fire outside a mountain hut covered with snow. The flame of the fire is the centre of the colour scheme and lights up the bright colours of the figures around it, the tones intensified by the contrasting areas of shadow beyond and the foreground snow. The blue sky shades down to grey.

One of the set *Hyakunin Isshu Ubaga Etoki*, with a poem by Minamoto in the square cartouche adjoining the title cartouche: 'Friends are gone from me, the grass and leaves are withered. Ah! how remembrance makes winter-time more lonely here in this mountain hamlet.'

SIGNED: Zen Hokusai Manji. CENSOR'S SEAL: *Kiwame.*
PUBLISHER: Eijūdō.
EXHIBITED: M.I.A., 1961, no. 132.
SUBJECT REPRODUCED: Focillon, *Hokusai*, pl. 19; Priest, *Japanese Prints from the Henry L. Phillips Collection,* no. XXVII; Ledoux, 1951, pl. 7; *U.T.S.*, vol. 15, no. 10.
ACC. 41.

CAT. NO. 249

250 VANITY OF VANITIES

Ōban yoko-e colour-print; 10¼×14¾ in.; *c.*1839

Outside a thatched cottage, women are cleaning and drying strips of linen, and a man is sweeping up the fallen blossom of cherry trees. Other figures include a fowler crossing the bridge, a woman drawing water and a man harrowing in the paddy. The maroon-brown roofs are framed in the deep green foliage, and along the edge of the paddy and between the green hillocks the paths are sandy yellow. The sky is blue only along the upper edge of the print. Everything tends to illustrate the drudgery of life, the passing of spring both in the fields and in the lives of men and women, and represents the mood of Ono no Komachi's poem in the cartouche, (no.9 in the anthology): 'While I have been sauntering through the world, looking upon its vanities, lo! my flower has faded and the time of the long rains come.' From the same *Hyakunin Isshu Ubaga Etoki* set as no.248.

SIGNED: Hokusai Manji (the 'Manji' in red). CENSOR'S SEAL: *Kiwame*.
PUBLISHER: Eijūdō.
EXHIBITED: M.I.A., 1961, no.133.
SUBJECT REPRODUCED: Miller Sale Catalogue, Sotheby, May 1911, no.195, pl.VII; Frank Lloyd Wright Sale Catalogue, New York January 1927, no.179.
ACC.94.

CAT. NO. 250

CAT. NO. 251

251 THE BULLOCK-CART OF SUGAWARA MICHIZANE

Ōban yoko-e colour-print; 10×15 in.; *c.* 1839

A ceremonial *gosho-guruma*, its brilliantly coloured sides topped by a brown roof with blue ridge, is at rest in the precincts of a temple, the bullock lying down between the shafts, the retainers of a nobleman grouped about it. Yellow *ishidōrō* are framed against the intense black of the wheels, and a blue and red cloth extends from the cart to the fawn and white bullock. Red maple leaves flutter in the sky.

This is another of the *Hyakunin Isshu Ubaga Etoki* set, the poem being by Kanke (Sugawara no Michizane): 'Since at the present time I may bring no offering, here for the pleasure of the *Kami* are rich brocades of red maple leaves spread on the Mount of Offering.' Views differ as to the occasion prompting this poem, but Edmunds in *Pointers and Clues* refers it to the occasion when Sugawara attended the Emperor Uda on a visit to Mt. Tamuke to solicit the favour of the deity Hachiman. It was improper for any subject to make an offering at the same time as the Emperor, and the poet, seeing the scattered maple leaves, aptly took advantage of them in addressing the god of the shrine (*Kami*).

SIGNED: Zen Hokusai Manji. CENSOR'S SEAL: *Kiwame*.
PUBLISHER: Eijūdō.
FORMER COLLECTIONS: Hirakawa, Ficke.
SUBJECT REPRODUCED: V. & I., Paris, 1913, no. 346, pl. CVIII; Perzynski, *Hokusai*, 1908, fig. 101.
ACC. 394.

SAKAI HŌITSU

(1761–1828)

This artist of noble rank–he was the second son of the Daimyō of Himeji–had a most eclectic art training, first, as might be expected of one of his birth, in the Kanō Academy, then under Toyoharu, the Ukiyo-e master, later with Watanabe Nangaku, the Maruyama school artist, with some study of the work of Sō-Shiseki, the Chin Nan-p'in disciple. But, finally, some say on the advice of Tani Bunchō, he turned to Kōrin, and found his true *métier* as a reviver of the art of the Decorative school, which had languished for almost a century. He made a great study of the works of Kōrin and Kenzan, was instrumental in causing the publication of woodcut picture-books of the works of those artists in 1815 and 1823, and developed a style that had much of the qualities of his great forerunners. His *Ōson Gafu*, containing colour-prints in inimitably Decorative style, was published in 1817. As a young man he entered the priesthood to attain the simple life, which his rank would otherwise have denied him, and the names under which he held priestly office, Togakuin Monsen and Kishin, frequently appear in his signatures and seals, together with the art-names Ōson, Keikyodōjin, Nison-an and Uka-an.

252 NARIHIRA RIDING BELOW FUJI

Kakemono. Ink and colour on silk; 46½ × 24 in.; *c.* 1820

A nobleman in antique garb, probably intended for Narihira, on a black charger riding right, a page in green walking beside him carrying his master's sword. Fuji dominates the skyline behind them.

SIGNED: Hōitsu Kishin. SEALS: Uka and Ōson.
PUBLISHED: M.I.A., Catalogue of 1966 Exhibition, no. 40.
EXHIBITED: M.I.A., 1966, no. 40.
ACC. 332.

CAT. NO. 252

TOTOYA HOKKEI

(1780–1850)

Like a number of other Ukiyo-e artists, Hokkei began by training in the Kanō Academy, his master being Kanō Yōsen-in, but about 1800 he was emerging as a Ukiyo-e artist under the name of Hokkei, and already his style was strongly influenced by Hokusai. He assisted in the production of a number of Hokusai's *ehon*, principally the earlier volumes of the *Manga*, but his own especial flair was in the designing of *surimono*, to which he brought that touch of poetic fantasy and sophisticated treatment of ordinary things possessed by a number of Japanese artists. He illustrated a considerable number of *kyōka* books and, apart from his *surimono*, is best known for a fine series of landscapes in unusual ateral shape, the 'Famous Views in the Various Provinces'. As a painter he is not considered the equal of certain other Hokusai pupils, notably Hokuba.

253 MANDARIN DUCK AND DRAKE: A *SURIMONO*

Chūban colour-print; 8⅜×7⅛ in.; *c.* 1830

A mandarin duck and drake standing close together, with verses above them. The drake has golden plumage at the head, grey body and pink claws; the duck a dark green breast and pink and brown body. The *takaramono*, emblems of good fortune, are outlined in gold on a blue band across the upper part of the print. Series title, in a cartouche like a rolled *makimono*, *Sanjū-roku kin tsuzuki* ('A Series of Thirty-six Birds'), and above the title the word *Ren* ('Club') in a geometrical shape within a circle.

SIGNATURE: Hokkei.
PRINT PUBLISHED: Mori Sale Catalogue, New York, December 1926.
FORMER COLLECTION: Mori.
ACC. 65.

CAT. NOS. 253, 254

254 THE MONKEY BRIDGE: A *SURIMONO*

Chūban colour-print; 8¼×7¼ in.

Sunrise at the New Year as travellers, one riding a horse, cross the Monkey Bridge in the mountainous region of Kai Province, the water below denoted by gauffrage and silver printing. The colour is subtle and applied largely without black outline. The bridge structure is brown-pink, the distant mountains, to left, blue, to right, against the red sun, pale buff. Elsewhere there is a *mélange* of soft blues, yellow, pink and grey. Poem above, by Gurendo-Ō, translated in the British Museum Catalogue: 'For a thousand springs has the Monkey Bridge endured; the first to pass across it was a man from Kudara.'

The 'man from Kudara' (in Korea) is explained as a phrase expressing great antiquity, as we might say 'a man from Nineveh'.

SIGNED: Kikō Hokkei. Seal not read.
SUBJECT DESCRIBED: B.M. Catalogue, 362, no. 2.
ACC. 36.

ICHIRYŪSAI HIROSHIGE

(1797–1858)

Hiroshige seemed destined to become a landscape artist: his early training in the Utagawa sub-school, instead of with Toyokuni, who would possibly have made yet another theatre-print artist of him, was with Toyohiro, who himself had a great deal to do with the pioneering of the landscape-print and must have directed his pupil's obvious talents into that channel. From 1812, when he was granted the name Utagawa Hiroshige, until 1831, his prints are not especially distinguishable from those of other artists of the school, but in 1831 appeared the first notable series of landscapes 'Famous Places of the Eastern Capital', and in 1833 publication began of the first, and probably greatest, of his numerous Tokaidō series. From then on the volume of landscape and *kachō* prints designed by him grew in numbers year by year, and he was also in demand as an illustrator of *kyōka* books. The Kisokaidō, the Ōmi Hakkei, the 'Provinces' Set, the 'One Hundred Views of Fuji' and a variety of sets devoted to Edo and its environs are typical of his extensive output, which also included several outstanding prints in the triptych form.

It was almost inevitable that comparisons should have been invoked with the other great print landscapist of the period, Hokusai, and, if nothing else, such comparisons bring out the essentially differing character of their art, and of their personalities. Both, however, transcended the limitations of their school and their period: Hokusai, a solitary even in company, by a craggy individuality and eccentricity that removes his art to a plane apart; Hiroshige, the most convivial and gregarious of men, by an impressionability to the landscape and sympathy with the life of the people of Japan and by a fusion with the Ukiyo-e style of the verve and freedom of Shijō. As B. W. Robinson wrote in his Introduction to Mr Tamba's recent valuable book on Hiroshige: 'We are indeed fortunate to be in possession of such a full and circumstantial picture of Japan on the eve of the Meiji Restoration as his work gives us, and to have the picture of the artist which they provide, so admirably filled in by his surviving diaries.'

255 # FULL MOON AT TAKANAWA

Ōban yoko-e colour-print; 9¼×14¼ in.; *c.*1831

Full moon over the Bay of Takanawa, with a skein of geese flying down. Mainly in tones of blue, the trees green and the booths, following the bend of the shore, red-brown, but a great feature of this, as of the other prints in the set, is the treatment of the sky, the lines of the cloud being printed in red. Series title, *Tōto Meisho* ('Notable Places in Edo'); sub-title, *Takanawa no Meigetsu* ('Full Moon at Takanawa').

SIGNED: Ichiryūsai Hiroshige ga.
FORMER COLLECTION: Bess.
ACC. 383.

This print differs to some extent from that illustrated in Ledoux, 1951, no. 24, especially as regards the border, but follows the example illustrated in the Jacquin Catalogue, no. 473.

CAT. NO. 255

CAT. NOS. 256, 257

256 MACAW ON A PINE BRANCH

Ō-tanzaku colour-print; 14⅞×6¾ in.; early 1830s

A red macaw with blue-and-green wings, its head turned back to the right, perched on the drooping branch of a pine tree. Gradated blue ground, darkest below, covering the lower half of the print. Chinese poem above: 'Colour of the pine deepened by the snows of a thousand years, now made brilliant by the 'eighteen-coloured' wisdom of the parrot bird'.

SIGNED: Hiroshige hitsu. CENSOR'S SEAL: *Kiwame.*
PUBLISHER'S SEAL: Jakurindō.
SUBJECT REPRODUCED: Lloyd Wright Sale Catalogue, New York, January 1927, no. 230.
ACC. 9.

This print is known with either blue or yellow background.

257 BUNTING ON CONVOLVULUS

Tanzaku colour-print; 13½×4½ in.; early 1830s

A grey bunting with red beak and claws perched on the slender tendril of a convolvulus, which has deep blue flowers above, pink-tipped buds below, and leaves of deep green; the background gradated blue above and yellow green below. A verse to right in upper part.

SIGNED: Hiroshige hitsu. CENSOR'S SEAL: *Kiwame.*
PUBLISHER: Kawashō.
SUBJECT REPRODUCED: *Ukiyo-e Zenshū*, vol. 4, fig. 158; Tamba, *The Art of Hiroshige*, no. 398.
ACC. 313.

CAT. NOS. 258, 259

258 RIVER TROUT IN A STREAM

Ōban yoko-e colour-print; 14⅜×10 in.; early 1830s

Five river trout, *ayu* (or *ai*, *Plecoglossus attivelis*), darting left, grey with brown heads, tails and fins, and with silver markings, (a feature of the earliest impressions). The water is blue, shaded to darker tones at the top along the lines indicating the flow of the stream. Verse above: 'The autumn rain does not spoil the beauty of the Tama River, no fleck of rust mars the sheen of its trout'.

SIGNED: Hiroshige hitsu.
PUBLISHER: Eijūdō.
FORMER COLLECTION: Stoclet.
SUBJECT REPRODUCED: Uchida, no. 363; *Ukiyo-e Zenshū*, vol. 4, fig. 166; Shraubstadter Sale Catalogue, New York, February 1921, no. 215.
ACC. 393.

259 THE FERRY-BOAT, ROKUGŌ RIVER, KAWASAKI

Ōban yoko-e colour-print; 9 11/16×14¾ in.; c. 1833

A ferry-boat crossing Rokugō, or Tamagawa, near Kawasaki, whose grey, yellow and brown roof-tops can be seen on the opposite shore, where another party is waiting for the return journey. Fuji is white against the pink sky at the horizon; above, it is still blue. The river is deep blue, shading to even darker hues in the foreground. From the series *Tokaidō Go-jū-san-tsugi* ('The Fifty-three [Stations on the] Tokaidō'), sub-title, *Kawasaki*, and, in the seal adjoining, *Rokugō Tosen* ('Ferry-boat, Rokugō').

SIGNED: Hiroshige ga. CENSOR'S SEAL *Kiwame*. (in margin).
PUBLISHER'S SEAL: Senkakudō Hōeidō.
EXHIBITED: M.I.A., 1961, no. 135.
SUBJECT REPRODUCED: Happer Sale Catalogue (Sotheby, 1909), no. 71, pl. VI; *U.T.S.* vol. 18, pl. 14 (colour); Narazaki *Tokaidō Go-jū-san tsugi* (Kodansha, 1964), pl. 12.
ACC. 4.

The genesis of Hiroshige's great Tokaidō series of prints and of his continuing interest and frequent return to the Tokaidō as a source of subjects for prints throughout his life was his attachment in some minor capacity to the Shōgunate procession of 1832 to Kyoto, the occasion of the annual ceremonial presentation of a white horse to the Emperor. He must presumably have made sketches *en route* which were later made the basis of colour-print designs. The series was published during the two succeeding years, 1833 and 1834.

 For some reasons unknown, though doubtless through accidental destruction of the original blocks, certain of the earlier mumbers of the set were recut with considerable changes in the designs. This impression of the *Kawasaki* print is the first edition.

260 THE RIVER OF THE HEAVENLY DRAGON

Ōban yoko-e colour-print; 9½×14½ in.; *c.*1833–4

Early morning, clear blue sky overhead, the mist flattening the distant woods into grey shapes; in the foreground, two ferrymen, one in green, the other in grey, wait in their boat for passengers; and beyond a grey sandy strand several other ferry-boats are plying and travellers wait on the bank of the blue stream. From the same *Tokaidō* set as no.259. Subtitle, *Mitsuke,* and in the seal adjoining *Tenryūgawa zu* ('Picture of the Heavenly Dragon River').

SIGNED: Hiroshige ga. CENSOR'S SEAL: *Kiwame* (in margin).
PUBLISHER'S SEAL: Hoeidō.
SUBJECT REPRODUCED: Tamba, fig. 286; Uchida, no.70.
ACC.308.

CAT. NO. 260

261 (*a*) EVENING SNOW, KAMBARA

Ōban yoko-e colour-print; 9¾×14¾ in.; *c.*1833–4

Three men trudging ankle-deep in the snow on a slope near to Kambara, whose roofs are set against a range of hills. The sky is dark above and becomes lighter towards the horizon, a gradation effected by the 'wiping-out' technique known as *tembokashi*. Snow lies thickly everywhere and is still falling from the sky. The only positive colour is on the figures: the left-hand man has a blue outer-coat and a red umbrella; of the other two one is wearing an orange-tinted *mino* and blue leggings, the other a yellow coat and red leggings. From the same *Tokaidō* set as no.260. Sub-title, *Kambara* and, in seal adjoining, *Yoru no yuki* ('Evening snow').

SIGNED: Hiroshige ga. CENSOR'S SEAL: *Kiwame* (in margin).
PUBLISHER'S SEAL: Takenouchi.
PRINT PUBLISHED: M.I.A., Exhibition Catalogue, 1961, no.136, fig.19
EXHIBITED: M.I.A., 1961, no.136.
ACC.146.

Impressions differ in regard to the printing of the sky. In some, as the one above-described, it is dark above and light below; in others, as in the next-described specimen, light above and dark below. It has been suggested that this difference distinguishes early from late impressions, but the one crucial indication of an early impression occurs in prints of either type of sky. This distinguishing feature is the result of a little carelessness on the part of the block-cutter. In early impressions, he had omitted to clear the surplus wood between the lines of the legs of the man furthest right in the picture (impressions showing this imperfection are the one described above; Uchida, 61, and Happer, no.93. pl.VII). In later impressions the wood had been cleared, but in doing so the cutter allowed the knife to slip and a break is shown above the right knee which is not present in the earlier impressions; (impressions showing this break are the one next-described, Ledoux, 1951, no.30, and *Ukiyo-e Zenshū* vol6, p.150).

261 (*b*) ANOTHER IMPRESSION OF THE SAME PRINT

(9⅞×15⅛ in.)

Similar in all respects, except that it has the sky printed in the alternative fashion – that is, light above and dark below – and that the wood has been cleared from the lines of the right knee of the figure at extreme right.

CAT. NO. 261 (*a, b*)

262 HAKONE

Ōban yoko-e colour-print; 9⅜×14¼ in.; *c.*1833–4

A great crag of variegated colour towers, right, over the blue lake, and travellers are streaming up a narrow pass at the side of the peak. At left, Fuji, outlined by gauffrage, rises white in the pink sky above the range of blue, brown and grey hills surrounding the lake. At the zenith the sky is purple. From the same *Tokaidō* set as no.261. Sub-title, *Hakone*, and, in the seal adjoining, *Kosui ga oka* ('The Hill by the Lake').

SIGNED: Hiroshige ga. CENSOR'S SEAL; *Kiwame.* (in margin).
PUBLISHER'S SEALS: Hōei and Dō.
FORMER COLLECTION: Vaucaire.
SUBJECT REPRODUCED: Uchida no. 66; Narazaki, *Tokaidō Go-jū-san Tsugi*, 1964, no.25; and elsewhere.
ACC.168.

CAT. NO. 262

263 UTSU HILL, OKABE

Ōban yoko-e colour-print; 9⅞×14¼ in.; *c.*1833

A narrow pass, with a swift stream running alongside the path, between the steep green slopes of hills, with faggot-bearers and other travellers on the road. One tree leans across the stream, its orange foliage thrown up by the grey of the hills beyond. From the same *Tokaidō* set as no.262. Sub-title, *Okabe*, and, in seal adjoining, *Utsu no yama* ('Utsu Hill').

SIGNED: Hiroshige ga. CENSOR'S SEAL: *Kiwame* (in margin).
PUBLISHER'S SEAL: Senkakudō.
EXHIBITED: M.I.A., 1961, no.137.
SUBJECT REPRODUCED: Narazaki; *Tokaidō Go-jū-san Tsugi*, 1964, nos.44–5.
ACC.161.

The colouring of this print is dark everywhere except at the V-shaped opening to the blue sky at the end of the defile. This appears to be a mark of early impressions: see remarks in the Happer catalogue (1909) under nos.102–3.

264 THE WAYSIDE TEA-HOUSE, FUKUROI

Ōban yoko-e colour-print; 9¾×14¾ in.; *c.*1833–4

The road runs beside some flat rice-fields which have been harvested, and travellers have stopped beneath a large tree with dark foliage to brew a pot of tea. A large kettle is suspended from a branch of the tree over a wood fire. A bird is perched on a yellow notice-board, right. The foreground is blue-green, the sky dark blue at the zenith and pale blue at the horizon. There is a touch of yellow on the shack at left. From the same *Tokaidō* set as no.263. Sub-title, *Fukuroi*, and, in the seal adjoining, *De Chaya* ('Wayside Tea-house').

SIGNED: Hiroshige ga. CENSOR'S SEAL: *Kiwame* (in margin).
PUBLISHER'S SEAL: Senkakudō Hōeidō.
FORMER COLLECTION: Schraubstadter (no.21 in the February 1921 sale).
SUBJECT REPRODUCED: Uchida, no.69; Narazaki, *Tokaidō Go-jū-san Tsugi*, 1964, p.52.
ACC.307

CAT. NOS. 263, 264

265 YAHAGI BRIDGE, OKAZAKI

Ōban yoko-e colour-print; 9¾ × 14¾ in.; *c.* 1833–4

A long wooden bridge, its timbers brown and black, crossing the wide, blue Yahagi
River, a colourful *daimyō's* procession passing over it towards the castle on the far bank.
In the distance a bold hill printed in deep blue. The sky is suffused with orange, becoming
pale yellow on the horizon. From the same *Tokaidō* set as no. 264. Sub-title, *Okazaki*, and,
in the seal adjoining, *Yahagi no hashi* ('Yahagi Bridge').

SIGNED: Hiroshige ga. CENSOR'S SEAL: *Kiwame* (in margin).
PUBLISHER'S SEAL: Hōeidō.
FORMER COLLECTION: Vaucaire.
SUBJECT REPRODUCED: Narazaki, *Tokaidō Go-jū-san Tsugi*, 1964, p. 70; Exner, *Hiroshige*, p. 39.
ACC. 167.

CAT. NO. 265

CAT. NO. 266

266 RAIN-STORM AT SHŌNO

Ōban yoko-e colour-print; 10×13¾ in. (margin trimmed to border at both sides); *c.*1833–4

On the green ridge above the village, belts of tall trees are tossing under the driving rain-storm coming from the right and reduced to flat, grey shapes. Three coolies, two bearing a *kago*, are struggling up the foreground slope, and two others are descending, one of them protected by an umbrella on which there is the publisher's announcement, *Takenouchi Han, Go-jū-san tsugi*, ('The series of Fifty-three published by Takenouchi'). The touches of pink flesh-colour and the blue and green on the clothes of the figures and on the *kago* are the strongest notes of colour in the picture. From the same *Tokaidō* set as no. 265. Sub-title *Shōno*, and, in the seal adjoining, *Haku-u* ('White Rain' [Sudden Shower]).

SIGNED: Hiroshige ga. CENSOR'S SEAL: *Kiwame* (in margin).

PUBLISHER'S SEAL: Hōeidō Han.

SUBJECT REPRODUCED: This is one of the most widely reproduced of all Japanese colour-prints, and only a few typical references are given: Uchida, no. 60; Happer, no. 132, pl. IX; V. & I., Paris, 1914, no. 226, pl. LX; Narazaki, *Tokaidō Go-jū-san Tsugi*, 1964, p. 86.

ACC. 311.

267 CLEARING WEATHER AFTER SNOW, KAMEYAMA

Ōban yoko-e colour print; 9¹¹⁄₁₆ × 14¾ in.; *c.* 1833

A sunset sky, pink at the horizon and blue above, and the snow-covered slopes of hills running diagonally from lower left to upper right. Beyond the foreground pines, a line of figures is mounting the slope towards the watch-tower of Kameyama Castle. From the same *Tokaidō* set as no. 266. Sub-title, *Kameyama*, and, in seal adjoining, *Yukibare* ('Clearing Weather').

SIGNED: Hiroshige ga. CENSOR'S SEAL: *Kiwame* (in margin).
PUBLISHER'S SEAL: Hōeidō.
EXHIBITED: M.I.A., 1961, no. 138.
FORMER COLLECTION: Tuttle.
SUBJECT REPRODUCED: Like the last print, this too has been illustrated on many occasions, e.g. Uchida, no. 62;
 Ledoux, 1951, no. 32; V. & I., Paris, 1914, no. 227; pl. LX; *Ukiyo-e Zenshū*, vol. 6, pl. 51, etc.
ACC. 62.

268 CLEAR WEATHER AFTER SNOW AT MASAKI

Ōban yoko-e colour-print; 10 × 14⅞ in.; *c.*1832–4

A raft and a covered boat with green bamboo blinds are being poled along the blue river by men in yellow *mino*. On the opposite bank are two *torii* and a village among the trees. Everything is under snow. The sky is pink above the trees, and deep purple at the zenith. Title in green cartouche outside the border, *Tōto Meisho* ('Famous Places in Edo'); sub-title, *Masaki yukibare* ('Clearing Weather after Snow at Masaki').

SIGNED: Hiroshige ga. CENSOR'S SEAL: *Kiwame.*
PUBLISHER: Kikakudō (red imprint in margin).
SUBJECT REPRODUCED: Uchida, no. 191; Strange, *The Colour Prints of Hiroshige*, p.66.
ACC. 109.

269 GION TEMPLE IN SNOW

Ōban yoko-e colour-print; 9½ × 14¾ in.; *c.*1834

The stone *torii* and fence and a party of brightly dressed women at the temple entrance, *ishidōrō* on either side, the snow everywhere, masking the blue stone and outlining the trees against the graded black of the sky on which the snow-flakes are picked out as they fall. One of the series *Kyōto Meisho* ('Notable Places in Kyoto'), with the sub-title, *Gionsha Setchū* ('The Gion Temple in Snow').

SIGNED: Hiroshige ga. SEAL: Ichiryūsai. CENSOR'S SEAL: *Kiwame.*
PUBLISHER: Eisendō (imprint in blue in margin).
SUBJECT REPRODUCED: Uchida; no. 89; V. & I., Paris, 1914, no. 206, pl. XV; *Ukiyo-e Zenshū*, fig. 97; and many
 other places.
ACC. 10.

Hiroshige's masterpieces are almost entirely snow, rain or moonlight scenes, and this has always been a highly popular print in the West.

CAT. NOS. 268, 269

CAT. NO. 270

270 SHOWER AT NIHON-BASHI

Ōban yoko-e colour print; 10⅛×15⅛ in.; *c.* 1832–4

In the foreground is part of the span of the Nihon-bashi, with figures hurrying across with umbrellas up, and beyond the waterway and the warehouses and the range of wooded hills is the faint shape of Fuji, seen through the mist of rain, which forms a network of criss-crossing lines across the whole print. The range of woods and hills is silhouetted against the bay and sky, and the soft orange tint at the horizon is, in a fine impression such as this, one of the subtlest colours in the whole range of Hiroshige's prints. Title on blue label outside the margin. Another from the series *Tōto Meisho*, with sub-title, *Nihon-bashi no haku-u* ('White rain i.e. sudden shower, on Nihon-bashi').

SIGNED: Hiroshige ga. SEAL: Ichiryūsai. CENSOR's SEAL: *Kiwame.*
PUBLISHERS: Kikakudō (red imprint in the margin), and Sanoki (blazoned on the nearest umbrella).
EXHIBITED: M.I.A., 1961, no. 144.
SUBJECT REPRODUCED: Uchida, no. 187; Strange, *The Colour Prints of Hiroshige*, p. 128; *Ukiyo-e Zenshū*, vol. 6, fig. 92; Tamba, pl. 26 (colour); and elsewhere. Generally accepted as one of the masterpieces of the set.
ACC. 281

CAT. NO. 271

271 THE SUMIDA RIVER IN SNOW

Panel colour-print; 15×5 in.; 1834

A boatman in yellow *mino* and brown hat poling a log-raft on the blue Sumida River in a snow-storm, passing a row of varicoloured posts at the foot of a steep bank, with trees on the upper slope. From a series of four with the title *Shiki Kōto Meisho* ('Views of Edo in the Four Seasons'), the sub-title being *Fuyu Sumidagawa no Yuki*, ('The Sumida River in Winter Snow'). At the top left is a *tanka* of which numerous translations exist, the best, perhaps, being Ledoux's:

> 'White on thy waters
> Fall, and float for an instant,
> What, O Sumida?
> Snow-flakes they seemed as they fell,
> Snow-flakes? Or were they *chidori*?'

SIGNED: Hiroshige ga. CENSOR'S SEAL: *Kiwame.*
FORMER COLLECTIONS: Mihara; Ledoux; Marion Cutter.
ACC. 147.

Although at one time in the Ledoux Collection, this is not the print reproduced in Ledoux 1951. Indeed, there is reason to suppose that the impression illustrated in the Ledoux Catalogue is from recut blocks: the Mihara/Cutter impression tallies with many others accepted as authentic, e.g. Uchida, no. 281; *Ukiyo Zenshū*, vol. 6, pl. 49 (Saitō Collection); *Landscape Prints of Old Japan*, (Grabhorn Collection), pl. 50.

Concerning the Mihara/Cutter print, Ledoux wrote: 'It is pleasant to record that this print was presented to me by my friend Mr A. S. Mihara of Tokyo, it being a duplicate in his carefully chosen and beautiful collection, and some years later was given by me to the owner of another lovely collection, Miss Marion Cutter.'

272 ROADSIDE PINES UNDER A FULL MOON AT MOCHIZUKI

Ōban yoko-e colour-print; 9×13-9/16 in.; late 1830s

A line of tall pines along one side of a broad road looms against a moonlit blue sky, a branch of one of the trees cutting across the face of the full moon. Trees in the hollow beyond the road are misty in the light. Travellers with packs, or leading horses, travel the road. From the set *Kisokaidō Roku-jū-kyu-tsugi* ('Sixty-nine [Stations] of the Kisokaido'). Number (in seal), 36.

SIGNED: Hiroshige ga. SEAL: Ichiryūsai.
PUBLISHER'S SEAL: Kinjūdō.
EXHIBITED: M.I.A., 1961, no. 141.
SUBJECT REPRODUCED: Strange, *The Colour Prints of Hiroshige*, p. 54 (colour); Uchida, no. 132; *U.T.S.*, vol. 15, pl. 9 (colour.)
ACC. 162.

The Kisokaidō, although an alternative route from Edo to Kyoto, was much less frequented, being a secondary road which led through the mountains and passed few main centres of population. As a result, the series was never so popular in Japan as those recording the Tokaidō, and this is reflected in the scarcity of prints from the *Kisokaidō* set compared with the series dealing with the other road. The series does, however, contain some of Hiroshige's greatest prints, especially moonlight scenes, of which this is outstanding.

273 ORIGINAL DRAWING FOR THE FOREGOING PRINT

Drawing. Ink and light colour on paper; 10×14¾ in.

Roadside pines under a full moon at Mochizuki, presumably a preliminary sketch made before drawing the *shita-e* for the block-cutter. It is interesting to note the differences from the final-print version. The inscription–*Kisokaidō Roku-jū kyu*–indicates that Hiroshige already had the series in mind when making the drawing.

EXHIBITED: M.I.A., 1961, no. 35.
ACC. 163.

CAT. NOS. 272, 273

274 SUWARA ON THE KISOKAIDŌ

Ōban yoko-e colour-print; 9⅞×14⅛ in.; late 1830s

A sudden rainstorm. Travellers are sheltering in a tea-house sited between trees, other people are running for cover there and, on the crest of the road beyond, a horseman and coolie, with mats held over their heads, are silhouetted against the misty grey ridge of distant woods. At right is the yellowish bole and the green foliage of a giant tree. The figures in the foreground make bright spots of colour against the prevailing gloom. From the same *Kisokaidō* set as no. 272. Sub-title, *Suwara*. Number (in seal), 40.

SIGNED: Hiroshige ga. SEAL: Ichiryūsai. CENSOR'S SEAL: *Kiwame*.
PUBLISHER'S SEAL: Kinjūdō.
EXHIBITED: M.I.A., 1961, no. 143.
SUBJECT REPRODUCED: Uchida, no. 135; Orange and Thornicroft Sale Catalogue, Sotheby, March 1912, no. 401, pl. XXXI.
ACC. 282.

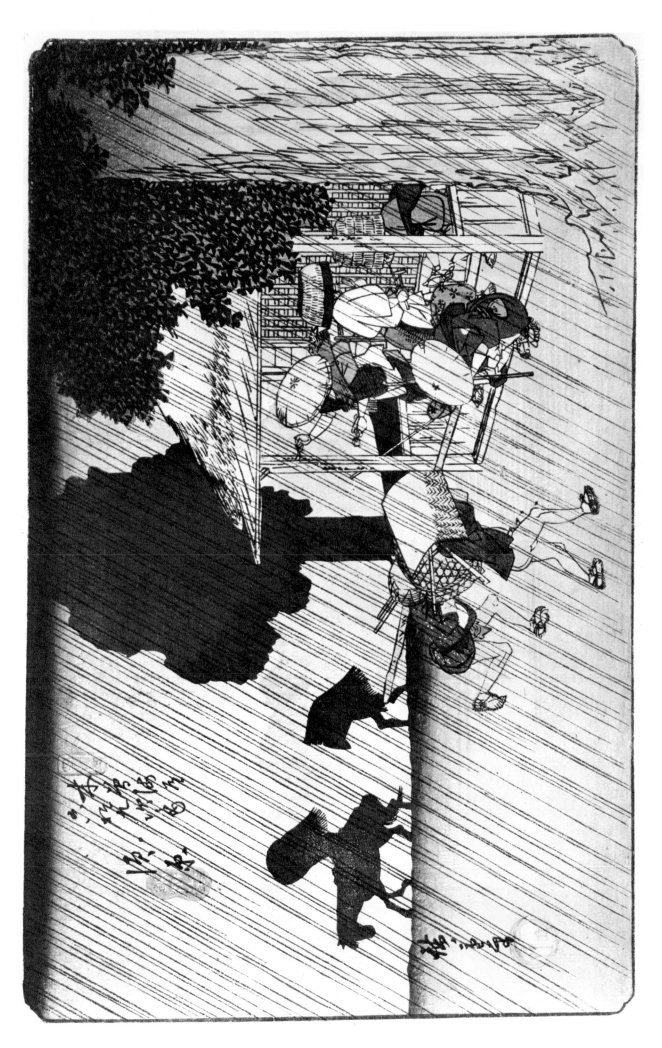

CAT. NO. 274

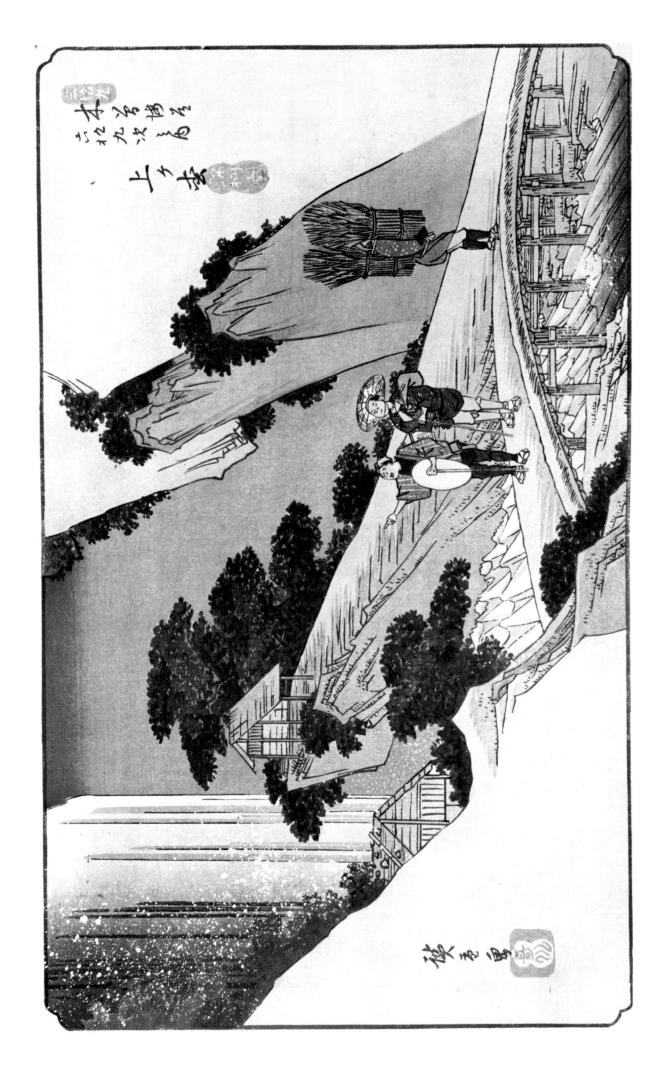

CAT. NO. 275

275 AGEMATSU

Ōban yoko-e colour-print; 9$\frac{5}{16}$×14$\frac{1}{2}$ in,; late 1830s

The famous waterfall on the outskirts of Agematsu, the water pouring in a solid sheet with colour gradation from white to dark blue, the falling spray simulated with scattered *gofun*. A traveller stands gazing at the spectacle, his porter pointing to it excitedly. The foreground rock, like the distant overhanging cliff, is a dull yellow, the sky is blue, darkening to grey at the summit. The figures are in blue and green. From the same *Kisokaidō* set as the no. 274. Sub-title, *Agematsu*. Number (in seal), 39.

SIGNED: Hiroshige ga. SEAL: Utagawa. CENSOR'S SEAL: *Kiwame* (in margin).
PUBLISHER'S SEAL: Kinjūdō.
EXHIBITED: M.I.A., 1961, no. 142.
FORMER COLLECTION: Vaucaire.
SUBJECT REPRODUCED: Tokyo National Museum Catalogue, vol. 3, no. 3,345.
ACC. 166.

As Happer points out, most impressions of this print are marred by the oxidization of the *gofun* used to indicate the spray, but here the *gofun* has retained its pristine whiteness.

CAT. NO. 276

276 NAGAKUBŌ

Ōban yoko-e colour-print; 9⅜×14⅛ in.; late 1830s

A full moon in a blue sky floods a wide river valley with light, against which a wooden bridge with a traveller on horseback and two others on foot, and a stout pine tree in the foreground are all silhouetted. On the near bank, beside the tree, is a man leading a horse and two children playing with dogs. From the same *Kisokaidō* set as no. 275. Sub-title, *Nagakubō*. Number (in seal) 28.

SIGNED: Hiroshige ga. SEAL: Ichiryūsai. CENSOR's SEAL: *Kiwame*.
PUBLISHER's SEAL: Kinjūdō.
SUBJECT REPRODUCED: Uchida, no. 129; Happer, 1909. no. 429, pl. xx.
ACC. 364.

277 SPARROWS AND CAMELLIAS IN SNOW

Tanzaku colour-print; 13½×4½ in.; early 1840s

Two sparrows on camellias in the snow, the vivid red and green of the plant half-covered by the snow, the sparrows with pink-brown heads (the back of the lower one touched with tawny yellow by hand). Grey background with snowslakes falling.

SIGNED: Hiroshige hitsu. SEAL: Hiro in diamond.
PRINT PUBLISHED: Ficke, 1920 Sale Catalogue, no.751.
FORMER COLLECTION: Ficke.
ACC.58.

278 NIGHTINGALE ON FLOWERING PLUM

Narrow *tanzaku sumizuri* print; 13½×3 in; *c.*1843–5

A nightingale, *uguisu*, on a flowering-plum branch, with a long verse above.

SIGNED: Hiroshige hitsu. CENSOR'S SEAL: Watari (Watanabe Jiemon).
ACC.315.

CAT. NOS. 277, 278

279 # THE MONKEY BRIDGE

Kakemono-e (vertical ōban diptych) colour-print; 28⅞ × 10 in.; *c.* 1842

The celebrated Monkey Bridge over the Katsura River in Kōshū Province, the full moon seen below its span and partially obscured by overhanging trees, a traveller on horseback and two on foot traversing the bridge. Between the steep walls of cliff at either side, there is a view across the river to a village amid belts of trees and, further off, of a range of mountains. Title, *Kōyo Saruhashi no Zu* ('A Picture of the Monkey Bridge Kōyo').

SIGNED: Hiroshige hitsu. SEAL: Ichiryūsai.
PUBLISHER: Tsuta-ya.
PRINT PUBLISHED: Nicholson Sale Catalogue, New York, May 1951.
EXHIBITED: M.I.A., 1964.
FORMER COLLECTION: Nicholson.
ACC. 317.

This, like the 'Snow Gorge', is among the most sought-after of Hiroshige's prints, and seems to be rarer than the 'Snow Gorge'. In fact, a number of the published specimens are from a clever reprint of fairly recent times: the V. & I., Paris, 1914, illustration (no. 281, pl. LXXV) is from one of these forgeries. The true print is illustrated in Uchida, no. 272; no. 397, pl. XVIII; *Ukiyo-e Zenshū*, vol. 6, pl. 9 (colour).

According to Seiichirō Takahashi (in *Ukiyo-e Zenshū*, vol. 6), Kobayashi Bunshichi at one time owned Hiroshige's *Kōshū Nikki*, a sketch diary of his journey in those parts in 1841, and it contained a sketch of the Monkey Bridge which formed the basis of the print-design. Unfortunately, this diary, like so many other treasures in the Kobayashi Collection, was destroyed in the great earthquake of 1923.

CAT. NO. 279

280 THE KISŌ GORGE IN SNOW

Kakemono-e (vertical *ōban* diptych) colour-print; 28½×9½ in.; *c.*1840–2

A blue stream winding between precipitous rock-faces with two boats with red-brown hulls being poled along. High up, a precarious foot-bridge crosses the gorge. At the left in a pine grove there is a temple on a peak above a blue waterfall, and beyond, towers a forbidding mountain. Everything is heavily covered with snow, which is still falling. Although the print has no title, the location is clearly the same as that of the well-known triptych which bears the title of the 'Kisō Gorge'.

SIGNED: Hiroshige hitsu. SEAL: Ichiryūsai.
PUBLISHER'S MARK: Sanoki.
EXHIBITED: M.I.A., 1961, no.140.
SUBJECT REPRODUCED: As one of the great masterpieces not merely of the Japanese print, but of landscape art
 –Strange calls it 'one of the great landscapes of the nineteenth century'–this print has been illustrated
 in many publications. A selection will suffice: V. & I., Paris, 1914, no.283, pl.LXXV; Uchida, 275; Happer, 398; Tamba, 71; *Ukiyo-e Zenshū*, vol.6, pl.56.
ACC.210.

CAT. NO. 280

CAT. NO. 281

281 SNOWY DAY, NIHON-BASHI

Ōban yoko-e colour-print; 10×15$\frac{1}{16}$ in.; *c.* 1840–2

Snow is falling heavily from a black sky, against which the snow-capped Fuji is in white reserve, like a cameo. The people traversing the great bridge, with its reddish timbers, make spots of bright colour, and snow-capped boats are passing beneath the bridge in the intensely dark blue water. From a series *Tōto Meisho*, ('Landmarks of Edo'), with sub-title *Nihon-bashi setchū* ('Nihon-bashi in Snow') (the titles within the border of the print).

SIGNED: Hiroshige ga.
PUBLISHER'S SEAL: Kawashō.
PRINT PUBLISHED: Church Sale Catalogue, February 1946, no. 89.
FORMER COLLECTION: Church.
SUBJECT REPRODUCED: Uchida, no. 205; Tamba, no. 200.
ACC. 289.

CAT. NO. 282

282 FAN-PRINT: SHORT-TAILED CAT

Fan; 10¼×8¼ in. overall; *c*.1855

A short-tailed cat, with white-spotted red ribbon around its neck, attacking a purple rope on the floor. Green ground.

SIGNED: Ryūsai. SEAL: Ichiryūsai. CENSOR'S SEAL: *Kiwame aratame.*
PUBLISHER: Izumiya.
ACC. 180.

283 NUMAZU ON THE TOKAIDŌ

Ōban colour-print; 14¾×9¾ in.; 1855

A snow scene, with two bridges over a blue stream, a traveller in grey and blue and a porter in a yellow *mino* crossing the nearest. Fuji is in the distance, white against the blue sky, and there is a flush of yellow above the hills at the right. From the series *Go-jū-san tsugi Meisho Zukai* ('A Series of Famous Places Connected with the Fifty-three' [Stations of the Tokaidō]).

SIGNED: Hiroshige ga. CENSOR'S SEAL: *Aratame* (examined).
PUBLISHER: Tsutakichi.
DATE: Hare seal 7 (i.e. seventh month of Hare Year, 1855).
ACC. 56.

284 MAIKO BEACH, HARIMA PROVINCE

Ōban colour-print; 14¼×9¾ in.; 1856

The beach at Harima with a wood of gnarled red-brown pines along the sand and a cluster of small yellow-roofed houses among the trees. The sky is blue above, purple at the sea-level. One of the series with title in red cartouche, *Roku-jū-shū Meisho Zukai* ('Views of the Sixty-odd Provinces'); sub-title in yellow cartouche, *Harima: Maiko no Hama*.

SIGNED: Hiroshige hitsu. CENSOR'S SEAL: *Aratame* (in margin).
PUBLISHER: Koshi-hei (Heisuke).
SEAL DATE: Dragon 12 (twelfth month, 1856).
SUBJECT REPRODUCED: V. & I., Paris, 1914, no. 351. pl. XCIII (colour); Tamba, no. 57 (colour).
ACC. 83.

CAT. NOS. 283, 284

CAT. NO. 285

285 TIMBER-YARD AT FUKAGAWA

Ōban colour-print; 13¾×9½ in.; 1856

A winter snow scene at the timber-yard in the Fukagawa district. Logs lying in the deep blue stream running through the area, two dogs on the nearby bank, and immediately in the foreground a snow-capped yellow umbrella, sheltering an unseen person from the falling snow and bearing the mark of the publisher Uoei. The large logs left are pink beneath the snow, the sky uniform grey, except at the zenith, where it darkens almost to black. From the 'One Hundred Views of Edo'; sub-title, *Fukagawa Kiba* ('Fukagawa Timber-yard').

SIGNED: Hiroshige ga. CENSOR'S SEAL: *Aratame.* (in margin).

PUBLISHER: Uoei (in margin).

SEAL DATE: Dragon 8 (eighth month, 1856). (in margin).

SUBJECT REPRODUCED: Uchida, no. 182; Tamba. nos. 46–8. Tamba's three illustrations in colour show three variorum impressions: the earliest with three-colour cartouche (as in the impression in this collection); the second with the two-colour cartouche and showing some loss of refinement in printing; and the third with a single graded colour in the cartouche and the printing of the sky in black, turning this scene, not very convincingly, into a night-piece.

ACC. 82.

286 THE DRUM BRIDGE, MEGURO, IN SNOW

Ōban colour-print; 13⅝×9 in. (partially trimmed outside border); 1857

The Drum Bridge with a few pedestrians, some in purple and green, others in yellow straw capes (*mino*), crossing in the snow, and, beyond, the mound known as Yūhi. The stones of the bridge are grey-blue, the water a brilliant blue. The sky is blue-grey, light at the horizon and shading to black at the extreme top of the print. From the set with title cartouche, *Meisho Edo Hyakkei*, ('The Hundred Views of Edo'); sub-title in square cartouche alongside, *Meguro Taiko-bashi Yūhi no Oka* ('The Drum Bridge and the Yūhi Hill, Meguro').

SIGNED: Hiroshige ga. CENSOR'S SEAL: *Aratame* (in margin).
PUBLISHER: Uoei (in margin).
SEAL DATE: Snake 4 (fourth month, 1857).
SUBJECT REPRODUCED: Ledoux, 1951, no.47; Exner, p.95.
ACC. I.

287 FOX FIRES ON NEW YEAR'S EVE AT THE
ENOKI TREE, ŌJI

Ōban colour-print; 14×8⅞ in. (Trimmed almost to border); 1857

Unlike the majority of foxes in Japanese legend, the pale pink foxes of this print are of good omen, gathered under the ancient *enoki* near the Fox Temple at Ōji, which is faintly visible under the dark trees in the distance. At that temple, the fox-god, Inari, has his shrine, and the foxes assemble there each year on New Year's Eve (according to legend), their supernatural character made evident by the magic fire playing beside each. The red fox fires, glimmering like glow-worms in the dark, trace the line of the foxes to the shrine in the distance. The green on tree and stook is barely discernible in the gloom. From the 'One Hundred Views of Edo'; sub-title, *Ōji Shōzoku Enoki Omisoka Kitsune-bi* ('Under the Power of the Fox Fires at the *Enoki* on New Year's Eve at Ōji').

SIGNED: Hiroshige ga. CENSOR'S SEAL: *Aratame* (in margin).
PUBLISHER: Uoei (in margin).
SEAL DATE: Snake 9 (ninth month, 1857).
SUBJECT REPRODUCED: Ledoux, 1951, no. 51 (first state: Ledoux gives a detailed consideration of the difference between the first and later states); V. & I., Paris, 1914, no.318, pl.LXXXVI (showing the 'knot' in the lower left-hand corner which is the mark of later impressions). The print in this collection bears the mark.
ACC. 164.

CAT. NOS. 286, 287

KAWANABE KYŌSAI

(1831–89)

As a very young man, Kyōsai was a pupil under Kuniyoshi, but his main training was in the Kanō style, with Masura Tōwa as his master. But he was of that independent spirit to ignore the hard-and-fast tenets of the schools, and gave free rein to a verve and drollery that singles him out as a master in his own right, independent of any school. He was a lively figure during the period of ferment before the Restoration and was three times imprisoned for caricaturing Shōgunate officials. He was, of course, still very much alive after the opening up of the country to the West, and in *Promenades Japonaises* two Frenchmen who met him before 1880, M. Guimet and M. Regamey, have given a lively account of him. In 1887 his *Kyōsai Gaden* was published, and in it he gives, among other interesting material, pictures of himself at work. He had the reputation of living riotously, and is said to have done his best painting whilst under the influence of *sake*.

288 THREE CROSSBILLS ON A TREE

Kakemono. Ink and colour on paper; 53¼×24 in.; *c.* 1878

Three crossbills perched on a leafless tree, with details of the tree redrawn at the side in greater detail. Probably a first sketch for a *kakemono*.

SIGNED: Kyōsai. SEAL: Tōiku.
PUBLISHED: Sotheby Sale Catalogue, 18th Jan. 1965, no.28.
FORMER COLLECTION: Conder.
ACC. 346.

CAT. NO. 288

CAT. NO. 289

SHIBATA ZESHIN

(1807–91)

In the West, Zeshin is better known as a lacquer artist than as a painter, whereas the reverse is the case in Japan. He studied the lacquer art under Koma Kansai and painting under the Shijō artist Suzuki Nanrei, and also spent some time in the school of another great Shijō artist, Toyohiko.

His printed work is not so well known as his paintings and lacquer. Some of his earliest prints appeared in the small *ehon, Natsu-no-yo* of 1839, and from then on until his death in 1891 he designed prints for *surimono* and for poetry-albums, as well as several series of colour-prints under the title *Hana Kurabe*, published by Kaibara over the years from 1875 to about 1890. His family name was Shibata Junzō; his art names Zeshin and Tairyūkyo.

289 WHITE MICE

Ōban yoko-e colour-print; $10\frac{1}{8} \times 13\frac{5}{8}$ in. (trimmed). *c.* 1880s

A group of five white mice bunched together and another single mouse at some distance from them. The design is in shades of black and grey, except for touches of faint pink on the noses and ears of the mice. The red seal is the only note of strong colour.

SIGNED: Zeshin. SEAL: Koma.
PRINT PUBLISHED: Mori Sale Catalogue, New York, december 1926, no. 439; Church Sale Catalogue, New York, February 1946, no. 218.
FORMER COLLECTIONS: Mori; Church.
SUBJECT REPRODUCED: Ledoux, 1950, no. 56 (an untrimmed specimen, measuring $11\frac{1}{4} \times 16\frac{7}{8}$ in.).
ACC. 67.

KOBAYASHI KIYOCHIKA

(1847–1915)

One of the outstanding artists of the transitional period between the Meiji Restoration (1868) and the Taishō Era, which began in 1912, Kiyochika was the first print artist to forsake Japanese for Western style. There had been, in the history of Japanese art, painters and print designers who had introduced certain Western features – the 'perspective' prints and the prints based on Western line-engravings are examples – but none had so completely adopted Western style and technique before Kiyochika. He studied drawing under the English artist, Charles Wirgman, and photography under the Japanese pioneer, Shimooka Renjō, and from 1876 onwards an enterprising publisher, Matsuki Heikichi, began to publish his landscape and *kachō* prints in the novel Western style. The wood-block technique, and the indestructible elements of Japanese style which remained with him like an accent to the end, prevented his work from being confused with an European's or American's work, and it is this subtle difference which gives his prints their value as the documents of an amazing transformation in the way of life and the arts of Japan during the period covered by his life.

290 VIEW OF MATSUCHI HILL AND TAIKO
BRIDGE IN WINTER

Ōban triptych colour-print; each sheet 15⅛×10¼ in.; 1896

A view of Matsuchi Hill and the Taiko Bridge in winter, looking across the Sumida River from a ferry-boat in the foreground. The passengers on the boat are standing up and their hats and umbrellas are heavily snow-laden. There is considerable variety of colour in this group, which is enhanced by contrast with the snow. In the distance it is misty and the colours faint. Dated Meiji 29 (1896).

SIGNED: Kiyochika. SEAL: Kiyochika.
PRINT PUBLISHED: Mori Sale Catalogue, New York, December 1926, no.411.
EXHIBITED: Chicago Art Institute Exhibition, 1955, no.340.
FORMER COLLECTION: Mori.
SUBJECT REPRODUCED: *Ukiyo-e Zenshū*, vol.6, pl.62.
ACC.26.

CAT. NO. 290

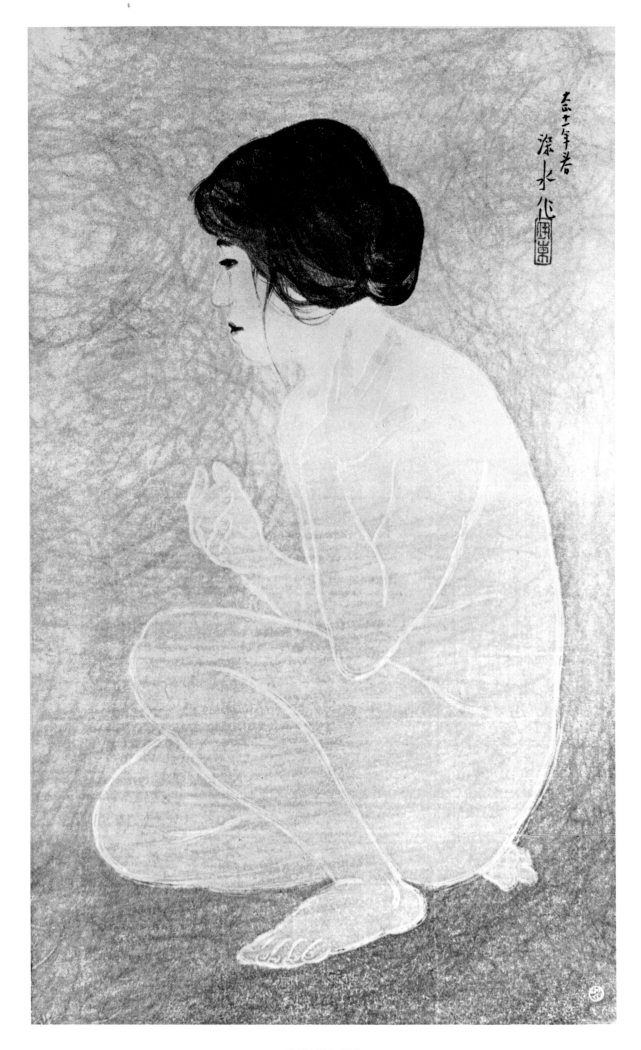

CAT. NO. 291

ITŌ SHINSUI

(born 1898)

Shinsui was an important painter of *bijin-ga* (beautiful women) in a neo-Ukiyo-e style. He was a pupil first of the noted Kaburagi Kiyokata, and from 1916 produced designs for prints, published by Watanabe, mainly of two kinds, *bijin-ga*, and landscapes.

291 NUDE WOMAN FACING LEFT

Large colour-print; 16⅛×9⅝ in.; 1922

The squatting figure of a nude woman facing left. The outline is in intaglio in white, the flesh tint varied by overprinted blue shadow, the hair dark blue over purple, and the background blue. The *baren* marks of the printer are clearly evident, and by intent. Dated Taishō II (1922).

SIGNED: Shinsui. SEAL: Itō.
PUBLISHER: Watanabe.
INSCRIPTION AT BACK: no. 182 of a limited edition of 200.
ACC.64

BIBLIOGRAPHY

ABBREVIATIONS USED IN THE TEXT

A.I.C. 'Harunobu': Gentles, Margaret O., *The Clarence Buckingham Collection of Japanese Prints*, vol. II: *Harunobu Koryūsai, Shigemasa, Their Followers and Contemporaries*, Chicago, 1965.

A.I.C. 'Primitives': Gunsaulus, Helen C., *The Clarence Buckingham Collection of Japanese Prints: The Primitives*, Chicago, 1955.

Binyon and Sexton: Binyon, Laurence, and Sexton, J. J. O'Brien, *Japanese Colour Prints*, London, 1923 (reprinted, New York, 1954; 2nd Edition, ed. Basil Gray, London, 1960).

Dallas, 1969: *Masterpieces of Japanese Art*, Dallas Museum of Fine Arts, 1969.

Hirano: Hirano, Chie, *Kiyonaga: A Study of his Life and Works*, Cambridge, Mass., 1939.

Ithaca: Young, Martie W. and Smith, Robert J., *Japanese Painters of the Floating World* (Catalogue of an exhibition of Ukiyo-e paintings), Andrew Dickson White Museum of Art, Cornell University, Ithaca, New York; Munson-Williams-Proctor Institute, Utica, New York, 1966.

Ledoux, 1942: Ledoux, Louis V., *Japanese Prints of the Primitive Period in the Collection of Louis V. Ledoux*, New York, 1942.

Ledoux, 1944: Ledoux, Louis V., *Japanese Prints by Harunobu and Shunshō in the Collection of Louis V. Ledoux*, New York, 1944.

Ledoux, 1948: Ledoux, Louis V., *Japanese Prints, Bunchō to Utamaro in the Collection of Louis V. Ledoux*, New York, 1948.

Ledoux, 1950: Ledoux, Louis V., *Japanese Prints, Sharaku to Toyokuni, in the Collection of Louis V. Ledoux*, Princeton, 1950.

Ledoux, 1951: Ledoux, Louis V., *Japanese Prints, Hokusai and Hiroshige, in the collection of Louis V. Ledoux*, Princeton. 1951.

Michener/Lane, *Japanese Prints*: Michener, James A., *Japanese Prints from the Early Masters to the Modern*, with notes on the plates by Richard Lane, Rutland, Vermont and Tokyo, 1959.

M.I.A., 1961: *Japanese Paintings and Prints. A Loan Exhibition of Selected Works from the Collection of Mr and Mrs Richard P. Gale*, The Minneapolis Institute of Arts, Minneapolis, 1961.

M.I.A., 1966. *Japanese Paintings from the Collection of Mr and Mrs Richard P. Gale*, The Minneapolis Institute of Arts. Minneapolis, 1966.

Nikuhitsu Ukiyo-e: Narazaki, Muneshige, and Kikuchi, Sadao, *Nikuhitsu Ukiyo-e* (Ukiyo-e Paintings), 2 vols. text, 2 vols. plates. Tokyo, 1962.

Narazaki/Mitchell *The Japanese Print*: Narazaki, Muneshige, *The Japanese Print: Its Evolution and Essence*. English adaptation by C. H. Mitchell, Tokyo and Palo Alto, California, 1966.

N.T.S.: *Nihonga Taisei* (Survey of Japanese Painting), Tokyo, 1930–34.

Shibui, *Zuten*: Shibui, Kiyoshi, *Ukiyo-e Zuten* (Illustrated Dictionary of Ukiyo-e), Volume 13, *Utamaro*, Tokyo, 1964.

U.T.: *Ukiyo-e Taisei* (Survey of Ukiyo-e), 12 vols, Tokyo, 1930–1.

U.T.S.: *Ukiyo-e Taika Shūsei* (Survey of Ukiyo-e Masters), 20 vols., Tokyo, 1931–2.

V. & I., Paris, 1909: Vignier and Inada, *Estampes Japonaises Primitives Exposées au Musée des Arts Decoratifs en Fevrier 1909*, Paris, 1909.

V. & I., Paris, 1910: Vignier and Inada, *Harunobu Koriusai Shunshō Estampes Japonaises Exposées au Musée des Arts Décoratifs en Janvier 1910*, Paris, 1910.

V. & I., Paris, 1911: Vignier and Inada, *Kiyonaga Bunchō Sharaku. Estampes Japonaises... Exposées au Musée des Arts Décoratifs en Janvier 1911*, Paris, 1911.

V. & I., Paris, 1912: Vignier and Inada, *Utamaro. Estampes Japonaises... Exposées au Musée des Arts Décoratifs en Janvier 1912*, Paris, 1912.

V. & I., Paris, 1913: Vignier, Lebel and Inada, *Yeishi Choki Hokusai. Estampes Japonaises... Exposées au Musée des Arts Decoratifs en Janvier 1913*, Paris, 1913.

V. & I., Paris, 1914: Vignier, Lebel and Inada, *Toyokuni Hiroshige. Estampes Japonaises... Exposées au Musée des Arts Décoratifs en Janvier 1914*, Paris, 1914.

Waterhouse: Waterhouse, D.B., *Harunobu and his age: The Development of Colour Printing in Japan*, London, 1964.

Yoshida, (Harunobu prints): Yoshida, Teruji, *Harunobu Zenshū* (The Complete Harunobu), Tokyo, 1942.

Yoshida, (Utamaro prints): Yoshida, Teruji, *Utamaro Zenshū* (The Complete Utamaro), Tokyo, 1942.

OTHER BOOKS REFERRED TO IN THE TEXT

ADACHI, TOYOHISA, *Selected Masterpieces of Ukiyo-e*, Part I, Tokyo, 1969.

—— (ed.), and YOSHIDA, TERUJI (author), *Sharaku: A Complete Collection*, vol. 1, 1940 (rev. ed., 1952), vol. 2 Tokyo, 1960.

BARBOUTAU SALE CATALOGUE, *Biographies des Artistes Japonais dont les Oeuvres figurent dans la Collection Pierre Barboutau. Tome II, Estampes et Objets d'Art*, Paris, 1904.

BARCLAY SALE CATALOGUE, *Catalogue of the Valuable Collection of Japanese Colour Prints representative of the Best Period, the Property of Ford G. Barclay Esq...* Sotheby, Wilkinson and Hodge, London, March 1910.

BERÈS, HUGUETTE, *Portrait d'acteurs Japonais du XVII^e au XIX^e siècles* (Catalogue of an Exhibition at the Quai Voltaire), Paris, n.d.

—— *Hokusai 1760–1849: dessins, aquarelles, estampes, livres...* (Catalogue of an exhibition at the Quai Voltaire), Paris, July 1958.

BING, S., *Artistic Japan*, 6 vols., London, 1888–91.

BINYON, LAURENCE, *A Catalogue of the Japanese and Chinese Woodcuts in the British Museum*, London, 1916.

BLANCHARD SALE CATALOGUE, *Illustrated Catalogue of the Notable Collection of Japanese Colour Prints the Property of Mrs John Osgood Blanchard*, American Art Galleries, New York, 1916.

BRASCH, HEINZ: *Farbholzschnitte aus Japan* (Catalogue of the Reitberg Museum Collection, Zürich), Zürich, 1965.

CANEGHEM SALE CATALOGUE, *Rare and Valuable Japanese Color Prints, including the Collection of Julio E. Van Caneghem of Paris*, The Walpole Galleries, New York, March, 1921.

CHAVARSE SALE CATALOGUE, *Collection de M.C.... Estampes Japonaises appartenant I, à Monsieur C. II, à Divers Amateurs*. Hôtel Drouot, Paris, February 1922.

CHURCH SALE CATALOGUE, *Japanese Prints, Important Primitives and Works by Harunobu.... and others... Collection of Frederick E. Church*, Parke-Bernet Galleries, New York, February 1946.

EDMUNDS, WILL. H., *The Identification of Japanese Colour-prints*, II, in the *Burlington Magazine*, March 1922.

—— *Pointers and Clues to the Subjects of Chinese and Japanese Art*, London, n.d. (1934).

EXNER, WALTER, *Hiroshige*, German ed., Frankenau/Hessen, 1958; English ed., translation by Marguerite Kay London, 1960.

FENELLOSA, ERNEST F., *Epochs of Chinese and Japanese Art. An Outline History of East Asiatic Design* 2 vols., New York and London, 1912 (new revised ed., 1921 and 1963).

FICKE, ARTHUR DAVIDSON, *Chats on Japanese Prints*, London and New York, 1915 (reprinted Rutland, Vermont and Tokyo, 1958).

—— FIRST SALE CATALOGUE, *Illustrated Catalogue of an Exceptionally Important Collection of Rare and Valuable Japanese Color Prints, the Property of Arthur Davidson Ficke*, American Art Galleries, New York, 1920.

—— SECOND SALE CATALOGUE: *The Japanese Print Collection of Arthur Davidson Ficke*, The Anderson Galleries, New York, 1925.

FIELD SALE CATALOGUE, *Illustrated Catalogue of Japanese and Chinese Color Prints, the Collection of the late Hamilton Easter Field*, Catalogued by Frederick W. Gookin, American Art Association, New York, 1922.

FOCILLON, HENRI, *Hokousai*, Paris, 1914.

FUJIKAKE, SHIZUYA, *Sesshoku Ukiyo-e Hyaku Sugata* (One Hundred Figure Paintings of Ukiyo-e in Colour), 2 vols. Tokyo, 1927.

—— *Harunobu*, Tokyo, 1939.

FULLER SALE CATALOGUE, *Japanese Prints...the Noted Collection of Gilbert Fuller*, Parke-Bernet Galleries, New York, November 1945.

GENTLES, MARGARET O., *Masters of the Japanese Print: Moronobu to Utamaro*, an Exhibition at the Asia House Gallery, New York, 1964.

GILLOT SALE CATALOGUE, *Collection Ch. Gillot. Deuxième Partie. Estampes Japonaises et Livres Illustrés*, Hôtel Drouot, Paris, 1904.

GOOKIN, FREDERICK WILLIAM, *Catalogue of a Loan Exhibition of Japanese Colour Prints, with Notes Explanatory and Descriptive and an Introduction and Essay by Frederick William Gookin*, The Art Institute of Chicago, 1908.

HAPPER SALE CATALOGUE, *Catalogue of the Valuable Collection of Japanese Colour Prints.... the Property of John Stewart Happer, Esq., of New York City, U.S.A.*, Sotheby, Wilkinson and Hodge, London, 1909.

HARUNOBU MEMORIAL CATALOGUE, Tokyo, 1925.

HAVILAND SALE CATALOGUE, *Collection Ch. Haviland. Estampes Japonaises, Peintures des Écoles Classiques et de quelques Maîtres de l'Ukiyoye*, Première Vente, Hôtel Drouot, Paris, November 1922.

—— *Collection Ch. Haviland. Estampes Japonaises (Deuxième Partie)*, Hôtel Drouot, Paris, June 1923.

—— *Collection Ch. Haviland (Quatorzième vente). Estampes Japonaises, Ceramique du Japon...* Hôtel Drouot, Paris, February 1924.

HAYASHI SALE CATALOGUE, *Dessins, Estampes, Livres Illustrés du Japon réunis par T. Hayashi*, Hôtel Drouot, Paris, 1902.

HEMPEL, ROSE, *Sammlung Theodor Scheiwe*, Münster, 1957.

HENDERSON HAROLD G., and LEDOUX, LOUIS V., *The Surviving Works of Sharaku*, New York, 1939.

HILLIER, J., *Japanese Masters of the Colour Print*, London, 1954.

—— *Hokusai: Paintings, Drawings and Woodcuts*, London, 1955.

—— *Landscape Prints of Old Japan. Collection of Marjorie and Edwin Grabhorn*, Introduction and descriptive text by J. Hillier, San Francisco, 1960.

—— *Utamaro: Colour Prints and Paintings*, London, 1961.

—— *Twelve Wood-block Prints of Kitagawa Utamaro illustrating the Process of Silk-culture, with an Introductory Essay by Jack Hillier. Reproduced in Facsimile from the Originals in the Collection of Edwin and Irma Grabhorn*, San Francisco, 1965.

—— *Japanese Colour Prints* (revised ed., of *Japanese Masters of the Colour Print*), London, 1966.

HIRAKI COLLECTION, *Olympic Memorial Exhibition: Master Works of Ukiyo-e. Hiraki Collection*, Tokyo, 1964.

HUNTER SALE CATALOGUE, *Japanese Color Prints: the Important Collection of Frederick W. Hunter*, Walpole Galleries, New York, March 1919.

Images du temps qui passe, peintures et estampes d'Ukiyo-e (catalogue of an exhibition at the Musée des Arts Décoratifs, Palais du Louvre), Paris, December 1966.

INOUE, KAZUO, 'Toyokuni no Yakusha Butai no Sugata-e' (Toyokuni's 'Pictures of Actors on the Stage'), in *Ukiyo-e no Kenkyū* vol. II, no. 1, Tokyo, November 1922.

—— 'Utamaro no Fujin Sō Jūppin ni oite' (Concerning Utamaro's Fujin Sō Jūppin Set), in Ukiyo-e no Kenkyū, no. 19, Tokyo, August. 1926.

—— 'Okumura Masanobu ni Kansuru Sensaku' (Research concerning Okumura Masanobu), in Ukiyo-e no Kenkyū, vol. v, no. 2, Tokyo, December 1926.

JOFFE, 20,000 Years of World Art, New York, 1967.

KANEKO, FUSUI, 'Kitagawa Utamaro no Nikuhitsu-ga' (Brush-paintings of Kitagawa Utamaro), Part II, in The Ukiyo-e Quarterly, no. 2, Tokyo, 1962.

—— Kodai Fuzoku Gashū (Collection of Old Genre Paintings), Tokyo, 1918.

KOKA, YAMAMURA, Kabuki-e Taisei, Kansei-ki (Survey of Kabuki Pictures, Kansei Period, 1789–1800), Tokyo, 1930.

Kokka, The: A Monthly Journal of Oriental Art, no. 390, no. 729, Tokyo, December 1952.

Kobe Yamato-e Kyōkai Tenran. (Exhibition of the Kobe Yamato-e Society), Kobe, 1922.

KONDŌ, ICHITARŌ, Suzuki Harunobu, English adaptation by Ogimi Kaoru, Rutland, Vermont and Tokyo, 1956.

—— Kitagawa Utamaro: English adaptation by Charles S. Terry, Rutland, Vermont and Tokyo, 1956.

—— The Thirty-six Views of Mount Fuji by Hokusai, English adaptation by Charles S. Terry, Tokyo, 1956.

KOTEI, ASAOKA, Koga Bikō (Reference Book for Old Paintings), 4 vols., Tokyo 1905, (2nd ed., 1912).

KURTH, JULIUS, Suzuki Harunobu, Munich and Leipzig, 1910 (revised ed., 1923).

Kyoto Yamato-e Kyōkai (Kyoto Yamato-e Society) (Catalogue of the Second Loan Exhibition held at the Kyoto Public Library), Kyoto, December, 1911.

LANE, RICHARD, Kaigetsudo, Rutland, Vermont and Tokyo, 1959.

—— 'Kiyomasu', in Asia Scene, Tokyo, May 1968.

MANZI SALE CATALOGUE, Catalogue des Estampes Japonaises (Deuxième Partie), composant la Collection du Feu M. Manzi, Galerie Manzi Joyant et Cie, Paris, Novembre 1920.

MATSUKATA, Ukiyo-e Hangashū (Ukiyo-e Print Collection of Kōjirō Matsukata), Osaka, 1925.

MATSUKI SALE CATALOGUE, Catalogue of Antique Chinese Porcelain and Pottery ... A Very Important Collection of Color-prints ... recently acquired by ... Bunkio Matsuki, American Art Association, New York, 1908.

MELLOR SALE CATALOGUE, Catalogue of the Very Important Collection of Japanese Colour-prints and Illustrated Books, the Property of the late John Mellor, Esq., Sotheby & Co., London, July 1963.

MICHENER, JAMES A., The Floating World: The Story of Japanese Prints, New York, 1954.

MIYATAKE, GAIKOTSU, Okumura Masanobu Gafu, Osaka, 1910.

MORI SALE CATALOGUE, Ukiyo-é Paintings, Japanese and Chinese Color-Prints. The S. Mori Collection. Catalogue by Frederick W. Gookin, American Art Association, New York, 1926.

MUTIAUX SALE CATALOGUE, Objets d'Art d'Extrême-Orient et Estampes Japonaises Appartenant à Divers Amateurs, Hôtel Drouot, Paris, April, 1922.

NARAZAKI, MUNESHIGE, Hokusai Ron (A Study of Hokusai), Tokyo, 1944.

—— Tenryūdōjin: (Catalogue of an Exhibition of Tenryūdōjin's Paintings at Nezu Bijutsu-kan), Tokyo, 1960.

—— Odaka Ukiyo-e Shūshū (Catalogue of the Odaka Collection of Ukiyo-e), Tokyo, 1961.

—— Tokaidō Go-ju-san-tsugi (The Fifty-three Stations of the Tokaidō), Tokyo, 1964.

—— Master Works of Ukiyo-e: Early Paintings, English adaptation by Charles A. Pomeroy, Tokyo and Palo Alto, California, 1967.

Nikuhitsu Ukiyo-e Senshū (Collection of Ukiyo-e Paintings), Osaka, 1930.

Nikuhitsu Ukiyo-e Taikan (Exhibition of Ukiyo-e Paintings), Kyoto Museum, 1933.

NOGUCHI, YONE, Harunobu, Elkin Matthews, London, 1927; Tokyo, 1932.

—— The Ukiyoye Primitives, Tokyo, 1933.

—— Harunobu, Kegan Paul, Trench, Trübner & Co., London, 1940.

OCHIAI, NAONARI, *Enkyō Mondai in oite* 'Problems concerning Enkyō', in *Ukiyo-e no Kenkyū*, vol. 5, no. 1, Tokyo, May, 1926.

OSTIER, JANETTE, *Poésie de l'instant: peintures de l'ecole shijo* XVIIIᵉ–XIXᵉ *siècles*, an Exhibition at the Galerie Janette Ostier, Place des Vosges, Introduction and Catalogue by J. Hillier, Paris, 1964.

—— *Hanabusa Itcho, 1652–1724. Dessins*, an Exhibition at the Galerie Janette Ostier, Place des Vosges, Introduction and Catalogue by Janette Ostier, Paris, 1964.

PAINE, ROBERT TREAT, and SOPER, ALEXANDER, *The Art and Architecture of Japan* (Section I on Painting and Sculpture by R.T.P.), Harmondsworth, Middlesex, 1955.

—— *Toyokuni's 'Pictures of Actors on the Stage'*, in Bulletin of Museum of Fine Arts, Boston, vol. LX, no. 321, 1962.

PERZYNSKI, FRIEDRICH, *Hokusai*, Bielefeld and Leipzig, 1904.

PORTIER, ANDRÉ, *La Femme dans l'art Japonais*, Paris, 1933.

PRIEST, ALAN, *Japanese Prints from the Henry L. Phillips Collection* (in the Metropolitan Museum of Art), New York, 1947.

RINFU, SASAKAWA, *Suzuki Harunobu Gashū*, Tokyo, 1927.

RUMPF, FRITZ, *Sharaku*, Berlin, 1932.

SEIDLITZ, W. VON, *Les Estampes Japonaises*, Traduction de P. André Lemoisne, Paris, 1911.

Sekai Bijutsu Zenshū, (Fine Art of the World), vol. 5 Tokyo.

SEXTON, J. J. O'BRIEN, *Catalogue of Ukiyo-e, Selected from the O'Brien Sexton Collection*, privately printed, London, 1922.

SOTHEBY SALE CATALOGUE, *Catalogue of a Valuable Collection of Japanese Colour Prints…the Property of a Gentleman residing abroad*, London, June 1913.

STERN, HAROLD P., *Figure Prints of Old Japan. Collection of Marjorie and Edwin Grabhorn*, Introduction by Harold P. Stern, San Francisco, 1959.

—— *Master Prints of Japan: Ukiyo-e Hanga*, New York, 1969.

STOCLET, MADAME M., SALE CATALOGUE, *Catalogue of Important Japanese Prints, the Property of Madame Michèle Stoclet (from the Collection of the late Adolphe Stoclet)*, Sotheby & Co., London, June 1966.

—— PHILIPPE R., SALE CATALOGUE, *Catalogue of Important Japanese Colour Prints and Works of Art, the Property of Mr Philippe R. Stoclet (from the Collection of the late Adolphe Stoclet)*, Sotheby & Co., May, 1965.

STRANGE, EDWARD F., *The Colour-prints of Hiroshige*, London, 1925.

STRAUS-NEGBAUR SALE CATALOGUE, *Sammlung Tony Straus-Negbaur Beschreiben von Fritz Rumpf*, P. Cassirer and H. Helbing, Berlin, 1928.

TAKASHIMIYA EXHIBITION, *One Hundred Masterpieces of Ukiyo-e*, Osaka, 1961.

TAMBA, TSUNEO, *The Art of Hiroshige; Catalogue of Hiroshige Prints, Paintings and Illustrated Books in the Tamba Collection*, Tokyo, 1965.

TEBBS SALE CATALOGUE, *Catalogue of the Japanese Colour Prints and Fine Editions of Japanese Illustrated Books, the Collection of the late H. Virtue Tebbs, Esq.*, Sotheby, Wilkinson & Hodge, London, March 1913.

TOKYO NATIONAL MUSEUM, *Illustrated Catalogue of the Tokyo National Museum*, (Ukiyo-e prints), 3 vols., Tokyo, 1960–3.

UCHIDA, MINORU, *Hiroshige*, Tokyo, 1930.

Ukiyo-e Bijutsu (Ukiyo-e Art), no. 4, 1932.

Ukiyo-e Fūzoku-ga Meisaku Ten (The Shiroki-ya 'Olympic' Ukiyo-e Exhibition), Tokyo, 1964.

Ukiyo-e Hanga Zenshū (Japanese Prints in the Collection of Kenichi Kawaura), Tokyo, 1918.

Ukiyo-e Shuei (Paintings from the Takeoka Collection exhibited at the Kyoto Art Museum, 1923), Kyoto, 1923.

Ukiyo-e Zenshū (The Complete Ukiyo-e), 6 vols., Tokyo, 1956–8.

WALPOLE GALLERIES SALE-CATALOGUE, *Japanese Color-prints. A Collection from Berlin*, Walpole Galleries, New York, 1923.

WINZINGER, FRANZ, *Souzouki Harounobu: Jeunes Filles et Femmes*. Paris, 1956.

Worcester Art Museum Bulletin, April, 1925.

YAMANAKA & CO., *Exhibition of Japanese Prints. Illustrated Catalogue Notes and an Introduction* (by Will H. Edmunds), Yamanaka & Co. Ltd., London, 1926.

YASHIRO, YUKIO, 2,000 *Years of Japanese Art.*, ed. by Peter C. Swann, London, 1958.

YOKOI, KIYOSHI, *Early Otsu-e*, Tokyo, 1958.

YOSHIDA, TERUJI, *Ukiyo-e Kusagusa* (Ukiyo-e Miscellany), Tokyo, 1942.

—— *Ukiyo-e Jiten* (Ukiyo-e Dictionary) (vol.1), Tokyo, 1944.

—— *Ukiyo-e Tokuhon* (Ukiyo-e Reader), Tokyo, 1947.

—— *Yakusha Butai no Sugata-e Kenkyū* (Study of Toyokuni's 'Portraits of Actors on the Stage'), in *Ukiyo-e* no.27, 1966.

GLOSSARY

aiban	print size between *chūban* and *ōban*, about 13×9 in.
beni	pink.
beni-girai	pink-avoiding.
benizuri-e	pink-printed picture, (used to describe prints in two colours, usually *beni* and green).
bijin	beautiful girl.
bijin-ga	picture of beautiful girl.
chūban	medium print size.
daimyō	feudal lord.
e	picture
engawa	balcony, veranda.
e-goyomi	pictorial calendar.
ehon	picture-book.
eshi	painter.
fude	brush.
fuki-bokashi	in colour-printing, 'wiped shading', even gradation of colour achieved by wiping the block with a cloth.
furisode	long-sleeved *kimono*.
fūryū	elegant, *à la mode*, fashionable.
usuma	sliding doors or screens.
futon	a quilted coverlet.
ga	picture, drawing; also, drawn by.
gafu	drawing-book.
fgakkō	artist.
geisha	female entertainer skilled in music and dancing.
geta	wooden footwear with two tall bars beneath the sole.
giga	drawn for pleasure or amusement.
gō	art- or pen-name.
gofun	powdered chalk or similar mineral for giving body to water-colour.
gohei	paper strips hung in Shintō shrines.
hakama	long ceremonial trousers.
hakkei	eight views.
haori	short outer coat.
hashira-e	pillar-picture, about 26/29×4½ in.
hibachi	charcoal brazier.
hitsu	brush; also, painted by.
hon	book.
hoso-ban	narrow size.
hoso-e	narrow picture.
ichimai-e	single-sheet print.
ishizuri-e	'stone-printed picture' (actually, print from a wood-block in 'white-line' style of the stone-print proper).
kabuki	the popular drama.

kachō-e	bird-and-flower picture.
kago	palanquin, litter.
kakemono	hanging picture.
kakemono-e	large upright print, about 23×12 in. often hung as *kakemono*.
kamuro	young girl waiting upon a courtesan.
kimono	clothing in general; specifically, the long dress worn by men and women.
kinuta	wooden implement used in fulling cloth.
kiwame	approved.
kokyū	three-stringed fiddle.
komusō	Member of Zen Buddhist sect, known by 'beehive' hat and flute-playing for alms; also malcontents and outlaws similarly disguised.
kotatsu	foot-warmer with a quilt over it.
koto	thirteen-stringed musical instrument.
kyōka	comic verse of thirty-one syllables.
mino	straw cape.
mitate	parody or burlesque.
monogatari	story, romance
musume	young woman.
nishiki-e	'brocade picture', polychrome print.
nō	classical drama.
ōban	large size, about 15×10 in.
obi	sash
onnagata	female impersonator on the stage.
sake	spirits distilled from rice.
samisen	three-stringed guitar.
seirō	'Green House', term for brothel.
shakuhachi	bamboo pipe.
shinzō	apprentice courtesan.
shōji	sliding paper panels.
shunga	erotic picture.
suiboku	ink-painting in free style.
sumi	black ink.
sumizuri	black-printed.
surimono	literally 'printed thing'; specifically, prints, usually of small size, for announcement, commemorative or verse-publishing purposes.
suzuri-bako	ink-stone box.
tabi	socks.
tan-e	prints, hand-coloured with *tan*, red-lead pigment.
tanzaku	poem-strips; as a print format, about 14×4 in.
tatami	floor matting.
tate-e	upright pictures (as opposed to *yoko-e* horizontal).
torii	archway entrance to shrine.
tsuzumi	hand-drum.
uchikake	outer coat.
uchiwa	fan.
uchiwa-e	fan-picture or print.
uki-e	perspective picture.

ukiyo-e	picture of the 'Floating World'.
urushi-e	lacquer-print.
wakashū	a young 'blood', a fop.
yarite	women superintendent of a 'Green House'.
yoko-e	horizontal picture.
yukata	bathrobe, cotton *kimono*.

INDEX